Managing Your Photographic Workflow with Photoshop Lightroom

Managing Your Photographic Workflow with Photoshop Lightroom

Juergen Gulbins and Uwe Steinmueller

Uwe Steinmueller, ustein_outback@yahoo.com

Juergen Gulbins, jg@gulbins.de

Editor: Gerhard Rossbach

Copy Editor: Judy Flynn

Layout and Type: Juergen Gulbins

Cover Design: Helmut Kraus, www.exclam.de

Cover Photo: Uwe Steinmueller

Printer: Friesens Corporation, Altona, Canada

Printed in Canada

ISBN 978-1-933952-20-8

1st Edition

© 2008 by Rocky Nook, Inc.

26 West Mission Street Ste 3

Santa Barbara, CA 93101

www.rockynook.com

First published under the title "Adobe Photoshop Lightroom. Effizient arbeiten mit Lightroom" © dpunkt.verlag GmbH, Heidelberg, Germany

Library of Congress catalog application submitted

Distributed by O'Reilly Media

1005 Gravenstein Highway North

Sebastopol, CA 95472

This book is printed on acid-free paper.

Contents

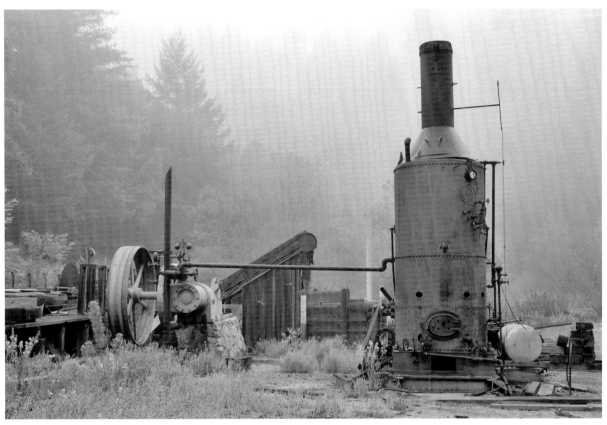

Camera: Canon 1DS Mark II; Keywords: Roaring Camp, Industrial relics., Black-and-white, Fog, Machinery.

Preface

With the boom of digital photography, a new market has emerged for software targeted especially at digital photographers. Until now, photographers needed three kinds of programs to cover their workflow requirements: a RAW converter like Capture One or Adobe Camera Raw, an image editor like Photoshop, and a digital asset management program like iView Media Pro or Extensis Portfolio. Simple image browsers like Adobe Bridge or those that came with RAW converters were just not good enough to manage thousands of photos and those professional Digital Asset Management (DAM) systems typically used in advertising agencies and publishing environments did not really meet the demands of photographers. Additionally, there were always minor but annoying inconsistencies in any photo workflow based on three or more different programs.

In late 2005, Apple came out with new software for the professional photographer: *Aperture*.

At that time, Adobe had worked for some time on a similar product code-named *Shadowland*. In early 2006, Adobe, in order to maintain its strong position in the photography market, answered with a "public beta" of this product, calling it *Lightroom* to both provide an analogy to the conventional darkroom and emphasize the difference.

After one year of beta versions and a number of changes and improvements, Lightroom version 1 was released in the spring of 2007. From the start, Lightroom was a remarkably rich and mature product. Of course, not all wishes could be fulfilled; the demands of the various types of photographers were too diverse – from the ambitious amateur to the experienced professional, from wedding photographers to landscape photographers, from fashion photography to food photography, all using a slightly or even considerably different workflow.

In June of 2007, version 1.0 was followed by version 1.1 with a number of improvements: better support for multiple libraries as well as functions to optimize libraries (now called "catalogs"), vastly improved sharpening and noise reduction functions, a *Clarity* control to enhance local contrast, and a lot of minor bug fixes and other improvements. In August 2007 Adobe shipped Lightroom 1.2 containing no new features but a number of bug fixes and performance improvements. (Along with Lightroom 1.2 came Adobe Camera Raw 4.2.) 1.2 is the version covered in our book.

> → *Most likely, there will be minor updates between Lightroom 1.2 and version 2.0 – all containing bug fixes and probably supporting new cameras. If you use Photoshop CS3, you, should update your ACR version along with your Lightroom version.*

Though Lightroom's interface is user-friendly, not every function is obvious and easy to find and users are often looking for more efficient ways to do certain tasks. That is where this book will help you. It will give you a thorough overview on the basics of Lightroom and show you how to build your own photographic workflow with Lightroom in the most efficient way.

Much of the experience that went into this book goes beyond just Lightroom and has been gained in our photographic work over several years with a number of programs like Photoshop, LightZone, several RAW converters, and various digital asset management systems. Many of the lessons that have been learned there can be applied to Lightroom.

Macintosh or Windows?

Whereas Aperture is a "Mac only" tool, Lightroom runs on Windows as well as on Mac OS X. So, for some of you, the following question may arise: Which is the better system for Lightroom and what are the differences?

The answer is easy: Lightroom runs equally well on both systems and the performance is fairly similar on either platform. Minor user interface differences will be explained. Most shortcuts will be shown for both versions. Additionally, see our note on keyboard shortcuts on the next page and in Appendix A.

We use Lightroom on both platforms without any platform-specific problems – though our main working platform is the Macintosh, which is why the screenshots in this book were mostly done with Mac OS X.

The Lightroom CD includes two versions – one for Windows and one for Mac OS X. In the European distribution, you can choose between an English, German, and a French user interface (at least under Mac OS X).

Acknowledgements

We would like to thank those who helped us with the production of this book, either by supplying us with test versions – here our thanks go to Adobe, in particular – or by reading early drafts, pointing out weaknesses and suggesting improvements. Very special thanks are due to Gerhard Rossbach (our editor at Rocky Nook) and Juergen's brother, Rainer.

Juergen Gulbins, Keltern (Germany) September 2007
Uwe Steinmueller, San Jose (California)

Conventions used in the Book

Most points will be self-explanatory. menu names appear in a different color and font. When we say View ▸ Loupe, it means to choose the item Loupe from the View menu. Items in dialog boxes and special terms are set in *italic*.

A reference like [05] refers either to a book or a Web link that you will find in Appendix A. Internet addresses like www.adobe.com are set in a different font (or color) to better distinguish them from other text.

Keyboard Shortcuts

Lightroom's keyboard shortcuts are very consistent both in Windows and Mac OS. In most cases, substitute the Windows `Ctrl` key with the Mac *Command key* `⌘` (also labeled `⌘`) and the Windows `Alt` key with the Mac `⌥` key (also called *Option key* and also labeled `alt`). When you read a key sequence like `Ctrl`/`⌘`-`S`, it means you have to press `Ctrl` and S together with Windows and `⌘` together with S with Mac OS. `⇧` is the symbol for the *Shift* key and `↵` is the symbol for *Return* or *Enter*. When we tell you to right-click, you will have to use `Ctrl`-click when you are working with a one-button mouse with Mac OS.*

You will find the keyboard shortcuts of the frequently used functions in Appendix A.

* *We strongly recommend investing in a multi-button mouse even when working with Mac OS and use your right button in this case.*

Camera: Nikon D2X
Caption: Burned Hills
Keywords: California, Hills, Grass, Burned Landscape

The Photographic Workflow

1

Before we plunge head on into Lightroom, we'll look at a typical photographic workflow. This workflow certainly differs from photographer to photographer. It will depend on how you work, what your purpose is, and what kind of photos you capture.

A good part of these considerations are independent of the software used. In some cases, you will have to fall back on more than just one application, even if this new generation of photo workflow programs claims to cover a broad range of tasks and demands. In reality, the whole spectrum of potential tasks is just too big and too heterogeneous and the software solutions are still new. Nevertheless, Lightroom will take you a long way.

We'll begin by naming the tasks and steps that you have to perform regularly as part of your digital workflow. This chapter is merely a brief overview. Later we'll cover in more detail what Lightroom offers to help complete these tasks.

We will often explain our own personal workflow and share our own practical experiences. Even if your own workflow is different in some details from ours, you will learn how to apply our solutions to your own needs. Many solutions are of a general nature, while others, with some simple modifications, can be adapted to your personal needs and preferences.

In this book, we will stick almost exclusively to the workflow for photos taken with digital cameras. We do acknowledge that shooting film in many cases still makes sense; however, this is not the subject of this book.

Of course, many who now use digital cameras still have a legacy of film-based images. Most will be looking for ways to bring at least some of these images into their computer to manage them together with digital images and to improve them using digital editing software. For those wanting to scan their films, we recommend *Scanning Negatives and Slides [05]*, a book by Sascha Steinhoff.

Once those pictures are scanned and available as TIFF or JPEG files, Lightroom will handle them in very much the same way it would if they were shot digitally. Instead of importing them from a camera memory card, you import them from a folder of scanned images. The same applies to images that were edited with some other software or tools–provided they are in one of file formats supported by Lightroom.*

** See section 2.2 about file formats supported by Lightroom.*

1.1 Image Preparation in the Camera

The digital photographic workflow starts in the camera. Here, we are not talking about photocomposition but rather about some relevant technical decisions:

▸ Which image format are you using in the camera?
▸ How to expose?
▸ What kind of preprocessing should be done in the camera?

These questions have already been answered in detail in our other books–e.g., on RAW conversion [01], as well as in articles that you will find on Uwe's Digital Outback Photo website and the free FotoEspresso Photo-Newsletter [11].** Therefore, we will give only a brief summery here.

Choosing the Camera Image Format

Depending on your camera, you may select three different image formats for your photos:

▸ JPEG. This image format is supported by all digital cameras
▸ TIFF is offered by only a few cameras.
▸ RAW file format is offered by all DSLRs and some bridge cameras.

DSLR = "Digital Single-Lens Reflex"

Additionally, newer DSLR cameras often allow selecting RAW plus JPEG. Whenever possible, we recommend to use RAW. Actually, there are a number of different RAW formats – almost every camera manufacturer uses his own proprietary RAW format. Even the RAW formats of different models of the same manufacturer will differ slightly. This results in a large number of different RAW formats. However, Lightroom supports most of them.

Understand the RAW File Format

To comprehend what this magic *RAW file format* is, you should understand how the majority of today's digital cameras work.

How the Camera Creates JPEGs

JPEG (*Joint Photographic Experts Group*) is the image format most commonly used by today's digital cameras. It provides a reasonably good image quality, but as you'll see, it has some limitations. The obvious one is that its compression format, although excellent, is lossy; some information is always thrown away when an image is compressed.[*] And even when the JPEG compression is low, the image still degrades slightly.

* *There are lossless JPEG formats, but they are not used in cameras.*

A more significant problem is that before the camera converts an image to JPEG format, the image must undergo extensive processing within the camera. This processing includes color and exposure correction, noise reduction, and sharpening. Because these adjustments are made in the camera, your ability to make further post-processing corrections is limited.

The upshot is that JPEG compression works best for images that don't need further substantial post-processing or when such post-processing is prohibited. However, if you demand high quality from your work, you will find that it is the rare image that does not need some post-processing.

How In-Camera Conversion Works

All new digital cameras capture color photos, right? Well, not exactly. While you ultimately get color prints from a digital camera, most modern digital cameras use sensors that record only grayscale (brightness or luminance) values. (The Foveon X3 sensor, some digital scanning backs, and multishot digital backs are exceptions.)

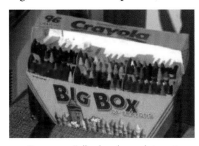

Figure 1-1: Full colored sample target

For example, say you want to photograph a box of Crayola crayons (Figure 1-1). A grayscale sensor would see the picture as it looks in Figure 1-2; that is, it would see only shades of gray. But how do you use a grayscale sensor to capture color photos? Engineers at Kodak came up with the color filter array configuration illustrated in Figure 1-3. This configuration is called *Bayer pattern* after the scientist who invented it back in the 1980s. (Other pattern variations are used as well, but this is the basic technology used in most CCD and CMOS sensors.)

The yellow squares in the grid shown in Figure 1-3 are the photoreceptors that make up the sensor; each receptor represents one pixel in the final image. Each receptor sees only the part of the light that passes through the

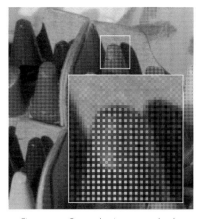

Figure 1–2: Grayscale picture seen by the sensor

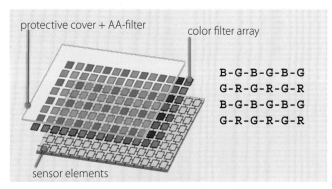

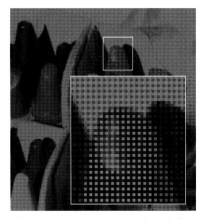

Figure 1-3: Bayer pattern achieved by a matrix of color filters

Figure 1-4: Color mosaic seen through the color filters

color filter just above the sensor element – red, green, or blue. Notice that 50 percent of the filter elements (and thus the receptor elements) are green, only 25 percent are red, and 25 percent are blue. This pattern works because the human eye can differentiate between many more shades of green than it can red or blue, which should not be surprising when you consider the number of shades of green in nature. Green also covers the widest part of the visible spectrum. Each receptor in the sensor captures the brightness values of the light passing through its color filter (see Figure 1-4). Each pixel, in turn, contains the information for one color (like a mosaic). However, we want our photo to have full color information (the R, G, and B channels) for every pixel. How does that magic happen? Here's where a software trick comes into play: a process called *Bayer pattern demosaicing,* or *color interpolation,* adds the missing RGB information by estimating information from neighboring pixels.

Demosaicing, then, is the method for turning raw data into a full-color image. A good demosaicing algorithm is quite complicated, and there are many proprietary solutions on the market.

The challenge is to resolve detail while at the same time maintaining correct colors. For example, think of capturing an image of a small black-and-white checkered pattern that is small enough to overlay the sensor cells, as in Figure 1-5.

White light consists of red, green, and blue, and the white squares in our example correspond exactly to the red- and blue-filtered photoreceptors in the sensor array. The black squares, which have no color information, correspond to green-filtered photoreceptors. So for the white square that align with the red photoreceptors, only red light passes through the filter to be recorded as a pixel; same is true for the blue photoreceptors.

Color interpolation cannot correct these pixels because their neighboring green-filtered photoreceptors do not add any new information, so the interpolation algorithm would not know whether what appears to be a red pixel is really some kind of "red" (if the white hits the red filter) or "blue" (if the white hits the blue filter).

Contrast this with the Foveon sensor technology illustrated in Figure 9-6. Instead of a Bayer pattern, where individual photoreceptors are filtered to record a single color each, the Foveon technology uses layers of receptors so that all three color channels are captured at the same photo site. This allows the

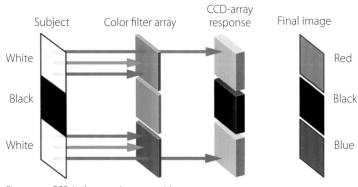

Figure 1-5: CCD/color mosaic sensor with color interpolation problem

Foveon sensor to capture white and black correctly without the need for interpolation.

The resolution captured by the Bayer sensors would decrease if the subject consisted only of red and blue shades because the pixels for the green channel could not add any information. In the case of monochromatic red or blue colors (those with very narrow wavelengths), the green sites get absolutely no information. However, such colors are rare in real life, and in reality, even when the sensor samples very bright and saturated red colors, there is information recorded in both the green and (to a much lesser extent) blue channels.

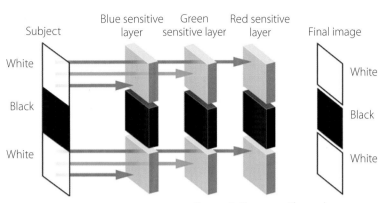

Figure 1-6: X3 sensor with no color interpretation errors

The problem in our example with the Bayer sensor is that in order to correctly estimate the color, we need a certain amount of spatial information. If only a single photosite samples the red information, there will be no way to reconstruct the correct color for that particular photosite.

Figure 1-7 illustrates a test we made in a studio to demonstrate the loss of resolution with a Bayer sensor when capturing monochrome colors. Notice how blurry the text in the Canon image is compared to that of the Sigma image.

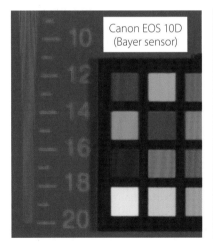
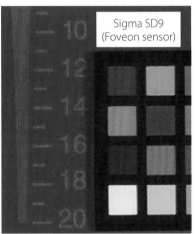

→ These test photos show an extreme situation because a Bayer sensor cannot really capture the transition from blue to red at a pixel level. While the failure is less dramatic in real-world photographs, it is still visible and definitely not something to be ignored. Increasing the resolution of a sensor naturally helps to diminish this effect.

Figure 1-7:
Fooling a Bayer sensor

Some of the challenges that interpolation algorithms face include image artifacts, like moirés and color aliasing (shown as unrelated green, red, and blue pixels or resulting in discoloration). Most cameras fight the aliasing problem by putting an *Anti-Aliasing* (AA) filter in front of the sensor. This filter actually blurs the image and distributes color information to neighboring photo sites. Of course, blurring and high-quality photography don't usually go together, and finding the right balance between blurring and aliasing is a true challenge for the camera design engineers.

After anti-aliasing, an image needs to have stronger sharpening applied in order to re-create much of the original sharpness. (To some extent, AA-filtering degrades the effective resolution of a sensor; therefore, some strong sharpening is typically needed later, during the RAW workflow.)

The mission of creating a high-quality image from the data recorded by a sensor is a complicated one, but it works surprisingly well.* Every technology has to struggle with its inherent limitations, and in many aspects, digital photography can beat film today because film has its own limitations to contend with.

In our experience, some of the high-end Canon DSLR cameras, as well as some of the Nikon models, do this job very well.

The Limitations of In-Camera Processing

For any given digital camera, the RAW data is all the data for grayscale brightness values captured on a chip. To produce a final image, this RAW data needs to be processed (including demosaicing) by a RAW converter. To produce JPEG images, the camera must have a full RAW converter embedded within its firmware.

You've already seen that one effect of relying on in-camera conversion to JPEG is artifacts caused by lossy compression, but camera-produced JPEGs have other limitations as well:

➜ *Keep in mind that lost detail cannot be recaptured regardless of whatever fancy sharpening methods are used. Sharpening does, however, do quite a good job, and digital cameras work much better than this description of it sounds.*

▸ Although most sensors capture 10- to 14-bit color (grayscale) information, only 8 bits are used in the final file. (JPEG can't encode more than 8 bits per color channel.)

▸ The in-camera RAW converter can only use the camera's own, limited computing resources. Good RAW conversion can be very complex and computer intensive. It is much more efficient to have the host computer convert the image than it is to use the onboard ASIC chip commonly used today. Additionally, the in-camera chip can't be upgraded, so as software technology evolves, the difference in efficiency will only increase.

▸ White balance, color processing, tonal corrections, and in-camera sharpening are all applied to the photo within the camera. This fact limits your post-processing capabilities because a previously corrected image must be corrected again, and the more a photo is processed (especially 8 bit), the more it can degrade.

RAW File Formats

The advantage with working with RAW file formats directly is that they essentially store only RAW data (although they also contain an EXIF section). Fortunately, you can perform all the processing that would be done in the camera to convert a file to JPEG or TIFF (including white balance, color processing, tonal/exposure correction, sharpening, and noise processing) on a more powerful computing platform. This offers several advantages:

▸ No JPEG compression, resulting in some JPEG artifacts. We are working directly with the RAW data.

▸ You can take full advantage of the 12-bit to 14-bit color information. This becomes a significant advantage if you need to make major corrections to the white balance, exposure, or color. When processing an image, you lose bits of image data because of data clipping.[*] The more bits you begin with, the more data you'll have in your final corrected image.

** Which accumulates over multiple steps*

▸ You can use sophisticated RAW file converters such as Lightroom, Phase One's Capture One DSLR, or LightZone.

▸ You may do color correction (white balance) later within your RAW converter without any loss of quality.

Working with JPEGs created in-camera is like working with images produced by a Polaroid camera (where you simply shoot and receive your processed image immediately). Working with RAW files is more like working with a traditional film negative, which can be developed and enhanced in the dark room. RAW converters mimic the film development process, and because you can always return to your original RAW file and process it again, you aren't limited by the technology built in to today's cameras or even today's software. Over time, improved RAW file converters will appear, which will produce even better results from the same data.[**] All in all, shooting in RAW gives you much greater control while processing your images.

*** This actually happens all the time.*

The Digital Negative/Slide

The files created on your computer when shooting RAW are often called *digital negatives*. We recommend that you keep these RAW files even after converting them because they hold all the information captured in your shot. You can always revisit these original RAW files when the following occurs:

▸ You've improved your own digital workflow.
▸ Better RAW converter software becomes available.
▸ You lose your derived files.

➔ We have seen many improvements over the last four years and expect more to come.

A RAW file is like a latent image and the RAW converter software your preferred magic developer, bringing detail out of over- or underexposed shots. The difference between film and digital is that you can perform multiple kinds of development on your images, returning to them over and over again.

The TIFF Option

What about setting your camera to save images as TIFF files? Saving as TIFF files solves only the lossy compression issue because the images are still converted to 8-bit inside the camera. Also, most TIFF files are larger than RAW files,[***] and they don't offer the flexibility and control benefits that RAW does.

➔ TIFF is hardly supported anymore with new cameras.
**** holding only one 12-bit or 14-bit grayscale value per pixel*

An 8-bit in-camera processed TIFF file is only slightly better than a high-quality/high-resolution JPEG.

JPEG

If you shoot JPEG, you should use the highest possible (native) resolution the camera can provide and use the lowest compression rate the camera allows for. If you intend on doing serious picture optimization, we recommend that you either deactivate all other further processing steps in the camera completely or set them to the minimum. This, for instance, applies to sharpening, contrast enhancement, color saturation, and noise reduction. If possible, use Adobe RGB (1998) as your color space (instead of sRGB), as Adobe RGB (1998) allows for a wider color gamut than sRGB.*

** See Figure 8.5 on page 157.*

RAW

With cameras that support RAW, it is in most cases the best choice. The reason is simple: Images shot in RAW contain the maximum amount of information the camera can provide. With most cameras, there are 12 bits per pixel (and color) instead of 8 bits JPEG provides. Some newer top cameras even deliver 14 bits per pixel. It would be pity to waste the gain in information. These additional 4 to 6 bits of information give us some valuable quality reserves when editing images. Thus, for instance, slightly overexposed photos, whose highlights will already be burned out with JPEG, may still be recoverable in the RAW converter.** Using RAW, you may also recover some shadow detail, which with JPEG would be blocked, by pulling up the shadows in you RAW converter (here in Lightroom).

*** In some cases about 0.5 to 1.5 exposure values (EVs) may be recovered.*

In addition, selecting RAW as image format allows you to postpone some of the image processing steps (and with them decisions on what the best settings would be) from the time of taking the picture to when you do RAW conversion –when you'll be working on a computer with a lot more processing power than that available in the camera, and you'll have more time for your choices. With RAW files, you may also try several variations to find the best one for your image.

The price you pay when working with RAW lies in the fact that RAW images take up more space on your memory card and will take a bit longer when writing to your card (in the camera). This will reduce the maximum number of pictures you can shoot in a row. In the past, you also had to do an explicit RAW conversion on your computer. With tools like Lightroom, this effort is dramatically reduced.

→ A fine feature of Lightroom is the ability to process RAW image as well as TIFF, PSD, and JPEG in an almost identical, very transparent way.

Using a combination of RAW plus JPEG makes sense if you want to have a finished image as fast as possible without much post-processing and at the same time want to be able to get the most out of your photos. For the first requirement, you will use the JPEG version. When you need the best quality available in your image, you will work with the RAW version of your images.

Exposure in the Camera

Apart from image composition, the proper exposure is the most important step toward a good photograph. The essential parameters are as follows:

- Exposure
- Aperture
- ISO

There is no general rule for all these settings – photographic scenes and light situations vary too much, and the right exposure will also be influenced by what you have in mind for the picture. The automatic exposure of up-to-date digital cameras will most often get the job done. However, exposure is by no means a cure for every photographic situation, and many professionals prefer to set it manually.

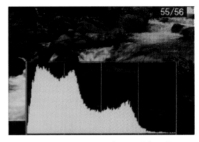

Figure 1-8: Histogram from a Nikon D70. Ideally, the right side of your histogram will stop just short of the right edge.

The decision on the ISO setting is relatively easy: as low as possible. The lower the ISO setting is in the camera, the lower the noise in the image. On the other hand, a slightly grainy (noisy) picture is still better than a blurry image. Often, a tripod will allow for a longer exposure and less motion blur due to camera shake.

The histogram, now available with all DSLR cameras, is an invaluable help for a good exposure. Up to now, only a few cameras provided a live histogram, which can be seen before the shot is taken. With the rest, you will have to inspect the histogram after the shot. While an image preview on your camera-back display will (to some extent) show if the image is sharp, the histogram can show if some image areas are over- or underexposed.

→ *Though Lightroom as well as Adobe Camera Raw (starting with version 4) allow to recover some of overexposed highlights (as will be described in Section 4.4 on page 85), this should be no excuse for sloppy exposure!*

If your photographic scene has a contrast that exceeds the contrast range of you camera, with digital cameras it is preferable to slightly underexpose the image rather than overexpose it. With most DSLRs, a blinking in the on-screen preview will indicate overexposed areas when you activate your histogram.[*]

* *For more on this, see Uwe's paper "Watch Your Histogram" in FotoEspresso 1/2005 [11].*

1.2 From Camera to Computer

You can download your images directly from the camera via USB or FireWire cable to the computer. We never do this, and instead download them from the memory card using a card reader. This is usually much faster and more reliable and comfortable and does not use up the batteries of the camera so fast. If you still have an older card reader with an USB 1.2 interface, you should replace it with a USB 2 reader; the time you save makes up for the expense.

Figure 1-9: We prefer to copy new camera shots using a USB card reader instead of directly connecting the camera.

The names of the images coming from the camera are very nondescriptive. Therefore, rename your images when downloading or immediately afterward. This also prevents images from having identical file names, which we avoid at all costs. This is a really important step. The procedure for this in Lightroom and our file-naming scheme are explained in section 3.1.

➔ A good book on how to set up your system for digital photographic work; how to name, organize, and manage your photos and how to set up your metadata is "The DAM Book. Digital Asset Management for Photographers" by Peter Krogh [06].

Figure 1-10: To the left you see my filled cards, to the right my freshly formatted cards, ready for use.

➔ In order to quickly provide different sized previews, Lightroom generates three different sized preview pictures from the same image. These previews are stored as JPEG images in a special preview library.

A well-thought-out and strictly adhered-to filing structure for the pictures might still be more important than good filenaming. While in the past it may have been too costly to keep all images online, this has changed. Today, disks are big and inexpensive. Therefore, we recommend keeping as much online as possible – or at least the shots of the last few years – and merely keeping multiple backup copies offline.*

From this discussion, it is only logical that the next step should be backing up your valuable images. It is imperative to do this before you delete the photos from the memory card. We even recommend having two backup copies – e.g., one on a second disk and one on a DVD. This may sound excessive, but taking pictures takes time and also comes at some cost. Some or even all of your shots may not be repeatable. So, planning and systematically maintaining your backups and archiving is not a waste of time but a task you should not ignore, even if it may be boring.

Only after we have completed all the previous steps do we delete the pictures on the memory card – by reformatting in the camera and not using our computer. Reformatting the card in the camera guarantees maximum compatibility with the file system of the camera.

After formatting the memory card, we mark the card empty by placing it brand-side upward in the card safe, while we store full memory cards (after use in the camera) backside upward in the card safe (see Figure 1-10).

1.3 Image Inspection

After you download your new digital shots to your computer – including renaming them and backing them up – it's time for image inspection. For this, you need large previews to properly evaluate your images. Here are some points to consider about each image:

▸ Is the picture composition convincing?
▸ Does the picture have a good exposure?
▸ Are there enough details – the highlights not burned out and the shadows not blocked?
▸ Is the picture sharp in its relevant parts?
▸ Are there annoying parts in the picture?
▸ Will you probably be able to get rid of them by simple cropping or do you need to digitally retouch them later?
▸ Is the atmosphere right?
▸ Which of several similar pictures is the best?

For this process, you will need a good preview – with RAW files this includes a preliminary RAW conversion. Thumbnails are only useful for an overview of you new images; a higher resolution preview is required for a content inspection and a full-sized image for the inspection of the finest details. Seeing several pictures side-by-side can improve the evaluation pro-

cess. Often, you may want to hide some pictures and delete others or prepare them for deletion. Sorting your images and assigning ratings helps to organize your new photographs.

Image Assessment

It makes good sense to assess your images and do some classification and prioritization. This assessment suggests a certain order of treatment, as in general one will work on the pictures with the highest rating first. It also helps to find your best images – we call them *portfolio images* – later on. Combined with further metadata, ratings will also help to recall the images – be it to sort those that are no longer needed or worth keeping or to group images in special topic collections.

Adobe has established a star rating – ranging from no star to five stars.* You have to define your own criteria for the way you rate images. We came up with the following rating schema:

no star Images that are acceptable and that we would like to keep for the time being or leave without assessment for the time being.

* Images we would like to keep that have some future use. Otherwise, they do not really stand out from the mass.

** Shots that are OK and on which we will work after the first inspection. We will probably do some optimizing on these shots and show them to a customer if the shot was done as part of a contract.

*** Good photos with only minor imperfections.

**** High-quality images that we will include in our portfolio or will present to a customer.

***** Absolute top-notch photos (according to our taste and our standards). There will be only very few images that justify a costly reproduction without reservation and that we might also sell.

Figure 1-11: Lightroom allows you to mark up your images using star ratings, color labels, and flags. The preliminary markups should be done in your inspection workflow.

After some experimenting, your rating scheme should remain stable. The assessment of single images, however, may change over time, be it, because you did some image optimization – perhaps with a new tool – or because you became more critical and down-rated some of them.

The images in these star classes should, so to speak, form a pyramid with a wide base of pictures with no or few stars at the bottom and tapering off toward the top, where few images with high ratings lie.

A negative rating of images also helps – e.g., to mark pictures you would like to delete immediately (as part of your inspection workflow) or to mark them as candidates for a thinning out process at a later time.

Starting with Bridge**, Adobe offers color labels and provides five different colors: ▉□□□□. In Bridge and Lightroom you are free to assign

verbal qualifications as text labels to these five colors. We use these labels to mark up certain working states of our images.

Finally, Lightroom provides flags – intended as *Accepted* (or *Pick*) marks (⚐) and *Rejected* marks (⚑). Lightroom provides an operation to delete all images marked with the *Rejected* flag. To make sure you do not delete any image unintentionally, you should stick to the deletion workflow we describe in section 3.3, page 62.

To some of you, this assessment phase after downloading your images may seem superfluous, because you may like to begin optimizing your pictures right away. Nevertheless, experience shows that this effort is well worth it in the long run – when you have a large collection of images and want to call up images for certain purposes, when you want to reduce the number of images in your catalogs some time in the future, or when you have to show photos well sorted and rated to a customer. Also, after importing a new image set, you will often prefer to just deal with your highly rated images and leave the rest to work on at some later time.*

** or you may never get to them at all.*

Metadata

Metadata is data about data (here, your images). Indeed, the marks described earlier are this type of data. However, these markups are not sufficient. We need much more – e.g., when searching for a particular image in a large catalog. Without further metadata, it would be like searching for a needle in a haystack. Fortunately, digital cameras embed some additional metadata called EXIF data into your images. But you can also add your own information as metadata in an information block called IPTC data.

EXIF

EXIF stands for *Image Exchange Format for Digitally Still Cameras.* EXIF data with modern digital cameras (even with all consumer models) are automatically embedded into the image file by the camera. What the camera embeds automatically depends on the manufacturer and model. In EXIF, we find information on the camera (e.g., manufacturer, model, firmware release, and serial number) and – as far as the camera can recognize it – the lens model and the focal length used with the shot. It also includes aperture and shutter speed, ISO speed rating, your metering mode, whether the flash fired or not, the color temperature recorded by the camera, what camera program was used for the shot, and some more information (see Figure 1-5). And it includes the crucial date and time the shot was taken (according to the clock setting of your camera). Today, some cameras even embed GPS (*Global Positioning System*) information. Most of these data can't be edited – at least not using Lightroom. Sometimes, however, you might like to correct the date or time the shoot was done. Lightroom allows for this.

Lightroom will only show nonempty EXIF fields. This makes the representation a little more compact and clear.

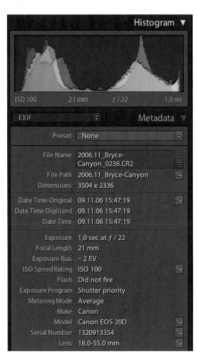

Figure 1-12: EXIF data will tell you quite a bit about your shot – e.g., the focal length, the shutter speed, and the aperture used.

This information is of interest not only to the photographer and may help when searching for particular photos – e.g., all shots taken with a specific zoom lens or a specific camera – but EXIF data are also used by some applications and plug-ins when doing certain optimizations automatically, such as correcting some lens distortion or vignetting.

IPTC

The metadata contained in IPTC – IPTC stands for *International Press and Telecommunication Council* – originally originated from the area of the press (where it is still and heavily in use). Meanwhile, the standard has been extended and adapted to the needs of digital photography. The information in the IPTC fields covers five areas:

1. Copyright information – Originator's data and information on rights of usage (Ⓐ in Figure 1-13)

2. Information on the (image) contents (what, where, who, how …) including Headline, Caption and Title (Ⓑ in Figure 1-13)

3. Categorization (classification) Ⓒ

4. Keywording (with some overlapping with points 2 to 3). Though keywords are part of the IPTC data, Lightroom and other Adobe applications provide a separate section for displaying and entering them.

5. Status information in the image Ⓓ

To those who are not aware of the meaning of the different IPTC fields, we recommend that you read the *IPTC4XMP Core User Guide [23]*. You will find the description of and the conventions for the different IPTC fields – e.g., the maximum field length and which IPTC code should be used for some of these fields. David Rieck's website [26] is also recommended reading, indeed.

 With some of the IPTC fields, specific codes should be used, such as for categories, scenes, genres, and the country in which the photo was shot. The country of the shoot, for example, is coded using the two-letter ISO 3266 country code (e.g., *US* for the USA, *UK* for England, and *DE* for Germany). This code corresponds to a great extent to the domain endings of the Internet addresses. You have to make up your mind whether you intend to use these codes. You may find them under [19]. If you prefer to not use these codes – and many of them are not very intuitive – you should at least use a consistent vocabulary in these fields.

 There are a number of books on keywording. If you want to plunge into this, again the website of David Rieck [26] will give you a good starting point. Be careful, however, that you don't get lost in the numerous information and discussions there. Therefore, we include a very brief representation of this subject.

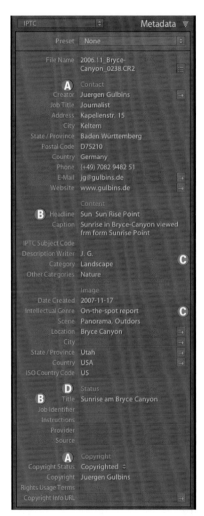

Figure 1-13: This is part of the IPTC data Lightroom may show for your image.

* For more on this, see [27]:
www.controlledvocabulary.com/
metalogging/ck_guidelines.html

Your keywording should provide answers to six "W" questions (the list was taken from [27], where you will find a more information):*

Who is to be seen in the image?
What do you see in the picture?
Where is the subject located?
When was the photo shot (as long as it is not explained by the EXIF data)?
Why was the photograph taken and why is the content important?
 How many persons or objects are seen in the picture?

The IPTC specification applies some rules to the keyword entries:

▸ The single keyword entry – it may also be a phrase – must not be more than 64 characters. You may, however, use several keywords in every keyword field (there is only one keyword field per image).

▸ The total keyword entry should not be more than 2,000 characters (the current IPTC standard allows for more, but 2,000 characters provide for backward compatibility with the previous version of the standard).

▸ Keywords are separated by a comma or semicolon followed by a space.

The questions mentioned above also help when entering a caption into the Caption IPTC field.

A restricted vocabulary is recommended for keywords – preferably a predefined list of keywords. This guarantees a uniform way of spelling and reduces the variety of words used for the same circumstance. This of course only applies to general concepts, not to names and special locations (e.g., Bryce Canyon or Hearst Castle). When keywording an image, think about the way you will be searching for it. For categories, use the plural – e.g., use *Mountains* instead of *Mountain* or *Cattle* instead of *Cow*.

Don't to be too worried about the keywords. Often, more is better here than less. When searching for images, it helps if a concept is represented by several spellings (which somewhat contradicts what we said before). This, in particular, applies to geographic terms for which there are often several ways of spelling.

Some of the IPTC items might be put into a metadata template that will be used when importing images. Typically, this includes your name and address* and some information on the terms of usage and a copyright notice. These templates can save you a lot of time, because you will not have to assign the data manually.

You may want to use some of the basic IPTC data (caption, title, keywords, file name) in certain forms of image presentation – e.g., the caption in a slide show or Web gallery. Keywords, additionally, are invaluable when searching for and sorting images.

You may also use the metadata for grouping images into collections (kinds of virtual folders). This allows for image grouping that is independent of the physical location of these photos. Collections in Lightroom are

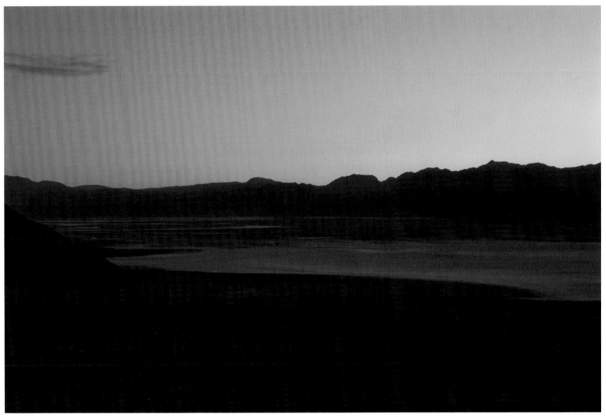

Figure 1-14: Blue Hour in Death Valley. Shot taken looking toward Bad Water. Keywords: Death Valley, Bad Water, Evening, Sunset, Holiday 2006, Landscape.

very cheap in terms of disk space. They are nothing more but simple lists containing references to the actual images. Thus, an individual image may be part of several different collections.

Digital asset management systems like Lightroom store metadata in their database. This allows for quick search and retrieval. Often, however, you may want to make the metadata accessible to external applications as well. Therefore, it is advantageous if there is a possibility to embed the metadata in your images too (provided the format allows for this). Lightroom does offer this. It is either done with every change or done on demand, or, optionally when exporting your images.**

The subject of metadata is not trivial and a professional, intending to sell his pictures, will do more on metadata entry than most amateurs will do. If you hand over pictures to a customer, metadata may increase the value, but watch for hidden metadata that you don't want to pass along.

** *With TIFF, JPEG, and DNG files the metadata is embedded into the image file. With RAW files, an XMP (Extensible Metadata Platform) sidecar file is created that contains this metadata.*

1.4 Image Optimization

With image optimization, in most cases our primary intent is to achieve a pleasing photo and an image that is close to what we had in mind when took the picture. This may not be the same as a truthful representation of the photographic scene we shot – neither the colors nor the tonality.

Of course, there are certain types of photography – e.g., product photography, documentary photos, and fashion shoots – where you have to get very close to reality – at least relating to colors. Even then it often is more a matter of getting a pleasing image than mirroring reality.

Image optimization depends on your personal preferences and your vision. Frequently, we produce several different versions of the same original. Some photos need relatively few changes; others need more steps and often several iterations. Therefore, nondestructive editing is a very powerful feature. It allows you to modify all or just one of your corrections without having to start all over again. Nondestructive editing allows you to perform several corrections without degrading your image quality with each step. A quality loss might occur if every correction were immediately rendered into your image. With applications like Lightroom, rendering of all corrections is only done to (temporally) update your preview on-screen or when exporting and converting your image. A single rendering process degrades the image quality less than a number of separate steps does.

For nondestructive editing, Photoshop provides adjustment layers. Certain corrections, however, – e.g., sharpening and most other filters – can't be done using adjustments layers.* The new generation of photo editors, like Lightroom, Apple Aperture, and LightZone, perform image editing nondestructively. Here all corrections are not (immediately) rendered into the original pixel image but stored as a sequence of correction instructions along with the picture. Only when an output is produced (e.g., for the preview on screen or when exporting the images) does rendering take place.

As all corrections can be undone without any loss of image quality, you may be more courageous during editing. At first, you can do a correction only cautiously and increase it when the result pleases you, or, you may do a strong correction and reduce it if it is too strong. You can experiment and achieve new, hopefully better results. Operations that when overdone can destroy a photo, e.g., increasing contrast or sharpening, now are less risky.

This is very elegant, but will cost CPU power and RAM. Additionally, at least with Lightroom and Apple Aperture, there are still some restrictions. They are primarily due to the high demand of computational power. Thus, up to now, for example, Lightroom offers neither perspective corrections nor correction of lens distortions. Also corrections that are restricted to a local image area are not possible in Lightroom yet. This also applies to composing panoramic views from several separate images and to HDRI

Well, since Photoshop CS3, you may use the "Smart Object" technique to overcome this restriction with some filters.

HDRI = "High Dynamic Range Imaging"

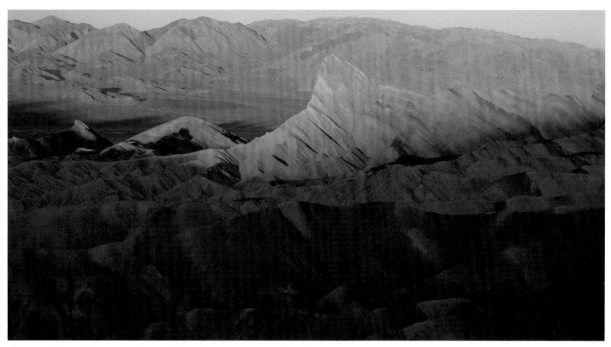

Figure 1-15: Sunrise in Death Valley, viewed from Zabriskie Point. Keywords: Death Valley, Zabriskie Point, Morning, Sunrise, Landscape, Holiday 2006.

techniques, which blend several individual shots using different exposure settings into a single image.

For such operations, you have to break out of Lightroom and use external tools. Additionally, if you intend to use images with some corrections already done in Lightroom, you will have to export them, do your operation outside of Lightroom, and re-import the results if you want to manage those resulting images in your Lightroom catalog.

If you need an image in a format not supported by Lightroom, you have to use other applications and export your image.* For instance, you could use Photoshop, if you need CMYK images for 4-color offset printing (e.g., for printed books).

We will discuss exporting in Chapter 8.

The same is true with some special optimizations. In these cases, you export your image and handle the optimization outside of Lightroom. Even Photoshop can't cover all kinds of optimization, and often you need special Photoshop plug-ins. Though Lightroom is a fairly open system, and we probably will see quite a few plug-ins and add-ons in the future, they are not available yet. Therefore, you have to export your images and use an external application for these corrections.

It you plan to optimize a photo outside of Lightroom, we recommend keeping some of the corrections (like tonality and sharpening) minimal in Lightroom.* In these cases in Lightroom, we avoid, for instance, final sharpening and just stick to proper white balance and eventually do some exposure compensation and tonal optimization. In most cases, we pass on the image as a 16-bit TIFF file.

** In order to avoid overcorrecting and some image quality loss due to repeated rendering*

1.5 Image Presentation

All our work on images only serves one purpose in the end: to achieve a good-looking image that may be presented as a print, in a slide show, or in a Web gallery (or be passed on to a customer).

Therefore, preparing an image for a specific presentation should, in most cases, be viewed as a separate step in our workflow. It turns out that different presentation forms (a fine art print, a slide show, a web gallery) will require different processing. Images have to be scaled to a different size or resolution, for instance, and sharpening has to take into account the output method as well as the output size.

While in the past we used different applications to produce different output formats – e.g., Adobe ImageReady for Web images and Apple iPhoto for slideshows –, the new generation of all-in-one applications like Lightroom claim to cover a broad range of output formats – something entry-level photo editors like Photoshop Elements or Apples iPhoto already have been doing for a while, but at a lower level of sophistication.

To cover these different output formats, Lightroom, in addition to basic administration and photoediting, provides different modules (equivalent to modes), one each for printing, slideshows and Web galleries, as Figure 1-10 illustrates schematically.

1.6 Mapping the Digital Photographic Workflow into Lightroom

Lightroom covers all tasks described earlier using different means:

▶ First, it imports the images of a shoot (this is done in Library mode). With Lightroom, similar to other digital asset management systems, you can only work on imported images.

▶ It generates preview images (icons) and stores them in a separate library. With RAW files, a preliminary RAW conversion is done.

▶ It provides a number of different views on your (imported) image files, allowing you to browse and sort your files and to search for images using different criteria. Lightroom also allows grouping images into collections and stacks.

▶ Lightroom provides very flexible and powerful metadata handling. All metadata are stored in the central Lightroom database (the catalog).

▶ Lightroom provides a very efficient and powerful image editor that can edit all supported file formats* in a very transparent and nondestructive way.

JPEG, TIFF, PSD, DNG, and about 150 different RAW formats.

▶ Using three dedicated modules (*Slideshow, Print,* and *Web*), Lightroom allows you to prepare images for different output/presentations methods.

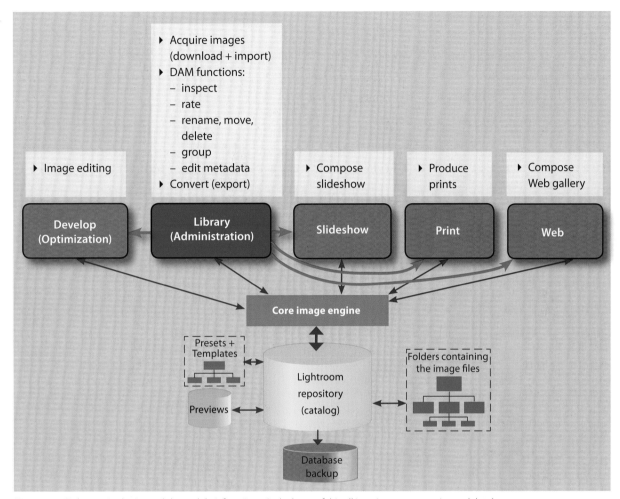

Figure 1-16: Lightroom's 5 basic modules and their functions. At the heart of this all is an image core engine and database.

▸ For all this, it makes use of five modules that are shown in Figure 1-16. These five modules at the same time are five Lightroom modes and the user may freely switch from any mode (module) to any other. Each mode has its own panels, controls, specific menus, and tools.

In visual terms, the connecting link for all these modules and functions is the filmstrip with its preview icons. Technically, the connecting element is a database where all metadata and administrative data are stored. The metadata contains references to the actual physical image files outside the database in a file/folder structure which the user passes on to Lightroom when importing images. The core image engine does all the image processing. This engine uses the same core engine as Adobe Camera Raw* (that is part of Adobe Photoshop CS3).

** The version corresponding to Lightroom 1.2 is Adobe Camera Raw 4.2.*

Understanding Lightroom

2

Lightroom – or to use its full name "Adobe Photoshop Lightroom" – is a new breed of application offering all the essential tools needed for an efficient digital photography workflow in a single application. It uses a single, homogeneous interface, a central database, and a powerful image engine. And it covers three important areas of every photography workflow:

1. *RAW conversion and image editing*
2. *Digital asset management*
3. *Producing image presentation in various output forms, such as prints, slideshows and Web galleries*

In Lightroom, you can work with RAW files as well as handle other important photo file formats like TIFF and JPEG. Photoshop is still the top tool for image editing; that is why Lightroom can also produce and edit PSD files. All editing is done nondestructively, thus leaving the original untouched.

Integrating this functionality into one application considerably simplifies the photography workflow because you have to learn only one application and hardly have to switch applications or deal with different user interface logic. This can be a tremendous help for your digital photographic work.

2.1 Nondestructive Editing

Figure 2-1: Your digital original (above) and your optimized image (below) may be just a few mouse clicks from each other.

** And sometimes a bit of patience when using a less powerful system*

Editing in Lightroom is *nondestructive.* Corrections are not rendered into the image immediately but are stored as a set of correction records alongside the image while the image file itself is left untouched. This is very economical in terms of disk space. The record containing the correction sets consumes only about 5–15 KB per image. Image corrections using Photoshop layers can create files that are much bigger. If you want to have several different versions of the same image, e.g., a color and a black-and-white version or versions with different color tuning, with Lightroom there is no need for copies of the original images. Lightroom will just keep the original once and save a correction record set for each additional variation of your photo. Compared to Photoshop and similar image editors, this may save you quite a bit of disk space.

There are some additional advantages with nondestructive editing. One is that you may redo a correction step several times without having to start from scratch over and over again and without losing image quality with editing.

However, every time you change a setting, the preview has to be recalculated. When an image is exported, the whole set of corrections has to be rendered into the exported image, and this might be quite a few. Therefore, working nondestructively requires a lot of computational power and a bit more main memory compared to the traditional way.* Plenty of CPU power, best combined in a multi-CPU system, and plenty of main memory are the means to keep your editing reactive and smooth.

2.2 Supported Image Formats

ACR = Adobe Camera Raw

PSD is the native image format of Photoshop.
DNG =Digital Negative Format

*** Well, Lightroom will import Lab mode files and do a proper preview, but it will convert them to RGB internally.*

**** If not, it may be activated in Photoshop Preferences in the "General" tab.*

For the RAW conversion (and other image corrections), Lightroom uses a core image engine that is the same as that of Adobe Camera Raw 4.x. However, in Lightroom you will see a different user interface. Lightroom operates as a different frontend to that core engine. Using the ACR core engine, Lightroom supports the same spectrum of RAW formats as Adobe Camera Raw – a very broad range of more than 160 different RAW formats and is quite up-to-date concerning new DSLR cameras. Apart from these RAW formats, Lightroom also supports TIFF (8 and 16 bits), JPEG, PSD (8 and 16 bits) and DNG. DNG is a universal RAW format, which was designed by Adobe. It is well documented and was presented as an ISO standard draft. All these formats are edited nondestructively.

Up to now, Lightroom supports only RGB and grayscale mode but not CMYK and Lab.** If you import PSD files containing layers (typically, layered Photoshop files), the Photoshop-compatibility mode must be set. This provides for the internal virtual layer, embedded in the file, which sums up all layers present. With Photoshop, this option is activated by default.***

2.3 Lightroom's DAM Features

A *Digital Asset Management* system (DAM) handles digital *assets*. For most photographers, these assets are mainly digital images. This handling is one of the tasks Lightroom does. Lightroom and competing programs like Apple Aperture offer essential DAM features for the photographer. They permit down-loading digital images and inspecting, assessing, sorting, and aggregating according to different criteria. Another important feature is assigning and editing metadata, i.e. reading EXIF data and editing IPTC data which provide information on the image, e.g., in the form of key-words, captions, and copyright notes. For image retrieval and sorting this is a most essential features. Lightroom allows for this in a very comfortable and efficient way. It even supports using your own keyword hierarchies.

Compared with a full fledged DAM system, what is missing in Light-room (as well as in Apple Aperture), is the support of a broad range of dig-ital asset formats, e.g., more image formats, audio and video files, and DTP documents.* It would be convenient if one could also organize these digi-tal assets using the same tools and, on demand, cut out all those objects you do not want to see for your current task.

DTP = Desktop Publishing

** For these, Adobe Bridge is much better. However, it does not use a database, thus it is very inefficient when working with a huge number of assets.*

2.4 System Requirements

Lightroom runs with Mac OS X** as well as with Windows XP (Service Pack 2) and Windows Vista. Adobe specifies a minimum of 0.75 GB of main memory and recommends 1 GB. Our experience suggests using 1.5 GB of main memory, and still more is even better.

Lightroom does not require a high-performance graphics card but the card will have to support a color depth of 24-bit (3 × 8 bits) with your work-ing resolution. You may get along by using a display resolution of 1024 × 768 bits (SVGA, the typical laptop resolution). Using a larger display and higher resolution will make your work easier and more efficient as it will allow for a better image assessment, less scrolling, and less opening and closing of panels and panes.

Lightroom requires approximately 1 GB for the program and its basic files. Count in, however, your image files, the growing Lightroom catalog files, and some space for your preview icons on top of that. Even on a lap-top you should put aside at least 10 GB for this. On a workstation, we re-commend putting your Lightroom database and your images file on a sep-arate dedicated disk partition or, better still, a separate disk.

Using the international version of Lightroom (the one you get when you purchase it in Europe), your may switch between an English, French, and German user interface on a Mac. There is also a separate Japanese version.

Before purchasing Lightroom, you can download a free 30-day trial ver-sion from Adobe's website.

*** Starting with version 10.4.8 and running on PowerPC-based systems as well as on Intel-based Macintosh systems*

SVGA = Super Video Graphics Array

Figure 2-2: A 24 inch monitor like this Eizo S24100W is no must-have, but allows for very pleasing work with Lightroom.

➜ *For a 30-day trial version of Lightroom, see www.adobe.com/downlaods/.*

2.5 Lightroom's User Interface

The huge number of features and their high integration causes a very compact user interface because a lot of information has to be accommodated in a small space. To achieve high clarity and a display in which you don't have to open and close panels or push aside function panes constantly, Lightroom uses just a single window and no floating palettes. All preview windows and all panes and bars are accommodated, at least visually, in a single window. However, Lightroom's window is subdivided into several panels and panes (inside the panels). Figure 2-3 illustrates the layout of the Lightroom window with its panels and panes. The main components are as follows:

1. The *Module panel,* containing the Identity plate Ⓐ and the Module bar Ⓑ.
2. The *Navigation panel,* containing the Navigator window Ⓒ and the template browser Ⓓ.
3. The *Filmstrip* (at the bottom); the *Info-bar* Ⓔ and *Filters* Ⓕ are also part of this panel.
4. The *Parameter panel* (to the right).
5. The *Content pane,* containing the preview. Here, optionally, you may hide/show the Toolbar Ⓖ.

Figure 2-3:

The anatomy of Lightroom's main window with all panels visible. In the areas marked red, you right-click to get a fly-out menu, that allows to set up some display options.

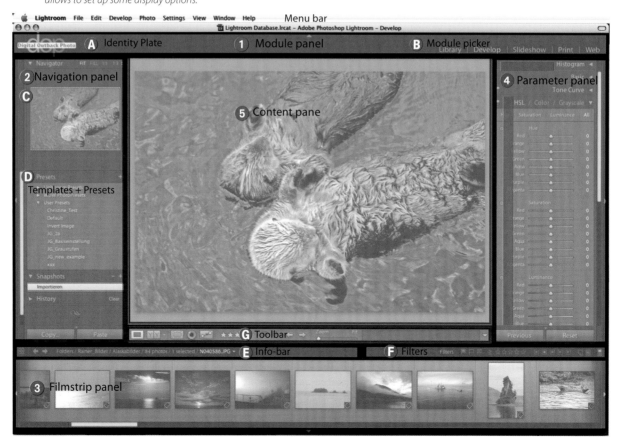

The first four panels (①–④) can be shown or hidden – either explicitly, by clicking on the triangle ◧ of the panel, or automatically when *Auto Hide* mode is activated and you enter or leave the corresponding panel site.

✓ Auto Hide & Show
 Auto Hide
 Manual

To set these different modes, call up panel fly-out menus by right-clicking on the edge of the panel area.* This mode may be separately set for each of the four basic panels (①–④).

* When working with a one-button Mac mouse, use Ctrl-click instead.

Within the left Navigation panel ② and the right Parameter panel ④, you can unfold and fold a pane by clicking on the ▶ icon of the pane. If several panes are open, you may have to use the scroll bar. However, you can also activate *Solo Mode.* In *Solo Mode,* the pane you click on will be opened while all other panes of the panel will close automatically. Here, again, with the right mouse button (in areas marked red in Figure 2-3), you may call up a fly-out menu and activate *Solo Mode.*

In this menu, you may also select which panes should show up in this panel (see Figure 2-4).** You can have separate setups like this for your Navigation panel as well as the Parameter panel for all five Lightroom modules.

✓ **Basic**
✓ **Tone Curve**
✓ **Adjustments**
✓ **Split Toning** *
✓ **Detail**
✓ **Lens Corrections**
✓ **Camera Calibration**

Show All
Hide All

Solo Mode

Expand All
Collapse All

The content of the Navigation panel (on the left) as well as that of the Parameter panel (on the right) depends on your current Lightroom Module (more about this a bit later). If you move the separation bar between these panels and the central content pane with the mouse, the control panels' width can be varied within certain ranges (both panels have a minimal width).

** If, for instance, you rarely make use of the Camera Calibration pane in Develop mode, you may fade it out, here.

Figure 2-4:
Here, showing the menu for Develop mode, you may activate Solo Mode and choose which pane should show up in your panel.

The top Lightroom panel is the *Module* (we sometimes call it also *Mode*) panel ①. It indicates which module you are in and allows switching to any other Lightroom module – just click on the module name.* Additionally, it may contain an Identity plate (which you have to set up first, as described on page 40).

The content pane occupies the center of the whole Lightroom window. Here you will see a matrix of image previews (when Grid view in Library mode is active), the preview of your currently active image (in *Library* or *Develop* mode), or a preview of your slideshow, print or Web gallery when you are using the *Slideshow, Print,* or *Web* module, respectively.

Below the content window you will find the Toolbar ⑤, which you may also show and hide (use ⊤ for this). The tools found here depend on the module you are currently using.

* There are more ways of changing modes, e.g., when this panel is faded out. For example, you may use the following keyboard shortcuts:
Ctrl-Alt-1 → Library mode
Ctrl-Alt-2 → Develop mode
Ctrl-Alt-3 → Slideshow mode
Ctrl-Alt-4 → Print mode
Ctrl-Alt-5 → Web mode
Ctrl-Alt-↑ → previous mode module
(For Mac OS, replace Ctrl-Alt with ⌘-⌥.)

Figure 2-5: Toolbar in Develop mode with all items visible

In *Develop* mode, on the right side of the Toolbar, you will find a drop-down menu, from which you can select those tools that you want to show in the Toolbar (provided your current window width has enough room for all of them).

Quick Collection / 13 photos / 1 selected / 070415_D20_6769-2.CR2 ▾

Figure 2-6: Info-bar

Below the content pane and below the Toolbar, you'll find Lightroom's *Info-bar* (see Figure 2-6) which contains the following:

▸ The Library group your are currently viewing
▸ The number of images in that group which are currently visible
▸ The total number of images of that group
▸ The number of images currently selected
▸ The name of the image currently selected

** See section 9.1 for more on "views".*

At the right side of the Info-bar you will find a small fly-out ◪ menu listing your recent views.* Recalling one of these by using this menu is often faster than using the Navigation panel.

A click on the ⊞ icon (on the left side of the Info-bar) will immediately switch to *Library* mode in Grid view (more on this in section 3.3).

The arrow icons ⬅ ➡ to the left of the ⊞ icon allow switching back to the previous Lightroom mode and then back again to your current mode.

The *Info-bar* as well as *Filters* are part of the Filmstrip panel, and they are shown and hidden along with the Filmstrip.

To the right of the Info-bar you'll find *Filters,* which we will cover later. With filters, you can restrict your current view to images that fulfill all criteria set in the Filters bar.

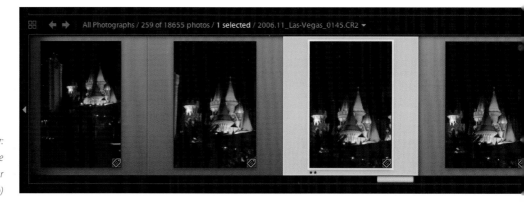

Figure 2-7:
The Filmstrip, including the
Info-bar and the Filters bar
(both part of the Filmstrip)

At the bottom of the Lightroom window you find the *Filmstrip* (see Figure 2-7) if it's not hidden. It contains the thumbnails of all currently visible images. You can scroll this list either by using the scroll bar at the bottom of the strip or in the Library module by using the ◀ and ▶ buttons to the left and the right of the strip. Still another method is to use the ⬅➡ icons of the Toolbar in *Library* and *Develop* mode or Ctrl-⬅ and Ctrl-➡, which will work in all modes.

* *Additionally, you may use the ⬅ and ➡ keys of your keyboard. This is useful when the Toolbar is faded out.*

Small icons in and around the thumbnails provide some status information:

Metadata was added to this image.

Image has been cropped.

Image has been edited (corrected).

Image is part of *Quick Collection*. A click on the icon will remove the image from it.

Top image of a stack with two pictures (for stacks, see section 3.2, page 57).

Figure 2-8: Colored backdrops and icons indicate the markings and state of the images.

Lightroom cannot access the original image currently. It probably was deleted, moved, renamed or is offline.

Metadata of image is not in sync with Lightroom's catalog metadata (see also Figure 2-17 Ⓑ, page 38).

Accept flag (also called *Pick*).

Reject flag (image marked for deletion).

Image has an *n*-star rating.

Additionally, there are colored borders or a colored backdrop indicating a color label (see also section 3.3, page 62).

The size of the preview icons in the Filmstrip is defined by the height of the strip. Pulling up or down the upper strip border allows you to adapt its height.

Figure 2-9: This fly-out menu will appear when you right-click a selected image.

** In Preferences, you may tell Lightroom how long to keep these preview images. See page 37, Figure 2-16.*

Fly-Out Menus

You have already learned about a number of fly-out menus that you call up by right-clicking your mouse.

With Mac OS, using a one-button mouse, you have to use Ctrl-click instead. However, we urge you to invest in a two-button mouse with a scroll wheel. (As you may have assumed, in the Filmstrip you can also use your mouse scroll wheel to scroll through your images, and you can also scroll in Grid view.) It will speed up you work considerably.

A right-click on a previously selected thumbnail in the Filmstrip or the matrix of Grid view (the latter explained a bit later) opens a useful fly-out menu that offers a number of image-related commands. The content of this window is dependent on the mode you are in and the object you have (see Figure 2-9).

2.6 More Lightroom Basics

Lightroom is a highly integrated application that combines modules to import images, a RAW converter, an image editor, light-box functions, a module for printing, one for creating slideshows, and one for Web galleries. The basic *Library* module performs all the asset management and administration.

The Lightroom developers have gone a long way to combine all this in a very standardized and transparent way. Nevertheless, as the workflow of each photographer will vary slightly (or even considerably), a certain complexity arises when so many functions have to be made available. The result is a very compact user interface, and it may take some time to deal with it and find the optimal way to fit it into your specific workflow and preferences.

Lightroom's Catalogs (Libraries)

Lightroom is based on a repository – a database. All information on images – metadata, file names, file location, and more – is held in this database. While in version 1.0 of Lightroom, this was called the Lightroom *Library*; version 1.1 (and later versions) calls it the *Catalog*. So, when changing over from version 1.0, don't get confused.

Lightroom uses special preview images to represent images in the Filmstrip and the matrix of its Grid view. These icons are generated when importing images. Lightroom will regenerate them if, when you are browsing a folder, the preview icons are no longer available.* Preview images allow for a quick presentation without opening every image of the list all over again when browsing the catalog. Lightroom will store these preview images (icons) into a separate container (see also Figure 1-16 on page 23).

Lightroom's database may grow to a considerable size and this can slow you down working with Lightroom. There are two solutions to this problem:

a) You may split up your images and put them into several separate cata- logs, e.g., one for every two years. Working with several catalogs was a bit clumsy in Lightroom version 1.0; this, however, improved with ver- sion 1.1.

b) From time to time, you may optimize your catalog. This will improve your working speed.[*]

* We will go into details on this in Chapter 9.2, page 178.

However, for most photographers, catalog size will be no real problem. Uwe Steinmueller's catalog, for instance, in 2006 contained information on about 30,000 images. Even Lightroom 1.0 could handle this without serious prob- lems (on a Mac). Importing this number of legacy images took about four hours (on a G5 Quad Mac). That library was about 374 MB, thus requiring about 13 MB per 1,000 images.

When importing images, Lightroom will copy the images either to a directory, as specified in your Import dialog, or leave them where they are. In both cases, the images are not part of the catalog; Lightroom's database contains a link to the physical location of the image file. This will keep the catalog lean and easier to handle (backup, move, …). External applications will easily be able to can access these images directly without having to go through Lightroom. On the other hand, you have to be very careful and disciplined not to confuse Lightroom and disturb its information struc- ture. For instance, you should use Lightroom's renaming function to re- name images, and not use your Windows Explorer or Apple Finder (or any other renaming utility) for this purpose. We also recommend delet- ing or moving images using Lightroom instead of using other applica- tions, although this might not be as comfortable as other means.

Templates and Presets in Lightroom

A Lightroom *template*, in some Modules and menus it is called a *preset*, is a set of parameters or settings (or control values) that is saved under a name. Each template or preset will be saved in a separate file. You will find presets for image corrections in *Develop* mode, and templates for prints, slideshows and Web galleries. Additionally, there are templates for renaming schemes for images (e.g., when importing), for metadata sets that may be included in prints, slideshows or Web galleries, and there are format templates for con- verting/exporting images.

Some of these presets and templates come with your Lightroom instal- lation, but you may add your own and modify, rename or delete existing ones. You can find additional templates in the Internet (see [16] or [17] for some examples).

This template and preset feature can simplify and accelerate your workflow considerably.

You find these templates (or presets) in your Navigation panel on the left side (see Figure 2-10 for some *Develop* presets).

Figure 2-10:
The Navigation panel will show
you a Template or Preset browser
for all your templates (or presets).
Since LR 1.1, these are separated
into Lightroom and user
templates (or presets).
Here, you see the Preset browser
in Develop mode.

When you roll your cursor over one of the preset or template items in your Preset browser pane, you will immediately see its effect in the small Navigator preview (if the Navigator pane is unfolded). If you click on the item, the preset or template will be assigned to your object in the content window, be it an image (in *Develop* mode), a slideshow, a print, or a Web gallery. If several images are selected in *Library* or in *Develop* mode, the preset will be assigned to all images selected.

Views

A *view* means all the images, out of your total collections of images in a catalog, that are currently in either your Filmstrip or your Grid view matrix (or both).* When you're working in *Slideshow* or *Web* mode, all images of this view will be part of your slideshow or Web gallery. When you're doing a contact sheet print, all images of the view will be included in the contact sheet (or several sheets).

Lightroom provides a number of ways to select a view, e.g., by selecting a specific Lightroom folder in your Folder pane of your Navigation panel.** This view can be further reduced by applying *Filters*. When you activate *Filters*, the view is reduced to those images that fulfill all filter criteria set in *Filters*. In *Filters* (see Figure 2-11), you may define a minimum of

* While Grid view is only available with the Library Module, the Filmstrip is available with all modules.*

*** You will find more on views in section 9.1.*

stars, a specific flag assigned to the image, or a specific color label, or you can make the picture to be a master or a virtual copy.

It will take some practice to make efficient use of *Filters*, but it turns out to be a very useful feature in many situations. Therefore, we cover *Filters* several times in this book.

Figure 2-11: In Filters, you may restrict the image in your current view to those fulfilling the criteria set here.

2.7 Lightroom Modules and Modes in Your Workflow

The typical digital photography workflow has three phases, or subjects:

a) Image (asset) management (include acquiring/importing images)
b) Image optimization (image editing)
c) Image presentation (preparing images for some specific kind of output)

For these tasks, Lightroom provides five modules, resulting in five modes (see Figure 2-12). These modes are implemented as independent modules that display their own operational controls as panels and panes inside the global Lightroom window: *Library* is the administrative module providing import, image browsing, and image management; *Develop* is for image editing (optimization), and there is a separate module for each of the three output methods: *Slideshow*, *Print* and *Web* (galleries).

➜ *We will dedicate a separate chapter to each of these five modules.*

Each of these modules covers one or several steps of the photographer's typical workflow. Every module presents its interface in a Preset/Template browser panel to the left, the preview in the central content pane, and its controls in the right Parameter panel grouped into several control panes. A common element of all modules is the Filmstrip at the bottom of the Lightroom window (if not hidden).

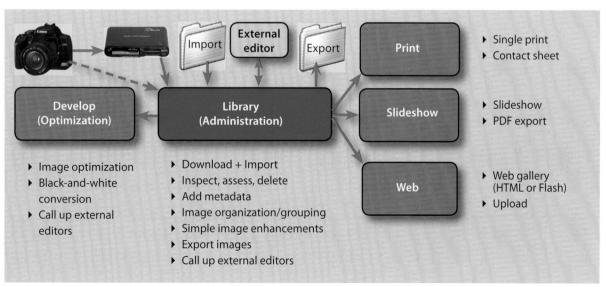

Figure 2-12: The five modules of Lightroom and their functions in your photography workflow

With a click on a module name in the Module panel, you switch to a specific mode. Additionally, there are keyboard shortcuts for switching modes (see Appendix A).

Figure 2-13:
Module pane; the current mode is highlighted

Library | Develop | Slideshow | Print | Web

2.8 Preferences Setup

Installing Lightroom is easy. Begin by simply clicking on the setup program. Just specify where to install the program. Lightroom is now ready to work and most default settings will be adequate for most photographers.

Nevertheless, we recommend having a look at the Preferences settings at least once (with the Mac under the Lightroom menu, with Windows under Edit). With Lightroom version 1.2, there are six tabs for your preferences (see Figure 2-14).

General Tab

On the General tab (see Figure 2-14), you will find two settings we feel are relevant:

Ⓐ Which catalog to use when starting Lightroom and

Ⓑ Your catalog settings (activated by clicking *Go to Catalog Settings*).

We prefer to use the catalog used most recently. If you want to work with a different catalog, you may press Alt/⌥ when starting Lightroom. Lightroom

Figure 2-14:
Here you define which catalog will be loaded when Lightroom is started and you can go to your catalogs settings.

will then ask you which catalog to use. This dialog will also allow you to cre-
ate a new catalog. By default, your Lightroom folder containing your cata-
log, your preview icons, and the backup of your catalog will be placed in
your private user directory. This may not be the best place, as it may grow
considerably. We prefer to put it on a separate disk together with all the im-
age files.*

 Alternatively, you can use File ▸ Open Catalog when Lightroom is
started to switch to another catalog.

 You can also click *Go to Catalog Settings* on the *General* tab in Preferen-
ces to configure catalog specific settings (see Figure 2-15).

 On the *General* tab, you define
whether Lightroom should do an auto-
matic back up of your catalog. We pre-
fer to back up our catalog at least once
a day when first starting Lightroom;
the catalogs are the heart of Lightroom.
With huge catalogs, this may take some
time when Lightroom starts, but it will
provide a high degree of security. From
time to time, you should delete older
versions of your catalog backups (see
Figure 2-16).

 On the *File Handling* tab, you de-
fine the size of the preview icons that
Lightroom will generate when import-
ing the image as well as the preview
quality (these previews are stored as
JPEGs). We recommend using a high
preview size and set Quality to *High* in
order to allow for a qualified assess-
ment of your images.

 You can also set how long these
previews are kept.

On the *Metadata* tab (see Figure 2-17),
you define metadata handling for the
specific catalog.

 Activating option Ⓑ *Write develop
settings to XMP* …and option Ⓒ
Automatically write changes into XMP
of Figure 2-7 will guarantee optimum
compatibility with Bridge and Adobe
Camera Raw (with Lightroom 1.2 you
should use ACR version 4.2). However,
for performance reasons, we recom-
mend to deactivate both options!

* We go into more detail on catalogs in
section 9.2.*

Figure 2-15: *Here you tell Lightroom when to back up. These settings are specific to your
catalog. Here you can also start an optimization of your catalog.*

Figure 2-16: *Here you define the settings for your image previews for a specific catalog.*

We check all other options as illustrated in Figure 2-17. Having achieved some familiarity with Lightroom, you may choose otherwise.

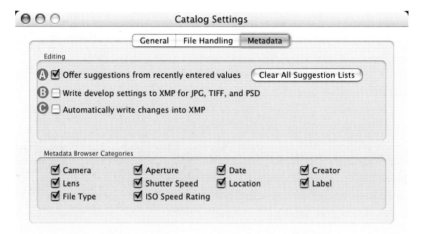

Figure 2-17:
To achieve maximum compatibility with
Adobe Camera Raw and Bridge, check
options Ⓑ and Ⓒ, but in order to improve
the performance, we deactivate them.

Presets Preferences

On the *Presets* tab, we leave all settings at their Lightroom defaults. We do not store our presets and templates with the catalog but in the standard folder because we use the same presets with different catalogs.

Figure 2-18:
For most users, Lightroom's default Presets
settings are appropriate.

Import Preferences

We deactivate the automatic import dialog of Lightroom if a camera is connected to the computer or a flash card is inserted (see Figure 2-19 Ⓐ). We both prefer to do an explicit import and tell Lightroom when to import and where to import. We dislike applications that bring up pop-ups whenever some device is connected to our machine.* Fortunately, Lightroom allows disabling this feature.

** When this option is activated, an import*
dialog will come up whenever you plug in
a USB stick – it's a real nuisance.

Figure 2-19:

According to our experiences, here, you may leave all settings at their default values.

External Editing Preferences

Lightroom allows you to select an image, call up an external editor, and pass along that image. With the External Editing tab, you can configure two such external editors, and you can choose the format, color depth, and color space used when the images are passed along.* There are two editors that can be configured, Lightroom, however, will select the first one – usually looking for Photoshop or Photoshop Elements on your system. In the dialog seen in Figure 2-21, we choose Photoshop CS3 and LightZone using 16-bit TIFF (ZIP compression), and Adobe RGB (1998) for both of them.

In most cases, a copy of the file will be passed on to the external editor. This copy will have a new name, and you are free to define a file-naming scheme for this in the *Template* of menu Ⓐ. This may be one of the

** We will cover external editors in section 8.1.*

Figure 2-20: Choose your naming template for the file name of the files that are passed along to external editors.

Figure 2-21:

While Lightroom will select the first of the two external editors, you may choose the second one. You should also set up a file-naming template.

predefined templates offered in the menu or you may set up your own naming scheme here. To set up your own, choose *Edit* from the menu. A template editor window will come up. We will cover this in section 3.1 on page 52.

Interface Preferences

On the *Interface* tab in Preferences, all default settings can be used. For most users, the dark gray window background is optimal for the color assessment. Make sure, options Ⓐ and Ⓑ (in Figure 2.22) are checked, because this will provide some information on the status of the image with the preview icons in your Filmstrip or in Grid view.

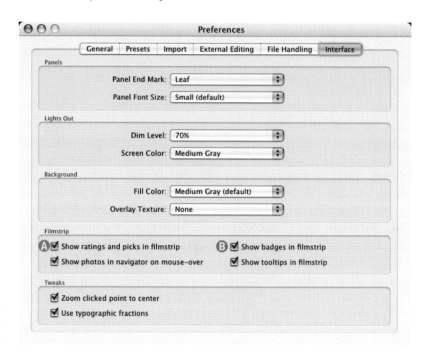

Figure 2-22:
According to our experiences, you leave all settings at their default values.

Set Up Your Identity Plate

Now is a good time to set up your identity plate, which will show up in the upper left corner of your Lightroom window in the Mode panel. It can either be a text-based plate or a graphical plate, and you can have several. Menu Ⓑ of Figure 2-23 allows you to select which one will be shown – however, you have to activate option Ⓐ to make the identity plate visible. While this may be a nice feature for your Lightroom window, it is even more useful when included into a slideshow, a print, or a Web gallery. To set your Identity Plate, choose Lightroom ▸ Identity Plate Setup in Mac OS X and Edit ▸ Identity Plate Setup in Windows (see Figure 2-23).

If you use a text identity plate, you are free to select any font (installed on your system) and font size. Additionally, you can choose color for the font. To select a color, click in Ⓒ to bring up a color picker.

Though text plates may not be as "sexy" as graphic plates, they are better suited when used in a print because they are resolution independent.

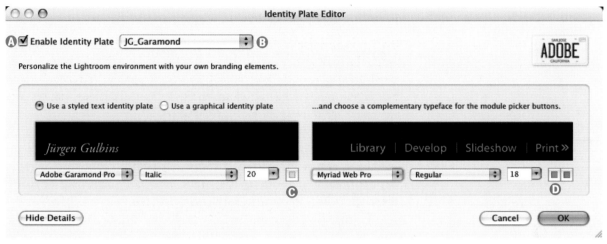

Figure 2-23: You may set up text Identity Plates as well as graphical plates, and you may set up several plates.

When you select *Use a graphical identity plate* (see Figure 2-24 Ⓑ) you can choose any image file that is on your system (it does not have to be part of a Lightroom catalog). The file format may be PDF, JPEG, TIFF, PSD, GIF, or PNG. We usually use GIF or PNG images as they allow for transparent areas. Click in Ⓒ to select your image file for this.

GIF = Graphic Interchange Format
PNG = Portable Network Graphics

The maximum height, however, is restricted to 60 pixels. This is OK for your on-screen window, a slideshow, and a Web gallery, but it is probably too small when used in a high-resolution print. However, you can get around this problem by setting up several Identity Plates. You can save a plate choosing the name you like in the *Enable Identity Plate* menu.

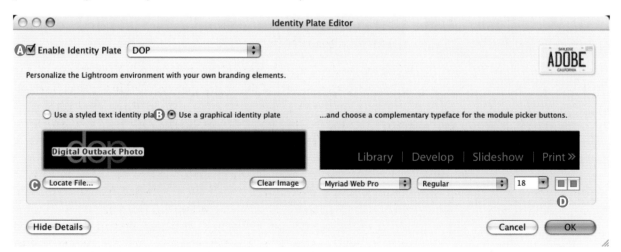

Figure 2-24: A graphical Identity Plate is restricted to a maximum height of 60 pixels.

On the right side of the Identity Plate Editor (see Figure 2-24 ⓓ), you can also select a font and font size for your mode indicators and a color for the inactive and the current mode. For the latter, we choose red in our example in Figure 2-24 (and all screenshots you will see in this book). With red, the contrast is slightly better than with Lightroom's default.

Lightroom's Window and Lights Out Modes

Lightroom, like other applications, offers a number of screen modes: a normal Lightroom window, a full-screen mode, and a full-screen mode with the menu bar shown. The latter will give you maximum window size that may be essential on a small laptop screen. Use ⒡ to toggle between these modes. As most operations can be initiated without using the menus on the menu bar, just by using keyboard shortcuts and fly-out menus by right-clicking objects (and with the help of the controls of the Parameter panel), the latter mode is the one we use most often.

Additionally, you may use ⓣᵃᵇ to hide or show the Navigation panel and the Parameter panel (both at the same time). Shift+ⓣᵃᵇ will show all panels, and, applied a second time, will hide them again.

When assessing the colors of your image, other colored elements on your screen may influence your color perception. Therefore, Lightroom offers several Lights Out modes. The toggle key for them is ⓛ. The neutral gray environment will help you judge the image colors:

Figure 2-25: Screen in normal "Light on" mode (left), in semi "Lights out" mode (middle,) and in "Lights out" mode (right).

Keyboard Shortcuts

Using keyboard shortcuts can speed up your Lightroom workflow considerably, and some functions are hard to find within the menus. Therefore, we use keyboard shortcuts quite a bit in our own workflow. In the following chapters, we will cover those most frequently used. You will find a summary of shortcuts in Appendix A.

You can call up a list of shortcuts for your current Lightroom mode (see Figure 2-26) using `Ctrl`-`/` (Mac: `⌘`-`/`). Some of those are mode specific, while other will work in any mode.

Library Shortcuts

View Shortcuts

`	Toggle between Grid and Loupe
Esc	Return to previous view
Return	Enter Loupe or 1:1 view
E	Enter Loupe view
C	Enter Compare mode
G	Enter Grid Mode
Command + Return	Enter Impromptu Slideshow mode
F	Cycle to next Screen Mode
Command + Option + F	Return to Normal Screen Mode
L	Cycle through Lights Out modes
J	Cycle Grid Views

Ratings Shortcuts

1-5	Set ratings
Shift + 1-5	Set ratings and move to next photo
6-9	Set color labels
Shift + 6-9	Set color labels and move to next photo
0	Reset ratings to none
[Decrease the rating
]	Increase the rating
Command + Up Arrow	Set Ranking to Flagged
Command + Down Arrow	Set Ranking to Neutral

Photo Shortcuts

Command + Shift + I	Import photos
Command + Shift + E	Export photos
Command + [Rotate left
Command +]	Rotate right
Command + E	Edit in Photoshop
Command + -	Zoom out
Command + =	Zoom in
Z	Zoom to 100%
Command + G	Stack photos
Command + Shift + G	Unstack photos
Command + R	Reveal in Finder
Delete	Remove from Library
Command + Shift + C	Copy Develop Settings
Command + Shift + V	Paste Develop Settings
Command + Left Arrow	Previous selected photo
Command + Right Arrow	Next selected photo

Quick Collection Shortcuts

B	Add to Quick Collection
Command + B	Show the Quick Collection
Command+Shift+B	Clear Quick Collection

Panel Shortcuts

Tab	Show/Hide the side panels
Shift + Tab	Hide/Show all the panels
T	Hide/Show the toolbar
Command + F	Activate the search field
Command + Option+ Up Arrow	Return to the previous module

Figure 2-26: Library Shortcuts

Image Management in the Library Module

3

The Library module is the default module for Lightroom and it's here that you do the actual image management, it's the image management heart of Lightroom. Here you import new images, directly from the camera, from a memory card, or from a folder on your disk. Also exporting images is performed in Library mode.

In Library mode, as a rule, you will select those images that you want to work on in any of the other modules. Therefore, you will regularly switch back to Library mode after you've finished a task in any of the other modules (press ⌧G for Grid view).

Library mode offers a number of different view modes, e.g., showing just a single image in the content pane. For browsing and having a fast overview, Grid view is often used, offering a kind of two-dimensional Filmstrip.

Clicking "Library" in the Module panel is the common way to switch over to Library mode, but there are several more ways: ⌧G, for instance will immediately bring you to Library Grid view from any other module. The same will happen when you click the ⊞ icon of your Info-bar. ⌧E will switch to Library mode and open Loupe view, and ⌧C will activate Compare view which allows you to compare two images side by side. If you want to see more than just two images at the same time, you use an Overview view.

You can also search for images that match certain criteria in Library mode. Understanding the Library module takes a bit of learning, but working with these functions is easy.

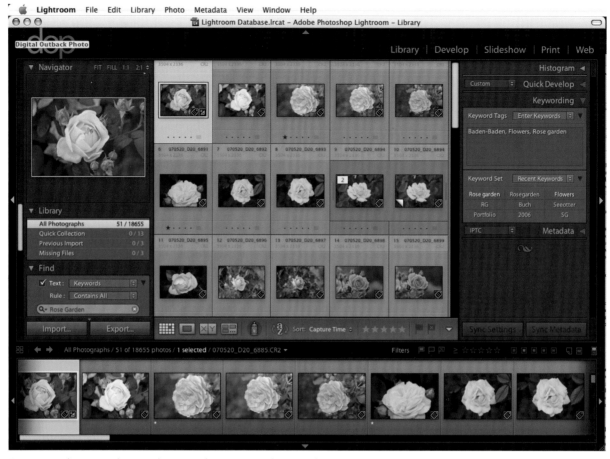

Figure 3-1: Lightroom in Library mode. Here, Grid view is active. This screenshot, like most screenshots, was taken with Mac OS X.

3.1 Downloading and Importing Photos

The first workflow step for digital photos is downloading the images from your camera or your memory card. In the past, we used special utilities for this; using Lightroom, we perform this task in Library mode using Import.

Organizing Your Image Filing System

Before you start to download your images, you should, at least once, think about how to organize your filing system and how to structure your folders and images on your disk. If you worked digitally in the past, you probably already have a scheme for this. If you are new to Lightroom, now might be a good time to think it over. There are two major points to consider: a scheme for naming your images and a scheme for a folder structure for your images. On import, Lightroom does not embed the images in its catalogs, but keeps them at a standard disk location. Therefore, you have to come up with your own filing system scheme.

You scheme should fulfill two points:

1. Your filing system should be clean and understandable.

2. The names of your images coming from your camera are both non-descriptive and not unique (at least not in the long run). An image name, however, should exist only once with all your image files and should provide some useful information.

Although it is impractical to put much descriptive information in the image name, some information is useful. The question is, however, which information? At the same time, the name must not be too long. Long names will frequently cause problems! Here are our three simples rules:

▸ The name must not be longer than 31 characters (plus a suffix).

▸ Avoid special characters (e.g., ß, é, è, and umlauts). Though most operating systems do allow for these characters in file and folder names, our personal experience indicates that you will encounter problems using them, e.g., when you migrate your data to another system.

▸ Use hyphens '-' and underscores '_' as punctuation marks in your names.* Do not use spaces.

** And the dot only once to append your file type extension.*

Take your time to come up with a clean naming scheme, test it, and then stick to it.

We have used our own naming scheme for a long time, and it has worked well with really large image collections.

Lightroom External Filing System

As mentioned, your image files will reside outside of Lightroom's catalog, stored in a regular folder structure on your disk. Only *Virtual Copies*, as explained later, are stored in your catalog. This keeps your catalogs slim. It also allows you to back up your catalogs and image files separately. When your filing structure grows, you can spread your image files across several disks. This is not possible with catalogs. This way, other applications can access your image files without having to go through Lightroom.

As mentioned in Chapter 2, this concept requires a strict discipline when you're moving, renaming, or deleting image files. Preferably, all this should only be done in Lightroom. While renaming files is easy in Lightroom, we prefer to do this right away when importing photos, since moving files to other folders or disks is less comfortable in Lightroom. So, it's best to organize your image filing on import. We will show you how this can be done later.

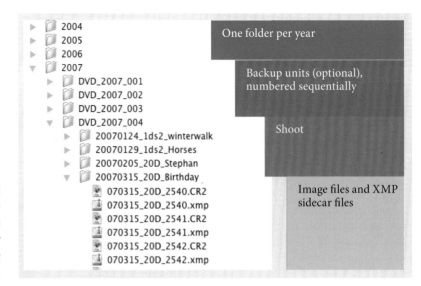

Figure 3-2:
This figure illustrates our filing structure. The
yellow layer is optional. We use it to facilitate
the backup to DVDs. Files with an "xmp"
extension are sidecar files and are explained
a bit later.

Figure 3-2 illustrates the filing structure we use:

1. At the top level, we use a folder for each filing year.

2. The next level is optional. These folders act as backup containers, each holding as many image folders as our backup media can take. With standard DVDs, this is about 4.3 GB; when dual layer DVDs are used, this will go up to about 7.8 GB of images. These folders allow us to do an easy backup of image folders to DVDs. When a backup container is almost filled, we burn the contents on a DVD and start a new folder.* If you use a different back strategy, ignore this layer.

* *When doing our backup to DVDS, we*
produce two copies of these folders, each
on separate DVDs, using two different DVD
brands.

3. The next layer consists of folders containing the images of a separate shoot. The names consist of the date of the shoot or session, using the international way of writing dates, followed by a camera model name and, optionally, the location or the reason for the shoot. If you use just a single camera, or if the camera type is of no relevance to you, just omit that part of the name.

4. In these shooting folders, we store the actual image files. Figure 3-3 illustrates the file-naming scheme we use. In the file name, we include the camera type too. If we have several cameras of the same model, we append a letter to identify the specific camera. Additionally, we include the number part of the file name that the camera applied to the image. Optionally, you can append a short name for the shoot (see the lower example in Figure 3-3).

Our file names always start with a date component, using the international manner of writing the date in the order *year*, *month*, *day*. When the files are sorted alphabetically, which is the sorting order most frequently used, they are displayed according to date the images were created.

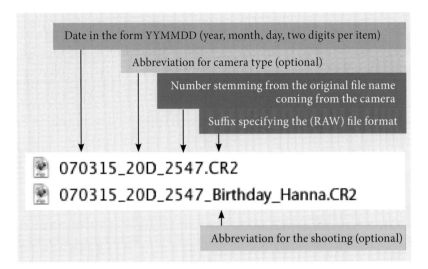

Figure 3-3:
Our file-naming scheme for image files. We rename files downloaded from the memory card in Lightroom using its Import function.

You don't have to use the same naming conventions. Your scheme, however, should guarantee unique file names and you should adhere to the rules given on page 47.

Do resist the temptation to put too much info in the names. Keep in mind that the prevailing part of the information is better accommodated in the file's metadata (predominantly in its IPTC part).

Having decided on a scheme for file naming and filing structure,* it's essential to stick to it!

Naturally, you should perform a test using a large number of files before deciding on a scheme.

Tip: We prefer not to put our RAW files (as well as the Lightroom catalog) in Lightroom's default folder. In that case, they would reside on the same disk as the operating system. We put these files on a separate partition or disk. It's better to separate user data and OS data.** We are looking for an easy way to back up both separately, have lot of disk space for our image files, and extend the user data areas without much fuss. Currently, Uwe acquires about 100 GB of RAW files per year, without shooting really a lot.

*** By "OS data", we mean the operating systems and all programs, fonts, and program libraries.*

Metadata

Metadata, discussed in section 1.3, are the icing on the cake for image (asset) management. Without these data, your image management is not complete. Metadata help when sorting images according to certain criteria – for instance, a project, date of the shoot, camera used, or even focal length or lens used. The camera will already acquire part of this metadata and embed it into your image files – this is the EXIF data.

The photographer has to add further metadata – for instance, information on the subject of the shot, where the shoot took place, keywords on the image, who took the shot, and copyright notices. This type of metadata was first standardized by the *International Press and Telecommunications Council* (*IPTC* for short) and, accordingly, is part of the IPTC metadata panel.

→ *With Lightroom and most other Adobe applications, further information such as image ratings, color labels, and flags may be part of your metadata.*

For all these metadata, Adobe uses XMP. You can consider XMP to be a kind of container for the different types of metadata. In addition to the EXIF and IPTC parts, Lightroom includes editing records as well as an editing history set.

Lightroom will store these metadata in your catalog (its database). This allows for very fast access. You may also store them (optionally) with your images files. With JPEG, TIFF, PSD, and DNG files, this XMP container is embedded in the image file itself, while with RAW files this information is stored in a separate *sidecar file*. The sidecar files share the same base name of the image, but use an ".xmp" extension.

There are two classes of metadata that you have to add yourself: the ones that you probably want to add to all images of a shoot and the ones that will be more specific to one image. There are even data that can be used for several sessions: the photographer's name, for instance, and some copyright notices. For these type of metadata, Lightroom allows creating metadata templates and assigning their content to images on import. This can save you quite a bit of work.

Importing Images from Your Memory Card

While image browsers like Bridge can deal with images without having to import them, Lightroom, like other DAM systems, shows and handles only imported images.

The import is handled in the *Library* module. To start the import, go to the Folders pane in the Navigation panel. Select the folder into which you would like to import the images of a shoot. If you intend to put the image of this shoot into a new folder, set up the new folder in the Import dialog.

You can import images directly from your camera, or from a memory card in a card reader (what we use as a rule), or from an existing folder – the latter, for instance, if you import images that were scanned.

To import from a flash card, insert your card into you card reader. Then start the Import dialog by clicking the Import button (situated at the bottom of the Navigation panel, see Figure 3-4).

If a card is inserted in the card reader (or you connected your camera directly to the computer), Lightroom shows two buttons, see Figure 3-5. The top button will show the name of your card reader or camera (we would rather prefer to see the volume name of the card, instead); the lower button allows you to import from a folder on disk. Here, let us stick to reading from the card reader.

Figure 3-4: To import, first select your destination folder and then click "Import".

Figure 3-5: When a card is in your card reader on import, Lightroom shows this window.

Import Dialog

In the import dialog box (see Figure 3-6), start by setting
your file management options: Ⓐ the file handling for the
import and Ⓑ where the images should go. Instead of just
importing the RAW files, Lightroom allows you to convert
them into DNG and import those. This makes sense when there is no other
good RAW converter for your specific RAW format. We use it rarely.

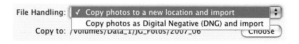

When importing from a folder, more options are offered (see Figure
3-42 on page 72).

Copy the images from the card
into a subfolder of your current DVD
container or your yearly folder. The
destination folder is named as de-
scribed, using the *Choose* button Ⓑ.
As the folder naming schemes offered
with the *Organize* menu Ⓒ do not
suite our scheme, we have to select

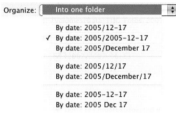

Import into a Folder and create a new folder name in the *Select Folder* dia-
log activated by the *Choose* button. If your filing concept allows for folder
names offered by the *Organize* menu, you may choose one of these and
Lightroom will create your folder automatically.

→ *DNG is a non-proprietary RAW format
and an open standard, and we support it
from the bottom of our hearts. However, as
long as both big ones – Canon and Nikon
– do not support DNG, we can't ignore
reality. In particular with NEF RAW files, Nikon
Capture NX does a better detail extraction
than Lightroom does. So we would like you
to be able to fall back to the original RAW
format when needed.*

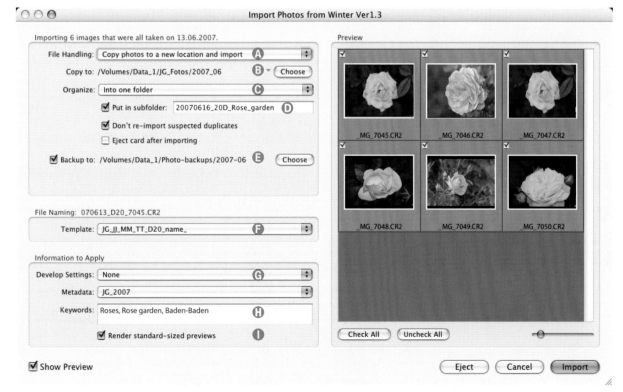

Figure 3-6: The import dialog with its numerous settings and the preview thumbnails

Figure 3-7: LR comes with some predefined naming templates. With Edit, you may call up a template editor.

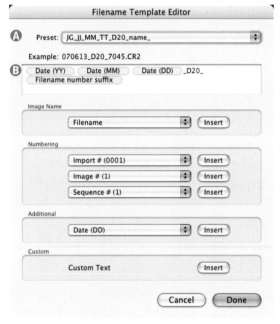

Figure 3-8: Here you may build your own naming template.

On import, Lightroom attempts to recognize duplicate files and ignores them. You can activate or deactivate this option (Figure 3-6 Ⓓ).

Activating option Ⓔ allows you to, in addition to copying your images from your memory card to your destination folder, make a second copy (a backup) to yet another folder. This fits well our backup strategy. Therefore we usually activate this option.

As mentioned, we think file renaming is important, if only to achieve unique file names. Renaming when importing files from your camera is the easiest way of doing this. You select your naming scheme from the Template menu Ⓕ, either choosing one of the predefined Lightroom templates or defining your own naming scheme. For the latter, select *Edit*. The Filename Template Editor appears (see Figure 3-8).

In the editor, select the individual name component from the corresponding menu and click *Insert*. Custom text can be entered either using the *Custom Text* item or directly in the name field Ⓑ. In the example of Figure 3-8, *Filename number suffix* is the file number part of the file name created by the camera (at least with most cameras).

Save your current template using the *Save Current Settings as new Preset* item in the *Preset* menu Ⓐ. Use a descriptive name. Click *Done*. From now on, you will find your new naming template in the *Preset* menu list.

Our goal is to make life easy – actually, to have an efficient workflow. Therefore, we try to add as much metadata in the import process as possible. Here, it is all metadata that will suit all images of your shoot. In Lightroom's Import dialog, you can do this in two groups:

a) Your IPTC basic data, containing your name (or that of the photographer), address, and other contact information, copyright notice, and similar data. For this, again, you can use a metadata template. Figure 3-9 illustrates one.

To build this template that you can use repeatedly, select the *Edit* item in the *Metadata* menu (Figure 3-6 Ⓖ). Save the template and use a name that makes sense to you.

b) Additionally, there are keywords that suit all images of an import or shoot. Enter these in the *Keywords* field (Figure 3-6 Ⓗ).

Lightroom will associate these metadata with each individual image of the import and store it in its database (your catalog). Optionally, if your catalog is set up in the way we recommended in section 2.8,* Lightroom will either embed these metadata in the image file or write them to a separate sidecar file. This will guarantee a high interoperability with Bridge, Adobe Camera Raw, Photoshop, and some other applications.

Edit Metadata Presets

Preset: Custom

☐ Basic Info

Caption	☐
Rating	· · · · · ☐
Label	☐
Copy Name	☐

⊟ IPTC Content

Headline	☐
IPTC Subject Code	☐
Description Writer	J.G. ☑
Category	☐
Other Categories	☐

☑ IPTC Copyright

Copyright	© 2007, Juergen Gulbins ☑
Copyright Status	Copyrighted ☑
Rights Usage Terms	☑
Copyright Info URL	www.gulbins.de/Rights_of_Usage/ ☑

⊟ IPTC Creator

Creator	Juergen Gulbins ☑
Creator Address	Kapellenstr. 15 ☑
Creator City	Keltern ☑
Creator State / Province	Baden–Württemberg ☑
Creator Postal Code	D752210 ☑
Creator Country	Germany ☑
Creator Phone	(+49) 7082 94 82 51 ☑

(Check All) (Check None) (Check Filled) (Done)

Figure 3-9:
Juergen's standard IPTC template, used when importing shots from a flash card. I have several of these templates, at least one for each year.

In addition, in *Development Setting* (see Figure 3-6 Ⓖ) you can add some *Develop* processing on the image imported by selecting a Develop preset from the menu. This, for instance, could be some sharpening or some lens-specific vignetting corrections that were saved as a preset.

Now, finally, click on the Import button. Lightroom will process the import in the background and you immediately continue working. Lightroom will show a progress bar in the upper-left corner of the window.

When importing, if Lightroom encounters an RGB image that has no profile embedded, it assumes that it is an sRGB file.

While the import is still running, you can start to work on the first images and rate them. You may also add additional individual metadata and even edit images that are already imported.

However, we recommend refraining from editing at this stage. Why? Importing and generating thumbnails (actually preview images for several sizes) will consume a lot of your CPU power – even on a multi-CPU system. Therefore, Lightroom may be quite sluggish updating your editing preview. This may easily lead to overcorrecting.

➜ *While caused by a shortcoming, LR 1.0 on import ignored your JPEG file when you shot RAWs as well as JPEGs. Since LR 1.1, you may get around this by checking the option "Treat JPEG files next to raw files as separate photos" in your Preferences (see Figure 2-19 Ⓑ).*

3.2 Image Organization

There are basically two kinds of image organization:

a) Your *physical filing system*, as described in Chapter 3.1. For this, Lightroom uses folders and subfolders on your hard-drives.

b) Logical image aggregations – for instance grouping images according to topics of scenes, by customers, portfolio images, or other similarities. For this, Lightroom offers *collections*.

Physical Folder Structure

Lightroom's folders, shown in the *Folders* pane of your Navigation panel, reflect the physical folders where your image files are located. Lightroom will show only those images that were explicitly and actually imported. If there are sidecar files, Lightroom will know about them but not list them. When importing images, Lightroom attempts to recognize duplicates and, configured accordingly, does not import those. Images, imported and later on removed, renamed, or deleted will be recognized by Lightroom. The icons of these files are marked by a [?]. You may either delete the images from your catalog or lead Lightroom to their new location (or name). If you relocated a whole folder of images, it is quite easy to redirect Lightroom to the new folder – you don't have to do it for every image.

Number of images in this folder (including all subfolders

Figure 3-10: Section of Uwe's folder structure. Uwe has about 30,000 images in his catalog (predominantly RAW files).

As illustrated in Figure 3-10, Lightroom displays the number of visible files in the corresponding folder (including all subfolders). Lightroom does the same for collections (explained later) and for items in the Metadata Browser. The + behind a number indicates that there are some hidden images in the folder (including its subfolders). This may be due to collapsed stacks.

In *Library* mode, Lightroom provides functions to create new folders, rename, delete, or move folders – and more. Open your *Folders* pane, select the folder, and right-click. A fly-out menu will offer these functions (Figure 3-11).

> Create Folder as Child of this Folder...
> Rename
>
> Delete...
>
> Save Metadata
> Show in Finder
> Synchronize Folder...
>
> Export this Folder as a Catalog...

Figure 3-11: Folder fly-out menu offering operations to perform on your selected folder

If you add images to a folder using another application, Lightroom will not recognize these images until you explicitly import them. If the folder contains images previously imported, select the folder in your *Folders* pane, right-click and select *Synchronize Folder*. This way, you can import all new photos and all images for metadata updates – changes of metadata that were done using external applications that wrote their changes into the image files or

Figure 3-12: "Synchronize" dialog

sidecar files. These changes will now be replicated into your catalog. This important new feature was introduced with Lightroom 1.1.

The fly-out menu (right-click) will offer some more functions when you select an image (or several images) in your Filmstrip. One of those is deleting the image. When deleting an image, you have two options:

▸ *Remove* the image only from your catalog. The image will remain in your folder.

▸ Delete the image from your catalog as well as from your disk. Lightroom will move it into the trash of your operating system (from where you can still recover it).

For deleting images as part of your assessment phase, we recommend the mini-workflow we describe on page 62.

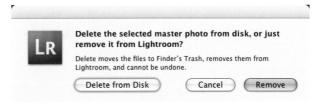

Figure 3-13: When you delete an image, Lightroom can either remove it form the catalog or completely delete it.

Lightroom's folders reflect the physical folder structure were the images are located. An image can be located in only one folder, unless you have copies with different names. Lightroom looks upon those as separate images.

If you want to move images to another folder, first open your source folder (in Lightroom) so that the images are visible in the Filmstrip. Then, in your Folders pane, navigate to the destination folder (without activating it), and drag your images onto the destination folder. Lightroom will move all photos selected and update its catalog. Keep in mind that moving images and folders this way will take a bit longer than using the *Finder* (Mac) or *Explorer* (Windows), but it ensures that Lightroom's catalog will be up-to-date afterward.

Using your *Folders* pane, you may also move folders inside your folder hierarchy.**

Collections

Images are often grouped according to certain criteria, e.g., according to image subjects or ratings. In most cases, it would be best do this independent of their physical location. In this case, an image database is ideal, because it allows you to sort images based on metadata. Instead of building your search criteria anew every time, Lightroom allows you to freeze the result of such a search into *Collections*. Memory-wise, these collections are quite cheap, allowing you to have many of them. A collection is a simple list containing links to the images. Images may reside in several different collections at the same time, which is not possible with folders. When you delete an image from a collection, the image file will not be deleted, just the link from the list; the image will still stay in its original folder.

With Lightroom, there are two types of collections: a *Quick Collection* (there is exactly one) and what we call a *named collection*.

** A solution using two windows would certainly be more comfortable. However, for the time being, we have to get along with one window.

Quick Collection

* Actually, you can have one Quick Collection per catalog.

You can have only one *Quick Collection*.* The easiest way to add images to your Quick Collection is by pressing B when the image is selected in your Filmstrip or in your Grid View matrix. Pressing B a second time will remove the image from the collection. An even faster way might be clicking on the tiny circle ● icon that appears when you roll your cursor over a thumbnail in the Filmstrip or in Grid view. The hollow circle will change to a filled circle. A second click will remove the image from the Quick Collection again. These functions are also available in your Photo menu.

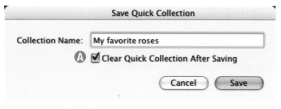

Figure 3-14: A Quick Collection can be turned into a named collection.

Ctrl-B (Mac: ⌘-B) will show only those images of the *Quick Collection* (will form your *current view*). Alternatively, you may select *Quick Collection* in the *Library* pane of the Navigation panel. You can convert your quick collection into a named collection by entering Ctrl-Alt-B (Mac: ⌘-⌥-B). Alternatively, you can use File ▸ Save Quick Collection. Give the new (named) collection a name. When option Ⓐ is checked, the Quick Collection will be cleared.

Named Collections

While a Quick Collection may be appropriate temporarily, e.g., to build a slideshow or Web gallery, in most cases you would like to keep your collection and give it a name. For this, there are two approaches:

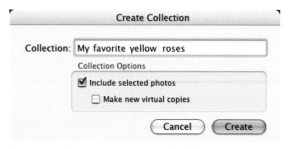

Figure 3-15: When creating a new named collection, you may immediately include those images currently selected.

1. Put your images into a Quick Collection and save it as a named collection, as described above.

2. Create a new named collection and then, from your Filmstrip or from Grid view, drag your images into the new collection item in your *Collections* pane. If at that time images are selected in your Filmstrip, you may immediately include them into the new collection. Optionally, you may even include them as *virtual copies* (more on these later).

➜ Your "active collection" is the one that is currently selected in your Collections pane.

You can find the list of collections in your *Collections* pane (part of the Navigation panel) – all but your Quick Collection, which you locate in your *Library* pane. To add a new named collection, click ➕. Lightroom will ask for a name (see Figure 3-15). Clicking ➖ will delete the active collection (Lightroom will ask for a confirmation). To remove images from the collection, select the photos and right-click. The fly-out menu will have an item *Remove Image from Collection*.

Named collections permit quick access to previously created aggregations of images – going beyond simple folder structure. So, for example, we have collections for our portfolio images – those having more than three

stars. We also use named collections for creating slideshows and Web galleries and we group images of special projects into named collections.

Though you may be able to reconstruct these groups by a search using metadata criteria, often collections are a faster way of accessing image aggregations.

If you are new to Lightroom, you really should take some time to get acquainted with all the features Lightroom offers to build your filing system and your catalog structure, and work with collections. Another feature of Lightroom that helps you to get a better overview are *Stacks*.

→ *Missing in Lightroom 1.2 is a feature allowing you to save a view based on several search criteria as a dynamic collection that is updated as soon as new images fit the criteria. In Aperture, it is called a "Smart Album".*

Stacks

Stacks help to arrange the images of a shoot more clearly by collecting several images, usually similar ones , in a pile. When a stack is collapsed, only the topmost image is visible (see Figure 3-16). The top image will have an icon indicating the number of images in the stack. To see all images of the stack, you have to expand it.

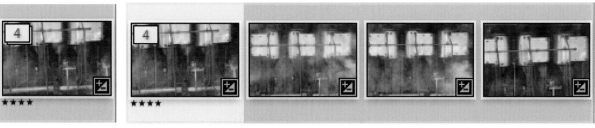

Figure 3-16: To the left, you see the stack collapsed, while to the right the stack is expanded.

To collect images in a stack, select the images in your Filmstrip and either use Photo ▸ Stacking ▸ Group into Stack or right-click and make your selection as shown in Figure 3-17. The best way, however, is to use Ctrl/⌘-G. Additionally, you can collapse the stack, either by choosing Photo ▸ Stacking ▸ Collapse All Stacks or, much faster, by pressing S. Pressing S a second time will expand the stacks again. Selecting an image in the expanded stack and pressing ⇧-S (Shift+S) will make this image the top image (cover image) of the stack. More stack operations are available, as you can see in Figure 3-17.

The stack can be also created automatically by specifying a time interval

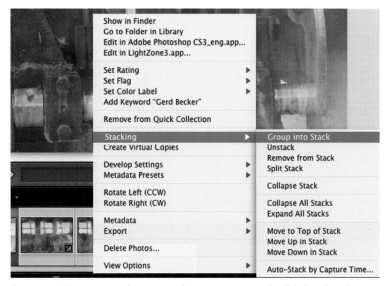

Figure 3-17: There are several ways to stack images. Here, we right-click the selected images and use the fly-out menu.

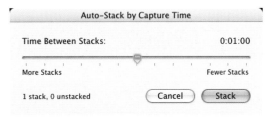

Figure 3-18: You can achieve automatic stacking by setting the maximum time interval.

* *For this, we usually use a virtual copy that we fine-tune in Photoshop or LightZone.*

in which the photos have to be taken in order to be grouped into a stack automatically. This allows several shots taken in a quick sequence to be stacked. For this use Photo ▸ Stacking ▸ Auto-Stack by Capture Time.

Once you get acquainted with stacks, you probably won't want to miss it anymore. When you call up an external editor from Lightroom and pass along a copy of your currently selected image, Lightroom by default will also stack this new image with the original one. Having optimized an image and prepared it for printing,* we make that image the top image of our stack and collapse the stack.

3.3 Browsing and Inspection

Having imported a new shooting session and done some preliminary stacking, the next step in our workflow is assessing the new shots:

▸ Are the images sufficiently sharp?
▸ Are the crops OK?
▸ Do the images show the right mood or properly show the subject?
▸ Are there any distracting objects in the images?
▸ Which of several similar images is the best one?

In this assessment phase, we will also rotate our images (if required) and add some image-specific metadata.

For this inspection and assessment phase, Lightroom offers several different viewing modes, each suited for a specific task. You toggle between them by clicking the different mode icons or by using keyboard shortcuts:

▸ *Grid view* (⊞ or Ⓖ, see Figure 3-19)
In this view the central pane will show your thumbnails in a size that may be adjusted with the *Thumbnails* slider in the Toolbar.

▸ *Loupe view* (▣ or Ⓔ, see Figure 3-20)
This view will show your active image in your preview pane, allowing you to zoom in and out quickly by clicking on the image in that pane. With this feature, a close-up assessment of the image is granted.

▸ *Compare view* (⊠ or Ⓒ, see Figure 3-22)
This view allows comparing two images side by side. This mode is also available in *Develop* mode, offering there a Before/After view.

▸ *Survey view* (▦ or Ⓝ).
This view allows you to see all images currently selected in your preview pane, and allows a better comparison than in the Filmstrip.

These four different view modes support an efficient inspection phase. You can do some more adaptations using the items of the Windows menu.

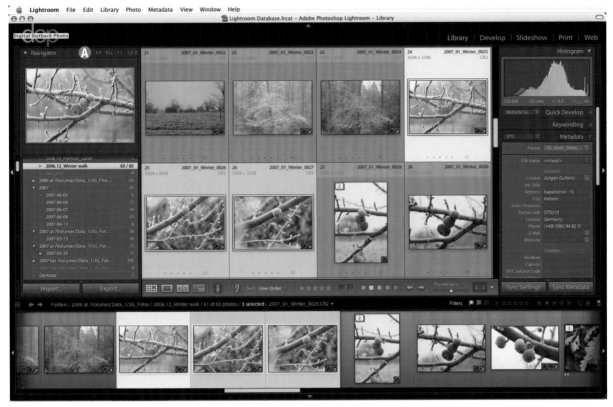

Figure 3-19: Lightroom in Library mode using Grid view

In Library mode, you frequently will have your *Filmstrip* opened. Its height, – and by that also the size of the thumbnails in the Filmstrip – can be adjusted by pulling up or down on the border between the Toolbar and the preview pane.

The Content pane will then either contain the thumbnail matrix when in Grid view (see Figure 3-19) or a large-scale preview of your active image when any other viewing mode is active. When several images are selected, the active one will be marked slightly brighter than the rest in your Filmstrip. The *active* image is then the one that was selected first.

Double-clicking a thumbnail activates the *Loupe view* (from any other view mode). If you are in *Loupe View* and you zoom in, Lightroom will use the zoom level set in the Zoom icon bar. This bar is situated above the Navigator window (see Figure 3-19 Ⓐ). Using the drop-down menu there, you may select different zoom levels. Selecting *Fit* will scale your zoom level to show the whole image in your preview pane, while *Fill* will choose a zoom level that will fit the preview size to the width of your pane. A second click into the pane will zoom out again. Ⓩ will toggle between *Zoom* view and your previous *Fit* or *Fill* view.

Zoom level 1:1 (100%) means that a pixel of your image will be represented by a pixel of your screen. This 100% level you should use in Develop

Selected images

Active image

Figure 3-20: Lightroom in Library mode and Loupe view, using a zoom factor 1:2

mode, when applying sharpening, noise removal, or removal of aberrations and fringes, because it will give you the best assessment on the effect.

↵ (*Enter* key) will toggle *Fit, Zoom In,* and *Grid view.* Yet another way to zoom in, is using Ctrl-+ (Mac: ⌘-+), and Ctrl-- (Mac: ⌘--) to zoom out. When you are zoomed in, seeing only a part of your total image, you can shift around the currently visible part with the mouse. The mouse cursor will be a hand 🖑.

When only part of your image is visible in the Content pane and your Navigator window in the Navigation panel is opened (see Figure 3-20), you can also shift the visible part by clicking into the Navigator window. Lightroom will center your visible view on this point. Clicking at a point in your preview pane will shift your section and Lightroom will center your view at this point of the image.

Unfortunately, Lightroom 1.2 does not provide special multi-monitor support. Therefore, as a substitute, in our twin monitor system (both our monitors provide a resolution of 1600 × 1200 pixels each), we widen our Lightroom window so that the Parameter panel is placed on the right monitor, giving us almost the whole of the left monitor screen for a large image preview.

Doing your very first inspection, where you sort out those images that are definitely not usable, Grid view is probably the best viewing mode.

Lightroom can sort images by a number of sorting criteria. You will find them in your Library Toolbar (see Figure 3-21). The ▧ icon allows toggling between forward or backward sorting. In your Filmstrip and in Grid View, you may also do a custom sorting by selecting an image and dragging it to the position you want (in your Filmstrip or in Grid view). *User Order* will show up with *Sort.* This will **not** be possible when your *Metadata Browser* is selected in your Navigation panel (use *Folders* instead).

→ *Yet another way of navigating in your image is using the scroll wheel of your mouse or the page-up and page-down keys of your keyboard (← and → will bring you to your previous and your next image of your Filmstrip).*

Figure 3-21: There are several sorting orders in Lightroom.

Figure 3-22: Lightroom in Library mode and Compare view. Using → and ← allows you to exchange the right image with the next or previous one from your Filmstrip.

Rating and Marking Images

As discussed in section 1.3, assigning markups to images is part of our inspection phase. For this, Lightroom provides three kinds of markups:

▸ Stars (0–5)
▸ Flags (also available in Bridge since Bridge 2.1)
▸ Color labels (five different)

Stars We have used stars for our traditional rating since Bridge CS1 was introduced. You can rate a photo with zero to five stars. Before you start rating your images, think about a scheme, as discussed in section 1.3. To assign stars to images, we exclusively use keyboard shortcuts (see sidebar). This is much faster than using the menus.

Flags Lightroom provides two flags: *Rejected* ▪ and *Accepted* ▪. These we use constantly in our workflow, again, using keyboard shortcuts to assign the flags (Ｕ will remove a flag):

▸ An absent flag indicates that no decision was made for this image.

▸ *Accepted* flag ▪ (Ｐ) indicates that we intend to use this image for further processing (editing). Images marked with this flag are also called *Pick*.

▸ *Rejected* flag ▪ (Ｘ) adds the image to those marked for deletion.

Keyboard shortcuts for ratings:

0	→	*no star*
1	→	*1 star*
2	→	*2 stars*
3	→	*3 stars*
4	→	*4 stars*
5	→	*5 stars*
[→	*decrease rating*
]	→	*increase rating*

Figure 3-23: *Lightroom allows you to assign label text to the five color labels. This helps to remember their meaning.*

Figure 3-24: *Icon cell in Grid view*

Alternatively use Ctrl/⌘-Delete.

Color Labels Our third kind of image markups are color labels. Again, you should have a consistent scheme for their usage. Like Bridge, Lightroom allows you to assign names to them (other than "red", "green"…). Make up your own scheme and name the colors accordingly. Since Lightroom 1.1, this scheme is catalog-specific.

We use these labels to mark certain states of processing in our workflow. Again, we use keyboard shortcuts to assign color labels. For all other colors, you may use the keys shown in Figure 3-23. There is no shortcut for the ● label.

If needed, we also rotate the image in this inspection phase. You can use Ctrl/⌘-. (comma) to rotate it 90° clockwise and Ctrl/⌘-. (point) to rotate it counter-clockwise. You can also click the ↱ ↰ icons in the Toolbar.

Using Grid view, you can click on the ↺ or ↻ icon below the image icon (see Figure 3-24). As mentioned, Grid view is the best view for this. Here, you can increase the thumbnail size to see your preview image better as well as all the other markups, like star ratings, color labels, and flags. The *Thumbnails* slider of the Toolbar allows you to scale thumbnails.

In Grid view, Lightroom also displays the file name as well as the image size in pixels. To set a rating, simply click at the corresponding point below the icon. Clicking on the Color Label icon ■ (to the right of the rating points) brings up a fly-out menu, allowing you to select your color label.

A double-click on the thumbnail image and Lightroom will switch to Loupe view. Another double-click will bring you back to Grid view.

Workflow for Deleting Photos

When you inspect and rate your photos, it helps first to sort out those that you would like to delete. Here is our deletion workflow:

1. All deletion candidate images are marked for deletion (using X).

2. In *Filters* (which will be discussed a bit later), we set ⚑ , thus reducing our view to all those images that have a *Rejected* flag. Additionally, we deactivate all other items in *Filters*.

3. Next, we evaluate the selected images carefully a second time in order to avoid deleting usable images by mistake.

4. Finally, we delete all remaining images using Photo ▸ Delete Rejected Photos.* Lightroom will ask you to confirm it.

Filters

Filters, above the Filmstrip but still part of it, are available in all five Light-room modes. Filters allow you to restrict your current view to those that ful-fill all filter criteria. These criteria are combined by a logical AND – mean-ing **all** of them have to be matched. You may set a certain flagging, a minimum number of stars, any of the color labels, and whether you are looking for *Virtual Copies* (⬛) or for *Master Photos* (⬛), make your selec-tion accordingly.*

With flags, ⬛ implies that you are looking for picks (*Accept* flags), ⊠ for *Rejected* images, and ⬛ for images with no flag at all. When setting more than one flag, any of theses flag states are accepted. With star ratings, us-ing the fly-out menu under the relation symbol, you choose what to match. If you check more than one color label, any of these labels are accepted.

To temporarily deactivate the filter, click on the small switch to the right of Filters. Its state will change from on ⬛ to off ⬛.

If images you expect to see in your view do not show up, this may be due to a filter set. Then check your *Filters* setting or disable *Filters* (Ctrl/⌘-L will toggle *Filters* on and off). We use *Filters* frequently – for instance for our de-letion workflow, or when building a slideshow to fade out the background image, or when aggregating images into a collection.

Virtual Copies

Occasionally, one would like to have several versions of the same image – for instance, a color version as well as a black-and-white one or a version optimized for on-screen presentation and one for printing. With *Virtual Copies*, Lightroom allows for this without having to duplicate your image. A *Virtual Copy* is just another set of adjustment records linked to the original image (the original image is also called the *Master Photo*).

To create a Virtual Copy, select your Master Photo and use Photo ▸ Create Virtual Copy.** In your Filmstrip or in Grid view, the thumbnail will bear a dog-ear (see Figure 3-26).

Lightroom, by default, will stack the copy with the Master Photo. The Virtual Copy has to stay in the same folder as the master. So, if you move it to another folder, the master has to follow suit.

While you may drag-and-drop an image onto another external appli-cation – up to now, this is only supported on Mac systems – you can't do this with Virtual Copies because external applications can't change Light-room's correction records. However, you may select the copy and call up an external editor (as described in section 8.1). In this case, a rendered copy will be passed to the external application where all corrections done in Lightroom will be rendered into the image file.

* *A "Master Photo" is any image that is not a Virtual Copy.*

✓ Rating is greater than or equal to
Rating is less than or equal to
Rating is equal to

◀ *Figure 3-25:*
Filters allows you to restrict your view to those images that match the criteria set here.

** *Instead, you may use Ctrl-' (Mac: ⌘-') or use the fly-out menu by right-clicking the image icon.*

Figure 3-26: Virtual Copies are marked by a dog-ear.

3.4 Viewing and Editing Metadata

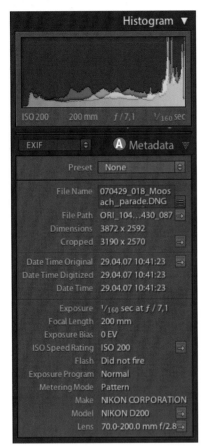

Figure 3-27: EXIF data will show up below the histogram as well as in your metadata pane.

The basics of metadata have been discussed in section 1.3. The different types of metadata will show up in Lightroom at several places. What may seem confusing at first, will make sense when you start using metadata:

▸ **EXIF dat**a provides information on your shot. Directly under the histogram, you'll see four important information items: ISO setting, focal length, aperture, and shutter speed. You will find more EXIF data in the *Metadata* pane of your Parameter panel. You can select the types of data shown using the drop-down menu (see Figure 3-27 Ⓐ). Additional EXIF data will be displayed with either *EXIF* or *All*.

With Lightroom, you can't edit EXIF. Usually, this would not make sense. There is one exception, concerning the date your photos were taken, e.g., when the date or time in the camera was not set properly or the shot was taken in a different time zone. To edit this date (or time), select the image (or several images) and choose Metadata ▸ Edit Capture Time. The dialog in Figure 3-28 will appear and you can do your update.

Figure 3-28: Lightroom allows you to correct your capture time

If, however, you need to change other sorts of EXIF metadata, which might make sense when you have stitched a panorama using several individual images or created an HDR image by blending several individual images, you have to fall back on specialized applications like *ExifTool* by Phil Harvey ([28]).* With Windows, there are a lot more tools for this, such as *Exif Pilot*, *Imatch*, and *Photo Studio*. The last three, however, are complete image management tools, and because we use Lightroom, we don't have much use for them.

HDR = High Dynamic Range

** A Perl tool that is available for different platforms*

▸ **IPTC data** is the most extensive part in the metadata block. A short form of it is displayed in your Metadata pane when you choose *Quick Describe* or *Minimal* (in menu Ⓐ of Figure 3-27). Choosing *IPTC* will provide you with the most detailed list (see Figure 3-29). Those for

whom the meaning of the different IPTC fields is not quite clear, should have a look at "IPTC Core Schema for XMP. Customer control Panel User Guide" [23].

Most IPTC data you will have to enter explicitly (though some cameras allow for preconfiguration of some fields). As stressed several times, IPTC templates, automatically assigned to your images on import by Lightroom, are the most efficient way of allocating some general fields (e.g., photographer, your address and contact information, rights of usage, copyright info URL, etc.). You may, however, add more using the *Metadata* panel or edit existing ones.

When you select several images in your Filmstrip or in Grid view, *<mixed>* will appear with some fields, merely indicating that there are different values with different images.

If you append text in your entry field, this text will be appended to the entries of all images selected. If, however, you clear the entry field and enter text, this new text will replace the text already there with all images currently selected.

If you have metadata templates (e.g., created as described on page 52), you may also assign the content of those templates to all images currently selected. To do so, use the *Presets* drop-down menu shown in Figure 3-29 Ⓐ, where you will find the list of metadata templates. You are free to add more data or edit existing data.

As these metadata templates are text files, you may also edit existing ones or create new templates.

▸ **Keywords** Lightroom dedicates a separate pane to keywords, thus honoring the importance of keywords when searching for specific shots. Keywords are displayed and may be edited in the *Keywording* pane (see Figure 3-32) – though, actually, keywords are part of IPTC data. Due to their importance, we will dedicate a separate section on them.

Lightroom offers some more metadata aggregations that you may choose from the drop-down menu at the top of the *Metadata* pane. The names in this menu are self-explanatory.

▸ **Image markups** The markups we mentioned, star ratings, color labels, and flags, are metadata too. Lightroom, however, will only show the ratings in its metadata panes (but embed them in its XMP structure) and store them in your catalog. Apart from that, all three types will show up in your Filmstrip as well as in the matrix of Grid view.*

The markups and metadata that will show up in your Filmstrip or in the matrix of Grid view may be defined by View ▸ View Options (or ⌃/⌘-J).** Additional setups concerning what kind and where some metadata will be displayed may be done in View ▸ Grid View Style and in View ▸ Loupe Info.

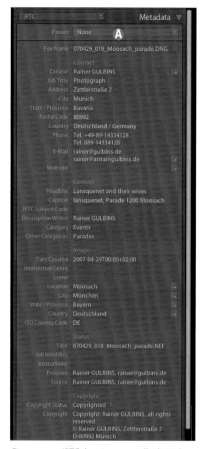

Figure 3-29: IPTC data is potentially the richest set of all metadata blocks. According to the IPTC standard, some of the fields are supposed to be filled using special IPTC codes.

* *If configured as described below*

** *See Figure 3-30 next page.*

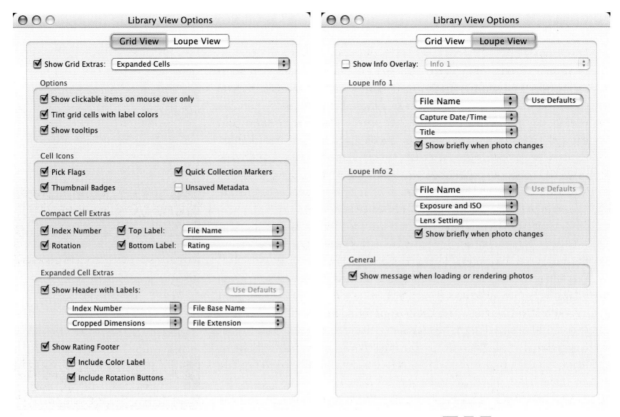

Figure 3-30: Here, you can define what kind of metadata should show up in your various viewing modes. Ctrl/⌘-J *will call up this dialog.*

Auto-Completion When Filling in Metadata

Lightroom will keep a record of your recent actions and input. This also applies to metadata entries. When you enter data into a field, Lightroom will offer auto-completion* – very much the same way a web browser does when you enter a web address. This can save you some typing.

** You can change this behavior in your Preferences (see section 2.8, Figure 2-17 Ⓐ).*

The Arrows Next to the Metadata Fields

You will see arrows next to some fields of your *Metadata* panel (see Figure 3-31, for instance). Whoever is expecting a drop-down menu will be surprised (or disappointed). What happens if you click on one of these arrows depends on the field the arrow belongs to. If it's *E-Mail*, Lightroom will call up your e-mail application. If it's *Website*, Lightroom will call up your web browser which will jump to the address given in this field. With most other fields, Lightroom will open the Metadata Browser using the content of your current field as search criteria. This will result in a view containing all images that have the same value in this field.

This effect may be a bit surprising at first, but it frequently turns out to be quite practical.

Figure 3-31: The arrows next to these fields will activate (in most cases) your LR Metadata Browser passing along the field's content.

3.5 Keyword Entry

When your image stock grows, keywords become indispensable when look-ing for specific images (or a group of images with the same characteristics) in your huge haystack of photos. We can hardly overemphasize the impor-tance and usefulness of keywords. The first opportunity to add keywords, and usually the most efficient, is when you import a shoot. But you may add keywords at any time later as well. We prefer to do this (on top of those added when importing) when we do our first image inspection. Experience shows that if you don't do it now, you will have a hard time doing it later.

We discussed keywords in section 1.4. Here, we will deal with the way Lightroom allows you to display, add, and edit keywords.

The easiest way to add keywords (after importing) is to use the *Key-wording* pane (see Figure 3-32). If several images should get the same key-words, simply select these and enter your keywords in this pane.

When you're doing your keywording, categories and keyword hierar-chies turn out to be quite useful. Lightroom (as well as Adobe Bridge) is quite good at creating these. So, apart from those entries in the *Category* and *Genre* IPTC fields, it's a good idea also to use category terms with key-words, e.g., *Landscape, Persons, Fashion, Flowers, Stills, Animals,* and so on.

Figure 3-32: This pane displays the keywords of your image and allows you to add new ones and edit existing ones.

Using *Persons* as an example, you may (on your own discretion) define subcategories like *Friends, Relatives,* and *Children* and yet more categories below these. The names of my children could thus be the lowest level of the *Persons* hierarchy. If I assign *Hanna,* the name of one of my daughters, to an image, Lightroom (in this scheme) would also assign *Children, Family,* and *Persons* (see Figure 3-33 for an example).

To set up these hierarchies, use the *Keyword Tags* pane. As with file naming and your filing structure, before you start to set them up, you should make a rough design on paper.

Keyword Tags

On the left in the Lightroom window – in the Navigation panel –, you find the *Keyword Tags pane* with an alphabetically sorted list of the keywords as-signed up to now. It also contains your keyword hierarchies.

Figure 3-33: A section of my "Keyword Tags" pane containing part of my "Persons" hierarchy

The numbers with each entry indicate how many images bear this key-word. When you see a display like 618/849 (see Figure 3-34), this indicates that 618 images in your current view (in your Filmstrip) bear this keyword tag out of 849 images out of your total stock of the current catalog.

A check mark ☑, as illustrated with *Sarah* in Figure 3-33, indicates that this tag is assigned to images currently selected.

This pane is not only useful for showing the keywords used, but also for assigning keywords. To assign a keyword tag from this list, select the corre-sponding images and drag them onto the item. You can also do it the other way around, dragging a keyword item from this list onto images in your Filmstrip or your Grid view matrix.

Figure 3-34: Another section of the "Keyword Tags" pane

The second use for the *Keyword Tags* pane is to quickly form a view of all those images containing a certain keyword (tag) – just click on the corresponding tag in this pane. You may enlarge your view by Ctrl/⌘-clicking on more tags. This will include all images that have any of the tags selected.

To add new tags (keywords) to this list, click on ■ – or right-click into the pane and select *Create Keyword Tag* from the fly-out menu that will appear (see Figure 3-37). The dialog box in Figure 3-35 will appear. Here you may not only enter a new tag, but also assign synonyms. Using our example of *Persons*, we could use *People* as a synonym.

Figure 3-35: Dialog for creating new keyword tags.

Now, let's follow our example by next creating a subcategory of *Persons*, namely, *Family*. This time, we would select *Persons* in the pane and once more call up the Create dialog (see Figure 3-36). This time, the dialog offers additional options and we will create a new tag, *Family,* that is a child of *Persons*. In the same way, we will create more members of the keyword hierarchy.

As shown in Figure 3-37, the *Keyword Tags* fly-out menu (right-click inside the pane) also allows you to rename and edit tags or delete tags from this list or from selected photos.

Figure 3-37:

Fly-out menu showing operations on tags in the Keyword Tags pane.

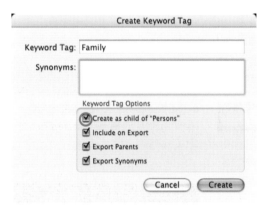

Figure 3-36: Here we create a keyword tag that is a subcategory of "Persons".

The item *Keyword Shortcuts* will be explained in the next section.

Keyword Sets

A *keyword set* consists of a number of thematically coherent keywords that are grouped into a set. From that set you can easily select elements and assign them to your photos. Figure 3-38 shows an example of such a set (*Wedding Photography*) that comes with Lightroom. If you shoot a wedding, you will find a number of potentially useful keywords in this set. You find these sets on the *Keywording* pane (in the Parameter panel), and you may have to choose your specific set from the *Keyword Set* menu Ⓐ.

To assign keywords from this set, just select the target image in your Filmstrip or in Grid view – again, you can also select several photos – and click on the set items you want to assign. These keywords will be added to the images and will immediately show up in the *Keyword Tags* field above the set. As these sets are quite cheap disk-storage-wise (they are stored as simple XML text files), you can have plenty of them.

Figure 3-38: Lightroom comes with a small number of Keyword Sets, but you may add your own and edit existing ones.

XML = Extensive Markup Language

The advantage is not only that assigning is easy and fast, it also avoids typos and will give you a consistent keywording.

Naturally, you can create your own sets (or modify exiting ones). For this, choose a set from menu Ⓐ (Figure 3-358). Now select *Edit Set* from the same menu. In the dialog that appears (see Figure 3-39), you edit your set.

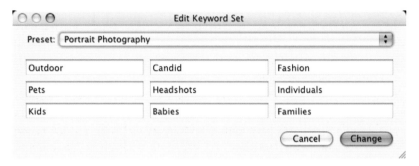

Figure 3-39:
You can modify single keywords or create a completely new set that you can save with a new name.

Keyword Paint Tool

We are not finished yet with keywords. There is still another way to apply them: this time, we use the *Paint* 🖌 tool that you find in the Library module Toolbar* – but only if Grid mode is active. (With Lightroom version 1.0, this was the 🖌 icon!)

When you click this icon, an entry field will appear next to it.

Here, you enter keywords (separated by commas or semicolons). If you roll your cursor over an image thumbnail, it shows a 🖌. Clicking the mouse will assign the keywords; clicking it again (on the same image) will delete the keyword(s) just assigned. Using the Paint tool you may not only copy keywords but also some other setting. Use the ▾ menu to define the kind of information that should be copied and applied by the tool (see Figure 3-40). The field behind the Paint tool will change according to the item selected there.

You will explicitly have to deactivate the Paint tool. Click again on the painter's space in the Toolbar to deactivate it.

** Use ⊤, to make the Toolbar visible, if required. Additionally, you may have to make the Toolbar show the Paint tool. To do so, check "Paint" in the ▾ menu at the right side of the Toolbar.*

Figure 4-40: The Paint tool allows you to copy different settings or metadata.

Summary on Keywording

As you may have seen, Lightroom takes keywording seriously. However, the variety of possibilities may be bewildering at first. Therefore, take your time to get acquainted with all these techniques. Start with the simple ways, though they may not be the fastest. Assigning keywords on import is the most efficient way, so make use of it. Then build up your keyword sets and your keyword tag hierarchies. Additionally, Lightroom allows you to check your spelling when entering your keywords. We will go into this in section 9.7.

→ What is absent in Lightroom, at least up to version 1.2, is the File Info dialog (as available in Photoshop and Bridge). It would allow you to add comments to images.

Transferring Metadata Using Copy and Paste

There is yet another way to apply metadata to images: by picking up meta-data from one image and pasting it onto other images.

First apply your metadata to one image. Then copy the metadata to your Lightroom clipboard by either choosing Metadata ▸ Copy Metadata or pressing ⇧-Ctrl-Alt-C (Mac: ⇧-⌘-⌥-C). A dialog appears that will allow you to specify what kind of metadata should go into your clipboard (see Figure 3-41). You will find neither keywords nor EXIF data in this list (the latter makes sense, for keywords, there are other ways of copying).

From the clipboard, the metadata is applied to an image (actually, to all images currently selected) either by choosing Metadata ▸ Paste Metadata or by using the shortcut ⇧-Ctrl-Alt-P (Mac: ⇧-⌘-⌥-P). For a second, the *Painter* icon 🖌 will appear.

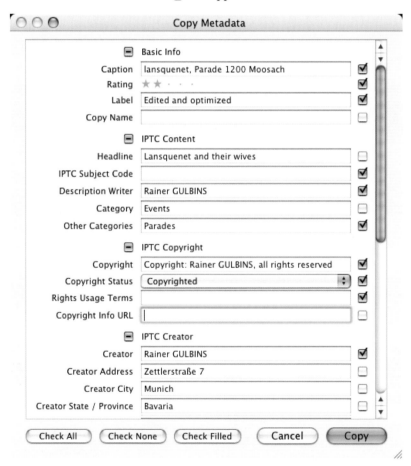

Figure 3-41:

When you copy metadata to Lightroom's clipboard, this dialog allows you to select those items that should go into the set.

3.6 Importing a Stock of Images from Disk

In section 3.1 we showed you how to import images coming from your digital camera or memory card. How you transfer images from one Lightroom catalog to another, will be explained in section 9.2. But when you start working with Lightroom, and if you are shooting digitally, you most likely will have a lot of digital images on your disk already. And they will probably be named, sorted, and organized in some way and have some markups that may have been applied using Photoshop or Bridge. These images can be brought into Lightroom quite easily:

1. The first decision to make is whether your current file names are appropriate or whether you should rename your files when importing.

2. The next decision is whether your files should stay where they are or if you should create a new filing structure on import. Even if you intend to stay with your current filing and naming structure, we urge you to copy your files to a new location. This allows you to get some experience with your files in Lightroom. At the same time, you have a backup (your files at their current location) that you can fall back on when encountering problems.

3. The actual import will run very much the way we described it on page 50–53. When you copy your files, you can first either create a new folder in your *Folders* pane (click ■ and enter your folder's name) or create the new folder in your Import dialog.

4. Next, click Import. The file browser dialog will appear. This time, instead of the memory card, select the folder where your image stock resides (which may also be a network drive) as the source. Now the actual Import dialog will open (see Figure 3-42).

 4a) Depending on whether you decided to copy your files or not, you can either use *Import photos at their current location*, if you want to leave your files where they are, or preferably, *Copy photos to a new location and import* (see Figure 3-42 Ⓐ). We never use the third option (*Move photos …*), because this will delete the files from their current location, which might be problematic if anything goes wrong.

 4b) Select your destination folder now Ⓑ. If you have not already created a folder in your *Folders* pane, create one now.

 4c) Select the way you want to organize your destination folder in the *Organize menu* Ⓒ. If you already used a sensible folder structure with your current filing system, you can carry that over to your destination. For this, select *By original folders*.

➜ *Instead of clicking on "Import", you can drag an image or a complete folder onto the Lightroom window (it does not matter where). Lightroom's Import dialog will open with the folder already selected as the source folder.*

Import photos at their current location
✓ Copy photos to a new location and import
Move photos to a new location and import
Copy photos as Digital Negative (DNG) and import

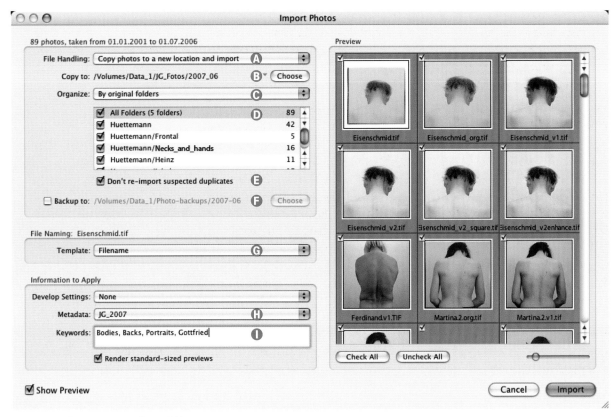

Figure 3-42: This time, we copy from a folder instead of a flash card. Here, we uncheck the Backup option as the image stock will still be available in its original place.

4d) In the scroll list of the dialog illustrated in Figure 3-42 Ⓓ, you can uncheck individual folders that you don't want to import this time. We recommend starting with a single folder and not importing a huge folder hierarchy right away.

4e) We also advise you to activate option Ⓔ, thus preventing importing duplicates.

4f) You should also deactivate the backup option Ⓕ. Because you kept your old files, you still have a backup.

4g) In this example (see Figure 3-42 Ⓖ), we didn't change file names. This is sensible if your current file names are already named according to your scheme.

4h) If your source image files already contain plenty of metadata, you don't have to do much; just select *None* in the *Metadata* menu. If, however, you did not yet apply your basic metadata, create a metadata template here (select *Edit* from the menu Ⓗ).

4i) You can add additional keywords that apply to all images imported in this run in the *Keywords* field Ⓘ.

5. Finally, click the *Import* button to start the actual import process.

6. When your import is complete, we recommend that you do your image inspection as described earlier. In the import process, problems may have been reported with some images.** Have a look at these files. It might help to open them in Photoshop and save them in a different format before trying to import them again, or set them aside to deal with later.

* For instance, because Lightroom does not support their file format or because these files were damaged.

You may have to do some major or minor adjustments (concerning naming, filing, or metadata templates) before importing more folders. It may even make sense to create a new temporary catalog. If everything worked out fine, you can rename that catalog or import from it to your main catalog.**

** This we will describe in section 9.2.

When you import and copy your images to a new location, keep your old folders for some time, even if this may mean using an additional external disk; they are quite cheap nowadays and probably are faster than the last ones you bought. Later, you may use it as an external backup store.

When inspecting your files, this may be a good opportunity to sort out those files you don't want to keep any longer. Mark them for deletion and follow our deletion workflow as described on page 58. If not done before, rate your files now.

If the first import went well, and minor inconsistencies have been cleared out, you can start to do a bulk import. But even here, if your current stock is huge, we recommend that you do it in several smaller steps and not all at once.

→ The final step might be optimizing your catalog as described in section 9.2. This will improve Lightroom's performance when working with that catalog.

3.7 Import from a Watched Folder

Lightroom allows for an automatic import, either when a camera is connected or you insert a flash card into your card reader or by using a watched folder. We use the latter method here. To set up the "watched folder" use File ▸ Auto Import ▸ Auto Import Settings. In the dialog that comes up (see Figure 3-43), you set up the folder Ⓐ Lightroom should watch regularly. The rest of this dialog is much the same as your standard *Import* dialog.

Additionally, in order to activate the Auto-Import feature, you have to activate *Auto Import* (File ▸ Enable Auto Import).

Lightroom will start importing images from that folder as soon as an image is added to the watched folder. When an import of an image is finished, Lightroom will remove the image from the folder.

We very rarely use this Auto-Import feature. There is one exception: when doing *tethered shooting*. With tethered shooting, your camera is directly connected to your computer, either using a USB or a FireWire cable. With some new cameras and additional (optional) WLAN adapters, you can even use wireless LAN. You usually do this when shooting in a studio and you want to control your camera from your computer. This allows for very quick processing and for a very detailed assessment of the images taken – here, you may use your large computer monitor instead of your rather tiny camera display to scrutinize your image shot.

LAN = Wireless Local Area Network
WLAN = Wireless Local Area Network

Figure 3-44: *EOS-1D Mark III controlled by Canon's "EOS Utility" in a "Tethered Shooting"*

Figure 3-43: *Set up your Auto-Import settings. For the actual import process, you have to activate "Auto Import", additionally.*

Lightroom has no feature for direct camera control; the protocols for this are too heterogeneous. But most manufacturers of DSLRs provide such programs, e.g., Canon with its free *EOS Utility* or *Remote Capture* (both coming with your Canon DSLR) or Nikon with its *Nikon Capture Control Pro*. While these applications do not interact directly with Lightroom, both write the captured images to a folder specified in their setup. This folder is used as the connecting link to Lightroom. When shooting, both applications have to be running: Lightroom as well as your camera control. The images will now immediately show up in Lightroom.

3.8 Library Module as Your Administrative Center

From the preceding paragraphs, it should be clear that the *Library* module is the administrative center of Lightroom and the starting point for most other workflow steps: for image editing (optimization) done in *Develop* mode (see Chapter 4) as well as all output-specific preparations as discussed in Chapters 5, 6, and 7. In addition, the export of photos (explained in Chapter 8), and the deletion, renaming, sorting, and grouping of images are all done in *Library* mode.

That's why, when beginning to work with Lightroom, you should first spend some time getting well acquainted with *Library*. You should get to

know the ins and outs and the shortcuts used most frequently, at least if you intend to work with Lightroom regularly. ([Ctrl]-[/] (Mac: [⌘]-[/]) will bring up an overview of the keyboard shortcuts of your current Lightroom mode.) Though you may use menu sequences, in our experience, menus will slow you down. More shortcuts (not all of them found in the Lightroom documentation) you will find in Appendix A of this book.

Click on ⊞ or use [G] to switch back to Grid view from any other mode and view. If you can't remember your keyboard shortcuts you can use a right-click (Mac: [Ctrl]-click) to call up fly-out menus that offer operations specific to the object currently selected.

More Features

Lightroom's *Library* module will offer a lot of features not mentioned yet. You can rename folders (this will also be reflected in your folder structure of your operating system) and you can rename images. Renaming, deleting, and creating folders is done in your *Folders* pane (part of the Navigation panel) using the right-click fly-out menu (Figure 3-45). In this menu, you will also find an item that will call up the *Finder* in Mac OS or the *Explorer* in Windows. The Finder will show you your selected folder in the folder hierarchy of your operating system.

Figure 3-45: Fly-out menu with folders in your Folders pane.

Renaming images (substantially more often used) can be done either by editing the file name in your EXIF or IPTC metadata pane or by choosing Library ▸ Rename Photo (or [F2]).

Quick Develop Pane

While *Develop* mode is the one to use to do your in-depth image editing, you can do some preliminary corrections while still in *Library* mode. This is the task of the *Quick Develop* pane (see Figure 3-41) in the Parameters panel. The corrections you do here, may be applied to a single image or to several images, depending on what currently is selected. The controls are grouped into three sections: *Saved Preset*, *White Balance,* and *Tone Control*. In *Saved Preset*, you will find a menu listing presets that Lightroom brought along, complemented by those that you previously saved. The menu *Treatment,* for example, allows a quick conversion to *Grayscale*.

In the lower two sections, you don't have regular slider controls, but only simple buttons, ▶ for increasing and ◀ decreasing the corresponding setting, and not all of the controls of Develop mode are provided here.

The corrections carried out here can be further refined in *Develop* mode.

We personally never use this way of doing image corrections but rather use the full Develop mode instead.

Figure 3-46: You can do some preliminary image corrections using the buttons and menu of this pane.

Editing Images in the Develop Module

4

Once you have checked the images of your shoot, rated them, and added metadata, the next big step is editing them to get the best out of them. It is best if you concentrate your efforts only on the photos you intend to use for customers, galleries or prints. Use Filters to restrict your view to images that exceed a certain star rating or to work only on images that you flagged as "Picks".

Lightroom's core image and editing engine is basically the same one used by Adobe Camera Raw (ACR 4.x). Unlike ACR version 3.x, Lightroom allows you to edit not only RAW files but JPEG, TIFF, and PSD files. (Adobe Camera Raw 4.x also supports these.) Nevertheless, we strongly recommend shooting and editing RAW files. RAW files contain better-quality image data than JPEG files.

Figure 4-1: The controls of the "Quick Develop" pane in Library mode

** E.g., correcting lens distortions or perspective distortions*

Lightroom offers four ways to edit images:

1. The first way is using *Quick Develop* (see Figure 4-1), which you find only in the *Library* module. It offers limited editing functionality. Instead of sliders, you use buttons like ▶ for "more" and ◀ for "less." They allow a basic correction that we rarely use, however.

2. The second way of editing is found in the *Develop* module. Develop controls are placed in the various panes of the Parameter panel at the right side. You can also apply presets to images. Presets are located in the *Presets* pane in the Navigation panel. They apply a set of previously saved correction settings to an image. These changes show up in the various controls of the Parameter panel.

3. Lightroom offers some automatic corrections. Although we generally mistrust these *Auto* features, and quite often the result created by these tools confirm this, some of the *Auto* corrections may provide a reasonable starting point for further editing. So give it a shot. Lightroom offers automatic tools for the following:
 – White balance (*WB Auto*)
 – Tonality (*Tone Auto*)
 – Grayscale conversion (HSL/*Color*/*Grayscale* → *Auto Adjust*)

4. Lightroom can launch other external image editors to do corrections that cannot be done in Lightroom.* Lightroom will render a copy of the image and hand it over to the external editor, using the file format set in *Preferences*. After the rendered photo is returned to Lightroom, the preview is updated automatically (expect some delay).

4.1 Order of Corrections

Although Lightroom does not enforce any specific order of corrections, it is better to maintain a certain workflow. More steps may follow then, in order to refine your preliminary corrections. We suggest the following workflow steps:**

*** Not all of them are always needed*

1. Basic cropping and image straightening (optional)
2. White balance
3. Adjustment of exposure values
4. Fine-tuning contrast, color, and tonality
5. Noise reduction, correction of vignetting and chromatic aberrations
6. Sharpening

➡ When we say "black and white", we are not referring to bitonal images, but grayscale images.

If you plan to convert an image to grayscale (black-and-white), it is best done after step 3. More and finer cropping and sharpening may be necessary, depending on the final output. Dust removal should not be done too early as dust spots and other artifacts will be more noticeable after initial adjustments, mainly after step 3 or 4. During this process, watch the preview in the content pane and also check the histogram!

Figure 4-2: Lightroom in Develop mode. To the left, you see Develop presets, to the right the Parameter panel with some correction panes.

4.2 Adjustment Controls

Image adjustment tools in the *Develop* module are grouped into seven panes (see Figure 4-3) – eight, if you count those in the Toolbar. Seven of them are part of the Parameter panel to the right. The top-down layout suggests the order of the workflow. On top, a histogram is displayed. It not only shows the distribution of tonal values in your image, but in Lightroom it also allows direct adjustments. This is a new feature available only in Lightroom and not in ACR. We will explain it later.

If the Toolbar is wide enough and the *Info* field is activated, the RGB values under your mouse cursor will be shown, not in values from 0 to 255, but in percent from 0 to 100%!

You will find additional tools in the *Develop* Toolbar. The menu (at the right side of the Toolbar) allows you to define which of those tools you want to show up in the Toolbar. For pure editing, you generally won't need stars, color labels, and flags. They can be deactivated if you work with the smaller screen of a laptop. This gives some more room for the RGB tool and the zoom slider.

The icons for the slideshow (▶) and the ones for navigation (◀ ▶) may not be needed either; you can still navigate to the next or previous

Figure 4-3: Adjustment panes (collapsed) of Develop mode.

Figure 4-4: Basic editing window in Develop mode. The Navigation panel (left side) is hidden, and the correction panes in the Parameter panel are collapsed. The Info field, visible in the Toolbar, shows the RGB values of the point under the mouse cursor.

** The arrow keys on your keyboard will not work this way when you are zoomed in Loupe mode. In that case, they will move the visible section of your image!*

image using your keyboard keys ← and → instead,* or you can use the scroll bar of the Filmstrip.

It is often useful to show the Navigation panel containing the Develop presets. This allows testing different presets, for instance, conversions such as grayscale or sepia. The *Auto Hide/Show* mode is quite useful for this panel too. The same applies to the Filmstrip.

Figure 4-5: Lightroom histogram. The left triangle shows a clipping warning for shadows (as does the histogram).

4.3 Histogram

The histogram of Lightroom grew up to be quite a powerful tool, providing analysis as well as direct corrections:

▸ **Analysis:** The first task of the histogram is to show the distribution of tonal values. Additionally, the two triangles ◣ indicate if highlights or shadows are clipped in the image. The left one applies to shadows, the right one to highlights.

Apart from the basic RGB colors, representing red, green, and blue, respectively, the colors of the histogram and the triangles (clipping warnings) have the following meanings: gray for R + G + B, yellow for

are also used ... res 4-6b and ... ogram, pro-

... ments of the ... s. Using the ... r to the right ... nto four re- ... white point, ... sed this fea-

... own the Alt/ ... nts the same ... /⌥ and shift ... g (see Figure ... working the ... control.

Figure 4-6a: An image with some clipping in the shadows. In this preview, however, it is hard to see.

Figure 4-6b. Preview when using the Exposure control pressing Alt/⌥. The white and colored areas indicate highlight clipping.

Figure 4-6c: Preview when using the Blacks control and pressing Alt (Mac: ⌥). The black and colored areas indicate clipping.

corners of the histogram. (These triangles have to be activated either by clicking on them or holding down J .)

A certain amount of clipping might be acceptable in some areas of a photo, usually in shadows rather than in highlights. Therefore, from time to time while correcting, you should release your Alt/⌥ key to see the preview image instead of the clipping indication to judge what amount of clipping you want to accept (remember, clipped highlights print on paper pure white).

There is yet another way to temporarily see where clipping occurs in your image. For this, move your cursor over the left or right triangle. With the left ▲ shadow, clipping is rendered in blue ■ in the preview, the right one, highlight clipping, in red ■. Clicking on ▲ activates a permanent warning, blended into your preview (*Develop* module). The triangle frames will be highlighted ◼. These permanent clipping indicators can, however, be quite distracting during editing.*

* The second click will deactivate the permanent warning again.

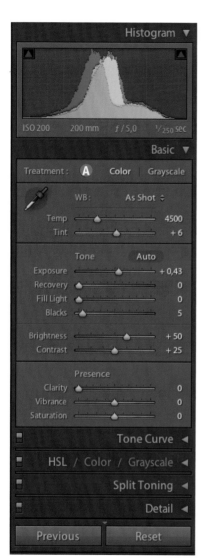

Figure 4-7: The primary controls are placed in the "Basic" pane.

4.4 Basic Corrections

Apart from cropping and straightening the image, we start by correcting the white balance, followed by exposure, tuning tonality, and – if required – a first basic correction of colors. You will find all controls needed for these tasks in the *Basic* pane (see Figure 4-7).

With *Treatment* (Ⓐ), you decide whether you want to handle your image as a *color* image or in *grayscale*. Let us stay with *color* first.

The order of the controls, found in the *Basic* pane, provide a useful order for corrections. Often you may need to go back and forth between the different controls. Most of the time, the first step is correcting the white balance (actually the camera white balance is often quite good).

White Balance (WB)

Performing *white balance* (often abbreviated WB) means adjusting the colors of your photo so that colorcasts are eliminated and areas that should be neutral (gray) are really gray without a colorcast. There are several fundamental ways to achieve a good white balance:

1. Automatic white balance, done by the camera. The camera analyzes the colors of the scene shot and estimates its color temperature. For JPEGs and TIFFs, the camera applies the WB to the image that is stored on the flash card. For RAW images, the color temperature value is embedded into the RAW file metadata but not applied to the pixel data. For outdoors photography, in-camera WB often works quite well; for tungsten and other kinds of artificial light, it can be way off.

2. Manual color temperature setting in the camera, adapted to the scene and lighting. You either select a color temperature using camera settings (estimating the color temperature) or perform an explicit white balance with your camera using a white card. You can find out how this is done from the manual for your camera. Again, with JPEGs and TIFFs the custom WB will be rendered into the image, while with RAW files the settings are embedded as metadata. Lightroom reads these values from the RAW file and uses them as an initial setting for white balancing (showing *As Shot*, as illustrated in Figure 3-7).

3. When shooting a series of photos with the same light, you may include a ColorChecker or a gray-card into your first shot. Later, working in Lightroom, you use a gray patch or the gray card in your image to adjust the white balance (using Lightroom's eyedropper tool). Then copy this WB setting to all other images that are part of the sequence under the same lighting conditions.

4. White balance adjustment using Lightroom's eyedropper tool (as described on page 83).

5. Using Lightroom's *Auto* white balance function. Like the camera, Lightroom can measure the current color temperature. You will find this *Auto* function in the *Basic* pane in the *WB* drop-down menu:

Figure 4-8:
Color temperature presets,
including "Auto".

6. Alternatively, you can look at the preview of your image and use the *Temp(erature)* and *Tint* controls of Lightroom to do a visual white balance adjustment. If you still have the lighting of the scene shot in mind, you can set the WB using a corresponding preset in the *WB* menu.*

There is still another variation. You can create a camera ICC profile. This only makes sense when shooting in a studio that has stable lightning. Additionally, it requires a camera profiling software package and a suitable color target. This method cannot be used with Lightroom because Lightroom does not support custom camera profiles (neither does Adobe Camera Raw).

After setting your WB with one of the methods mentioned above, you can perform some additional fine-tuning using the *Temp* control and *Tint*. We recommend starting with *Temp*. The final adjustment can also include the *Tint* control. Figure 4-9 illustrates the way these two controls shift your colors in the total color space. If the colors of the image look too cold and you want to give them a warmer appearance, shift your *Temp* slider towards higher temperatures. This may seem counter-intuitive. Shifting the slider to the right tells Lightroom that the lighting condition of the scene had a higher color temperature, and thus the image will look warmer when corrected. Higher scene color temperatures produce cooler colors, lower temperatures warmer colors.

Figure 4-9: This figure illustrates where you can shift your colors with the Temp and Tint controls.

White Balance Using the Eyedropper Tool

If there are areas in your photo that actually should be neutral gray, then Lightroom provides a convenient way for achieving good white balance, it's the eyedropper ✐. This tool allows the adjustment of the white balance easily and quickly. Click the eyedropper in the *Basic* pane. The mouse cursor now shows an eyedropper shape. Click on a point of your image that should be neutral gray. Lightroom adjusts the colors of the whole photo

accordingly. Neither pure white nor pure black image areas are suitable for this kind of WB. It is best to use light gray areas, for instance, a gray shade on a white shirt or a gray metal or concrete surface.

When the eyedropper tool is active and you move your cursor over your image, Lightroom shows an enlarged view of the areas beneath the cursor – a kind of magnifier view. It also shows the RGB values of the point directly beneath the cursor. Like all RGB values in Lightroom, these values specify percentages (0–100%). (Many of you will be used to seeing RGB values ranging from 0–255 as shown by Photoshop!)

If your first WB selection did not get the result you wanted, try another area in your image. (You have to reactivate the eyedropper tool first.)

In order to have a really neutral-gray reference in the image, with problematic lighting conditions, we sometimes include a color reference card into our shot. When shooting a series of images using the same lighting, it suffices to include this card with the first shot only.

Figure 4-10: Image above before and image below after white balance correction using the eyedropper tool.

Figure 4-11: ColorChecker by Gretag MacBeth/X.rite. We use the second grayscale patch from the left as our reference point.

As a color card, we use the *ColorChecker* by Gretag MacBeth/X.Rite [44]. On this card, we use the gray square (marked red in Figure 4-11) as our reference neutral patch. We then copy the color temperature, which Lightroom will set as the white balance, to the other photos taken at the same light conditions. With the eyedropper active, click on the field highlighted in the illustration (Figure 4-11). We will copy the WB values to the other images using the *Synchronize* feature in Lightroom.[*]

* See the description on page 110 for this.

Exact white balance adjustments are relevant with product and reproduction photography, while with many other shots we prefer to achieve pleasing colors rather than a correct color reproduction of the scene. For portraits and other people photography, you have to watch for skin colors. Also, a healthy brown tone for the skin is often preferred over the actual correct skin color – with Caucasians, at least. Different skin tones might be preferable for other ethnic groups.

Exposure Correction

Next, we start to correct the tonal values. Checking the exposure is the first important step. A well-balanced exposure in the camera, of course, is the optimum prerequisite, and the histogram of the camera is usually a good tool to check exposure in the field.[**]

In Lightroom, the histogram and a large-scale preview help to optimize exposure. For us, there is a strict rule: Avoid clipping – in particular in highlights. (An exception to this rule may apply to some single specular highlights you may encounter with reflections on metal surfaces or on water, like the one in Figure 4-10).

Lightroom offers again an *Auto* button, though with *Auto,* the results are rarely good. Sometimes it can provide a useful starting point before some more fine-tuning. The *Auto* feature sets the controls for *Exposure, Blacks, Brightness,* and *Contrast. Recovery* and *Fill Light* are set to zero.

If we get clipping in the highlights the histogram touches, the right side and the clipping warning triangle in the histogram are highlighted. In this case, we carefully push the *Exposure* control to the left, watching the image preview as well as the histogram. Ideally, we want no clipping in the highlights and not much clipping in the shadows.

** *For more on this, read Uwe's paper "Watch Your Histogram." You will find it in FotoEspresso 1/2005. You may download this free photo-letter from [11].*

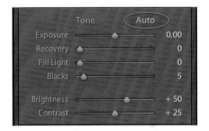

Figure 4-12a: This image is slightly underexposed but shows good details in highlights.

Figure 4-12b: Highlights control set to +24 and Blacks to +0.

** Never ever use this method as an excuse for sloppy exposure in the first way!*

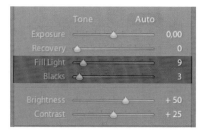

*** With some images, of course, dark shadows might be desirable.*

If an exposure correction of about -0.5 to -1.0 is not sufficient, we use the *Recovery* control – pushing it to the right. If your overexposure is not too bad, this should bring back details in your highlights without blocking the shadows.*

You can correct blocked shadows, showing no details, using *Fill Light* without brightening the entire image too much. If the clipping control of your histogram no longer indicates any strong clipping in your shadows and your image looks good on screen, all is fine. Don't overuse this control or your image might get an artificial impression. Using too much *Fill Light* will bring up noise in your dark image areas. *Fill Light* can be very effective used in moderation.

Blacks allows you to set your black point. The default used by Lightroom depends on your camera. If the shadows are clipped, move this control slightly to the left or set it to zero.** If your histogram indicates free space to the left, you may slightly push *Blacks* to the right. This will also increase the contrast of your image (if this is desirable). Again, watch your histogram and preview in order not to block too much of your shadows.

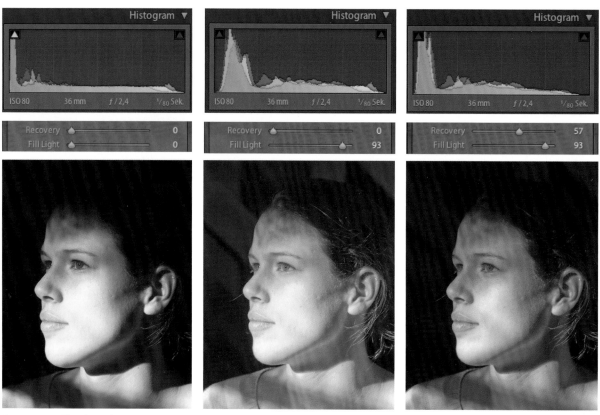

Figure 4–13a: This photo shows a strong contrast. The histogram indicates shadow clipping and not much to spare in the highlights.

Figure 4–13b: Here, we pushed up shadows using "Fill Light". Now more details are visible in shadow parts. The cheek is burned out in some parts.

Figure 4–13c: Using "Recovery", we restored more details in highlights. A selective correction, restricted to the cheek, could further improve the image.

Alternatively, temporarily hold down Alt/⌥ to see the clipped shadow parts of your image.

The *Brightness* control, as its name implies, controls the brightness. (It behaves a bit like the Photoshop Levels *Gamma* slider.) Be cautious when using this control because with most images, highlight clipping is more destructive than shadow clipping. According to our experience, the warning shown by the highlight clipping indicator of the histogram appears a bit late. The clipping indicator, which you see in your image preview when holding down Alt/⌥,* seems to be more precise. However, it only works when setting *Exposure*, *Recovery*, and *Blacks* but not with *Brightness* or *Fill Light*.

* As described on page 81.

Move your cursor over critical image areas and watch the RGB values displayed in the *Info* field of the Toolbar. If you optimize an image for printing, the brightest points should not go beyond 96% and the darkest areas should not drop below about 8%. Beyond these values, neither highlights nor shadows will show any details in the print, though they might be visible on screen.

For many photos, we do not touch the *Contrast* control. If we want more contrast, we often use *Tone Curve* instead.

The image in Figure 4-13a shows a strong contrast and the histogram indicates shadow clipping. Raising *Exposure* does not help here because the bright skin parts will lose details in the cheekbones and turn yellow. Therefore, we first use *Fill Light* to pull up the shadow areas. The result is illustrated by Figure 4-13b. Next, we recover overexposed highlights by pushing the *Recovery* control to the right. This improves the cheekbone parts, as illustrated by Figure 4-13c. A selective correction, restricted to cheeks and chin, could do even more. However, you have to use an external tool because Lightroom does not allow for this kind of correction.

Color Correction in the Basic Pane

In the *Basic* pane, Lightroom provides two controls for further color tuning (apart from *Temperature* and *Tint*): *Vibrance* and *Saturation*.

Both actually influence the saturation of your photo. If you want to increase saturation a bit, with most images *Vibrance* will be the better choice as it avoids oversaturating colors that are quite saturated already. It also adapts better to skin tones and does not saturate them too much.

However, most of the time you don't want to shift all colors of your image, only a certain color range. To this end, with Lightroom you should use the controls of the HSL/*Color*/*Grayscale* pane and not use the controls of *Presence*.

Clarity, introduced with LR 1.1, is a different affair. Clarity improves local contrast and midtone contrast. Most images benefit from some Clarity enhancement. To get an optimal impression of its effect, use a 1:1 zoom level and then switch back to *Fit*. The easiest way to describe it is to say: just try it, but don't overdo it. Pulling up Clarity too much may bring up some noise that was not visible before.

Figure 4-14: These three controls will all influence your colors. Clarity is new with LR 1.1, enhancing your local contrast (also called "micro-contrast").

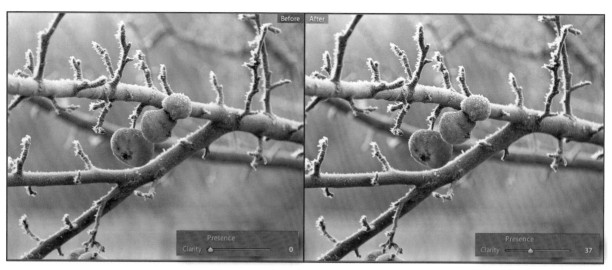

Figure 4-15: Before/After view of an image using "Clarity"

4.5 Tone Curve

If you've worked with Photoshop or similar image editors, Lightroom's *Tone Curve* might be a bit confusing at the beginning. It provides four controls, subdividing the tonal values of your images into four segments: *Highlights, Lights, Darks,* and *Shadows.* The tonal range that each of these controls covers, is not fixed but can be adjusted by shifting the separation line with the ⬦ sliders at the bottom of the diagram. There is a little bright belly around the curve (see Figure 4-16). It indicates the range in which the current slider can affect the curve and in which you control that curve segment.

Instead of using the sliders, you can also set your cursor on the curve and shift it up or down. Clicking on a point of the curve and then shifting that point using the arrow keys can achieve an even finer control.

At the bottom of the pane, you find a menu offering three different *Point Curve* presets. You can't add your own preset here (at least not without a hack

using ACR). If you want to save a specific Tone Curve setting, you can do so by saving it as a Develop preset, restricting the settings saved to *Tone Curve.* Having done that, you may then apply it to an image using your *Presets* browser.

There are actually two types of Tone Curves used in Lightroom:

▸ The parametric *Tone Curves* (new in Lightroom and ACR)
▸ The *Point Curves*

Point Curves were the only curves available in ACR prior to ACR 4.0. To keep ACR compatible with older versions, and also to provide more control

Figure 4-16: Lightroom's implementation of "Curves"

* See section 4.14 page 109 to see how this is done.

for expert users, ACR kept the old Point Curves and added the Parametric Tone Curves on top of it. With Lightroom, this implies that actually two sets of curves are merged into one final Tone Curve. While you can fully edit the Point Tone Curves in ACR 4.x, there is no way to edit them in Lightroom. But if you created a custom Point Tone Curve for your image in ACR and import the XMP settings of this image into Lightroom, the Point Curve drop-down menu shows this Point Curve with the name "Custom".

For some control panes, and Tone Curve is one of them, the pane text will change when Alt/⌐ is held down. With Point Curve, *Region* will change over to Reset Region . When you click on it, the curve will be reset to the standard curve.*

** This can is faster than resetting each control of this pane one by one.*

Target Adjustment Tool (TAT)

The *Tone Curve* pane also provides a *Target Adjustment tool* (TA tool for short). The principle of this tool is simple and still almost ingenious, very intuitive at least. Here is how it works:

Target Adjustment tool off (left) and on (right)

First activate the *Target Adjustment tool* by clicking on the ⊚ icon. Moving your mouse into the content window, the cursor will take on the shape of ⊹⊚.

Next, select a point in an area of the image where you want to change the tonal values. This is your reference point. Dragging your mouse up** will brighten the tonal values of image points so they're similar to the tonal value of the reference point. Dragging the mouse downward will darken this tonal range. Simultaneously, the sliders of the Tone Curve shift according to your mouse movement and the curve is updated too.

** With the left mouse button held down*

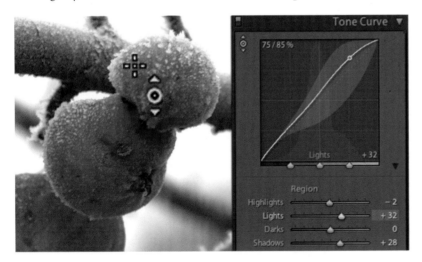

Figure 4-17:
Here, Tone Curve Target Adjustment tool is activated and the cursor is visible in this cutout of the image.

Using the TA tool for a short while turns out to be efficient and intuitive. We use this type of correction often. Though not available for all panes and settings, similar TA tools are also available for the *HSL/Color/Grayscale* pane and we use it quite frequently for fine-tuning grayscale images.

After fine-tuning the Tone Curve don't forget to disable the Target Adjust tool (click on ⊙ a second time); otherwise, you may get surprising effects when working with the controls of other panes.

4.6 Color Corrections Using the HSL Pane

When optimizing images, the next step is often fine-tuning your colors using the controls of the HSL pane (see Figure 4-18).

Why only now? It's because *Tone Curve* can change your contrast and this can change colors too. Often an S-shaped curve adds some saturation to your midtone colors, which may or may not be desired. As shown in Figure 4-18, your *HSL* pane actually offers two very different modes:

a) Choosing between *Color* and *Grayscale* (a black-and-white version of your image). If you click *Grayscale*, the image will automatically be converted to black-and-white. (Technically, however, it is still a RGB image.) Clicking on *Color* (or *HSL*) brings it back to color.

b) Working on a color version of your image, your *HSL* pane allows you to control *Hue*, *Saturation,* and *Luminance* (brightness). Therefore, the controls are grouped according to these color parameters. There are eight controls each which allows for very fine selective corrections.

If you have a small screen, e.g., working on a laptop, you may prefer to see only one of these sections. Click on *Hue*, *Saturation,* or *Luminance*, whatever you want to change first. Instead of using the individual controls, however, we make use of the Target Adjustment tool in many cases (as described on the previous page).

For this, click on the ⊙ icon of the corresponding control block and move the cursor on an area you want to change. Set your reference point to brighten or darken those colors (with *Luminance*) or to increase or decrease saturation or to fine-tune color hues with the *Hue* TAT. This is much more intuitive and faster than guessing which color slider is the right one for a specific image color range that you want to improve.

Usually, we start with *Luminance*. If, for instance, you want to darken the sky a bit to show bright clouds more clearly, set your reference point in the blue sky and reduce luminance. The sky will darken, intensifying the blue of the sky. White clouds will stand out more, as illustrated in Figures 4-19a and 4-19b.

With skies, our next step is usually to desaturate the blue of the sky a bit in order to get away from those awful postcard-like cyan skies, moving it more toward gray.

This, naturally, is a matter of personal taste. This partially improves the cloud drawing even more and creates a more dramatic sky, as illustrated in Figure 4-19c. Additionally, we slightly increased the reds of the sandstone bricks.

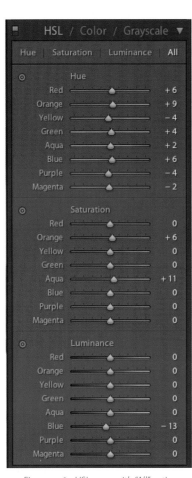

Figure 4-18: HSL pane with "All" active

Figure 4-19a: Cutout of the original image

Figure 4-19b: Here we decreased the luminance of the sky.

Only in a third step (with skies), might we also tune the hue. Most often it is not really needed.

These corrections to a great extent depend on the image, on what you want to achieve and to express.

The HSL pane with all its controls is also well suited to correct skin tones, at least for many shots, without changing too much of other color values (see Figure 4-20).

Because the correction is global to the entire image, other color maybe affected. Still, we would give the skin tone a clear priority.

Figure 4-19c: Saturation of the sky reduced, saturation of reds increased

This HSL pane with its various controls is a really powerful tool, and we make very frequent use of it when doing all our fine-tuning in Lightroom. As with other corrections, however, keep an eye on your clipping control in your histogram.

Figure 4-20a: Initial photo. The facial skin is a bit too red for our liking.

Figure 4-20b: Facial skin corrected. I reduced the saturation of reds a bit and slightly shifted the hue.

Figure 4-21: Lightroom's version of the Channel mixer

4.7　Grayscale – Converting to Black-and-White

Black-and-white images have a special kind of charm, often achieving stronger abstraction than color images. Converting to black and white is a standard feature in many image editors. Also Lightroom supports this kind of conversion. Black-and-white conversion can be done in many different ways, e.g., desaturating your image using the *Saturation* or *Vibrance* control in the *Basic* pane. Clearly the best way is to use the dedicated Grayscale Mixer that is part of the *HSL/Color/Grayscale* pane. Click *Grayscale* and the Grayscale Mixer opens.

At a first glance, these eight controls can look confusing. However, they allow you to fine-tune your tonality. But there are also two big helper functions available.

a) *Auto Adjust* does a nice job and gives you a good starting point for further fine-tuning.

b) As with HSL, there is also a Target Adjustment tool ⊙ for *Grayscale*. For many images, we use TAT to fine-tune our photos, selectively brightening or darkening tonal values related to the underlying color hues.

*The same is true of the Channel Mixer in Photoshop.

In Lightroom, a grayscale conversion still keeps the image in RGB.* This can be helpful because it allows you to do color-specific corrections in your grayscale image by brightening or darkening specific color areas of your underlying color image.

Figure 4-22a: Original image

Figure 4-22b: Black-and-white version using LR Grayscale function.

For instance, you can set the reference point of your Target Adjustment tool on a spot that initially was green and increase its luminance, hereby achieving an infrared-like appearance, or you can darken blue clouds to achieve a darker and more dramatic sky.

After performing a black-and-white conversion, you may have to go back and do some more fine-tuning using the *Basic* pane because the black-and-white conversion changes the tonality of the image.*

* See section 4.4.

Working on an RGB image also allows you to tone your image, e.g., using the controls of the *Split Toning* pane described in the next section. If you really want to convert an image to grayscale mode (as offered by Photoshop), you have to do this conversion outside of Lightroom, e.g., using Photoshop. Though not mentioned in its specs, Lightroom does support images in grayscale mode (but **not** bitonal images);* not all corrections support this color mode though. If you open your HSL pane with a real grayscale image, the following message will appear:

While, until recently, Lightroom was our tool of choice for black-and-white conversion, LightZone, starting with version 2,3, provides a black-and-white conversion, that we often prefer to Lightroom's. Therefore, we frequently export images to LightZone to carry out the black-and-white conversion and to do some more fine-tuning as well.** LightZone, too, will keep the black-and-white image in RGB mode.

** See also Uwe's paper on this at [31]. In section 8.4 you will find another example of an editing session in LightZone.

4.8 Split Toning

Split Toning allows you to correct your toning, hue as well as saturation separately, for highlights and shadows. Its main use is for toning black-and-white images (see Figure 4-24). We are referring to RGB images, converted to black-and-white in Lightroom.

Figure 4-23: The four controls of the Split Toning panel

When you use the *Split Toning* controls on a true grayscale image (e.g., imported as such), Lightroom will automatically convert it back to RGB mode and tone it.

Figure 4-24: Split Toning (actually toning), applied to the image of Figure 4-22b. The settings we used you see in Figure 4-23.

Split Toning can also be (mis)used to reduce the blue cast of your shadows, while in the highlights you may prefer to shift your colors to somewhat colder ones. A *Balance* control allows defining where shadows end and highlights start.

Note that you have to start with the *Saturation* control because, when *Saturation* is set to zero, no effect is achieved at all. We begin by setting *Saturation* to about 10%, then use *Hue,* and finally go back to *Saturation*. When you hold down Alt/⌥, Lightroom will temporarily apply full saturation. This allows you to see which areas will be toned.

4.9 Sharpening and Noise Reduction

* You will find more on this process in section 1.1.

While JPEG files coming from the camera are already sharpened in general, RAW images will be a bit soft due to the demosaicing process that is part of RAW conversion.* Therefore, a bit of sharpening is required in order to compensate for this effect. This is the reason, Lightroom does some sharpening by default. How much additional sharpening is required and in what way very much depends on your image and on your personal taste.

We are talking about general sharpening that may be required independent of your output method. Printing on an inkjet printer will introduce some more fuzziness (even more with offset printing) caused by dithering. If you're preparing images for printing, your sharpening can be a bit stronger. If, however, you print from Lightroom, this additional sharpening should be done as part of the printing process, as will be discussed in Chapter 6.

If, however, we optimize images in Photoshop or LightZone (or any other external application) and plan to do sharpening there, we do not do any sharpening in Lightroom at all.

So, here let us stick to *general* sharpening (or *basic* sharpening). You will find the controls for sharpening in the *Details* pane (see Figure 4-25). If you see a ⚠ in that pane, Lightroom reminds you that you should use a zoom level of 100% (1:1), to properly see the effect of your settings. This applies to sharpening as well as noise reduction!

There is a general rule for sharpening: Don't sharpen too much. It's too easy to bust an image by sharpening. You get halos and other kinds of artifacts if you sharpen incorrectly or too much. Actually, good sharpening is an art, and there are many sharpening plug-ins out there on the market for Photoshop.

Let's see what Lightroom can do for you with sharpening. Because Lightroom works nondestructively you can change your sharpening settings without any loss of quality!

While sharpening was quite restricted in LR 1.0, it improved quite a bit with Lightroom 1.1. Before starting with sharpening, first switch to a zoom level of 1:1 (100%) or more. Center your preview on an area with fine details; it's there that you want your sharpening to take effect. Only this allows the correct assessment of the results. Sharpening (like ACR 4.2) has four controls:

▸ *Amount*
▸ *Radius*
▸ *Detail*
▸ *Masking*

First, if *Amount* is set to zero, Lightroom does no sharpening at all. *Amount* and *Radius* work similarly to those of USM (*Unsharp Mask*) in Photoshop. Stay at a moderate level for *Radius* (0.8–1.0 is a good starting point) and keep *Amount* at a level at which your image does not look over-sharpened

(you need to use at least a 100% (1:1) magnification in Lightroom to judge sharpening results).

In some way, the *Detail* slider modifies the result. First let's mention halos. If sharpening creates halos (mainly the bright ones), this is good and bad. Good because it provides a stronger sharpening result; bad if you can see the halos on larger prints. If you set *Detail* to 100, you will potentially get quite strong halos, while a value of 0 suppresses them very well. We tend to use a very low *Detail* value (below 10–20) or even opt for 0, depending on the image.

The effect of the Detail slider is illustrated in Figures 4-26a to 4-26c. While Figure 4-26a shows no halos, the image in Figure 4-26b already shows strong halos (*Details* set to 50), and the image is actually busted due to halos in Figure 4-26c, where *Detail* is set to 100.

Figure 4-26a:
We start with a moderate sharpening "Amount" and a Radius setting of 1.0. Here "Detail" is set to 0. No halos are visible.

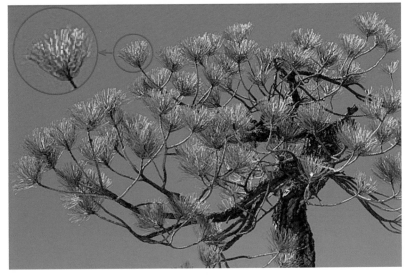

Figure 4-26b:
We increased "Detail" to 50. Strong halos appear.

Figure 4-26c:
"Detail" set to 100.
Here, the halos are horrible.

If you press the Alt/⌥ key while tuning the *Amount*, *Radius*, or *Detail* slider, Lightroom will show a grayscale preview that, in most cases, allows for a

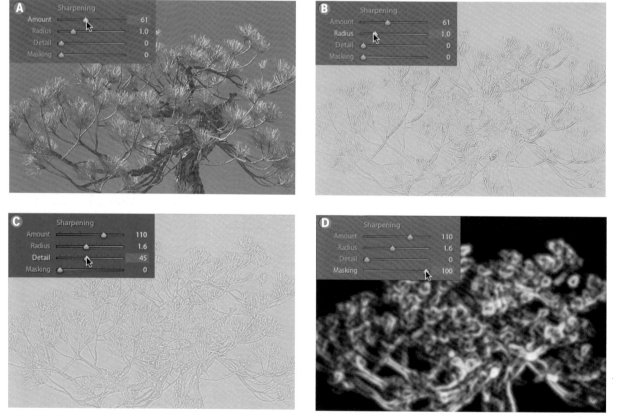

Figure 4-27. Lightroom will show a grayscale preview when you press Alt/⌥ while adjusting the sharpening sliders. The kind of preview depends on the slider you use.

better assessment of the sharpening effect. What actually is shown depends on the slider you use. With *Amount*, the image is shown in grayscale (see Figure 4-27 Ⓐ). With *Radius*, Lightroom will show a mask that allows you to judge the width of the radius (see Figure 4-27 Ⓑ). Adjusting Detail and pressing Alt/⌥ will also show a mask indicating which areas will be sharpened (see Figure 4-27 Ⓒ).

Masking creates a so-called *edge mask*. This mask restricts sharpening to edges only which helps to avoid sharpening skies and other smooth areas in the image. It's probably a good strategy to use quite a strong edge mask and then increase *Amount* and even *Radius*. You can even view the edge masks in Lightroom by holding down Alt (Mac: ⌥) while working with the *Mask* slider. All areas that are black in that mask are protected from sharpening;* with gray areas, some sharpening will occur. Using a strong mask, you can increase *Details* a bit. (But according to our experience, you should not go beyond 20).

** See Figure 4-27 Ⓓ

Once you have found your favorite sharpening settings for your images (depending on camera, ISO, and subject matter), create a new Develop preset to reuse these settings in the future.** It can make a lot of sense to spend some time to find your preferred settings because quality presets can make your life much easier when you're working on future images.

** As described on page 105.

Noise Reduction

If you have shot with film, you know that the film grain limits the final resolution you can archive. However, the noise in digital images looks a little bit different, unfortunately, worse. There are two kinds of noise: *luminance* noise and *color* noise. How much noise you will encounter in your image depends on several factors:

Figure 4-28: "Noise Reduction" includes luminance noise and color noise.

▸ The camera (sensor) you use. The smaller the sensor, the more noise you will potentially get. Newer cameras tend to have less noise (compared to older ones at the same sensor size and the same resolution).

▸ The ISO setting used for the shot. The higher the ISO value, the more noise will appear. It is always best to use as low an ISO value as possible. On the other hand, a noisy image can look much better than a blurred one caused by camera shake.

▸ Your image. Shadows show more noise than bright areas.

▸ Your image processing. Pulling up dark areas, e.g., using *Fill Light*, will make noise more visible in these areas.

With some shots, a bit of noise is absolutely acceptable, e.g., with available light shots. We are used to this from highly sensitive film. With other photos, noise can be rather annoying. It is a matter of taste. Don't get too obsessed about low noise. Some noise won't even show in most prints.

When you start reducing noise, the first step is to use a zoom level of 1:1; each pixel of the image is displayed on your screen. With noise reduction,

a zoom level of 2:1 may be even better. Focus on areas with disturbing noise, but also watch the rest of your image by frequently zooming out again. Reducing noise is quite easy if fine details are of no concern. Noise reduction is always an act of balancing noise against fine details!

Correct slowly because the update of the preview may take time. When adjusting these controls, be patient or you may tend to overcorrect!

Figure 4-29a: A typical "available light" shot taken by using a flash (Nikon D200 using ISO 3200) shows strong noise.

Figure 4-29b: Image with noise reduction applied (using Luminance +93, Color +75). Be patient, the update will take some time!

As with sharpening, if we intend to do fine-tuning outside of Lightroom, we refrain from doing noise reduction in Lightroom at all and do it in Photoshop, using a plug-in like *Noise Ninja* or *NoiseWare*, because we like their results sometimes better than those of the Photoshop filter and that of Lightroom.*

Nevertheless, you should only do noise removal if noise is really a problem on screen – with a standard viewing distance – or in you print. Frequently, we do not perform any *luminance* smoothing at all, while a certain level of *color* noise removal is an essential part of any RAW conversion.

* There are a whole lot more noise removal plug-ins for Photoshop out there on the market; these two are reasonably priced, however, and we like their results.

4.10 The Lens Corrections Panel

There are some flaws, caused by imperfections of your lens (often stronger with zoom lenses), which you can correct in Lightroom. Even good, expensive lenses may show these flaws to some extent. There are four kinds of flaws:

▶ Chromatic aberrations
▶ Fringing (also a fault of sensors)
▶ Vignetting
▶ Lens distortions

Figure 3-30: Lens corrections offered by LR

Lightroom can only deal with the first three. Again, as with noise reduction and sharpening, a ⚠, displayed in the *Lens Corrections* panel, will warn that you should do this correction using a zoom level of 1:1 (or larger). This applies to *Chromatic Aberrations* as well as *Defringing*.

Chromatic Aberrations (CA)

The refraction of light in glass is influenced by the wavelength of the light and the distance traversed in glass. This leads to the fact that different colors traversing normal lens glass do not focus at the same point. Special lens constructions can reduce this effect, but often not completely. Therefore, some fringing, red/cyan or blue/yellow colored seams at higher contrast edges, can be visible in your image. They are more obvious with edges of strong contrast and usually stronger farther away from the center of your image. Chromatic aberrations are stronger with wide-angle lenses (see Figure 4-32) than with standard or telephoto lenses.

Figure 3-31: *Lens corrections offered by LR*

Lightroom allows the reduction of these aberrations. Both controls, *Red/Cyan* and *Blue/Yellow*, help in the correction. If your image shows annoying aberrations, zoom in to such an area – at least to a 1:1 level, more might still be better.

The corrections here are a compromise because having strong aberrations, you can correct either the red/cyan fringes or the blue/yellow ones, but most often not both. Therefore, several trials may be necessary until you find an optimum result. For CA corrections, Lightroom will slightly scale the appropriate color channel of the image. When you hold down the ⎇/⌥ key when working with your AC sliders, Lightroom will show a more neutral color image in which the color fringes are easier to detect.

→ *Chromatic aberrations can often be reduced considerably by stepping down your aperture – or by using (mostly more expensive) lenses with less aberration.*

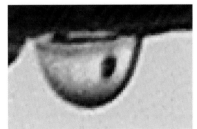

Figure 4-32: *When you use a wide-angle lens or a zoom lens at a short focus length, aberrations may be visible, as illustrated by the upper cutout. With the lower cutout we reduced this using Lightroom's CA tools.*

Defringe

There is another artifact effect resulting in some fringes at edges in some photos. These can be corrected, to some extent, choosing either *Highlight Edges* or *All Edges* from the *Defringe* menu.

Some cameras – actually caused by the sensor – can show fringing (we often find purple fringing) at high contrast edges (e.g., specular highlights in chrome or water surf). In these cases, the sensor data from one pixel is leaking into neighboring pixels. The result is quite annoying, as illustrated in Figure 4-33.

Lightroom now has an additional Defringe tool to remove or at least minimize these artifacts. There are three options:

▸ *Off* – Nothing is done.

▸ *Highlight Edges* – corrections are performed only for highlight edges (specular highlights).

▸ *All Edges* – This option will even try to find fringing at other less bright edges. Be careful when using this option because it may remove too much color at all edges.

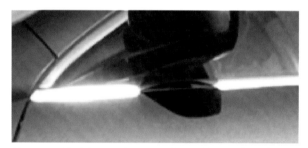

Figure 4-33: The left image (a section of the total image) shows fringing. This was corrected using Lightroom's Defringe tool (set to "Highlight Edges").

Vignetting

Vignetting describes the darkening of an image's corners in a photo. We rarely encounter this problem in our shots, but vignetting can occur both with wide-angle lenses at open aperture (see Figure 4-35) and in some flash photos. (We exaggerated the effect in this photo for demonstration purposes; the real image had only minor vignetting.) Vignetting will be most visible in homogeneous areas – blue sky, for instance.

As with the chromatic aberrations, with most high-quality lenses, stepping down your aperture one or two steps will reduce vignetting to a barely visible level.

Correcting vignetting is quite easy – as long as it occurs symmetrically. The *Midpoint* setting for this tool defines how far from the middle of your image the vignetting correction should start. However, in some cases, this approach may not be enough, because some lenses display asymmetrical

Figure 4-34: Vignetting provides only two controls. With the Midpoint slider, you define where the correction should start. A negative Amount value will darken your corner areas.

vignetting. In this case, you will have to use an external editor and do some selective dodging there (or use layer masks).

Figure 4-35a: This shot, captured using a wide-angle lens, shows vignetting – the corners are darker than the rest.

Figure 4-35b: Here, vignetting is reduced and no longer visible.

Deliberate vignetting can be used to add a creative touch to your image. By slightly darkening the outer border of your photo, you can focus your viewer on the center of the frame. For this, use a negative value for *Amount*. However, because of this circular darkening, we usually prefer to use a darker frame produced in Photoshop or LightZone.

For this correction, you should use a zoom level that allows you to see the whole image (e.g., *Fit*). Additionally, it might be useful to use Lightroom's "Lights out" modes. Press ⌃L⌄ repeatedly, until the screen environment is right.

Lens Distortions

Up to now, Lightroom allows neither the correction of lens distortions nor perspective distortions. Shooting at different focal length, you may eventually see a slight barrel or pincushion distortion, especially with zoom lenses at their extreme focal positions. For such corrections, as well as for the correction of perspective distortions, you will have to use an external editor like Photoshop. With Photoshop (since CS2), you can do the corrections using Filter ▸ Distort ▸ Lens Correction.

These flaws may be still better corrected by using special Photoshop plug-ins like profile-based tools such as *PTLens* ([38] Windows) or *LensFix* ([39] Mac *OS X*). These plug-ins read the camera type and the lens type as well as the focal length used from the EXIF data of the image. Additionally, they access a camera+lens-specific profile from a database (if available). Based on this information, both plug-ins (or stand-alone applications) correct distortions. All this is done automatically.

* *PTlens: http://epaperpress.com/ptlens/*
LensFix: www.kekus.com

4.11 The Camera Calibration Panel

Camera Calibration is identical to that in Adobe Camera Raw. As a general rule, it should be used for camera-specific corrections and not for image-specific color tuning. When using *Camera Calibration*, you should save the settings as a preset and apply it to images shot with that specific camera on *Import.*

* See the Import dialog (Figure 3-6, page 51). Use the "Develop Settings" menu ⓖ to select this preset.

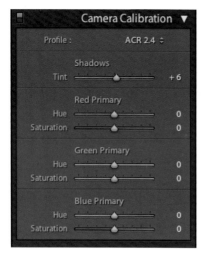

Figure 4-36 We almost exclusively use these controls to do some camera-specific corrections, but not for color tuning.

* See www.fors.net/chromoholics/.

Deviating from this recommendation, you may use these controls to do some kind of cross-development, achieving quite exotic image colors as may be seen in Figure 4-37. However, it is better to perform this development using the HSL pane. There, Lightroom provides the TA tool that is not available with *Camera Calibration*.

While Lightroom (being based on the same core image engine as ACR) does not allow for custom ICC camera profiles, you can do some simple camera profiling using a Gretag MacBeth/X-Rite ColorChecker as target. (See Figure 4-11, page 84, for a screen shot of *ColorChecker*.)

The result can then be applied using the *Camera Calibration* controls. These data should be saved as a Develop preset and can be applied on Import as mentioned. Often, it only makes sense when shooting with well-controlled, stable lighting, which can often only be achieved in a photo studio.

Thomas Fors provides a script to calibrate your camera using a X-rite ColorChecker and a Photoshop script: You shoot a photo of the Color-Checker, process this image in Adobe Camera Raw, open it in Photoshop, and then run the script. The results are copied into the Camera Calibration settings and saved as a preset. This preset can also be used with Lightroom. All this is well documented at Fors's website.* You can also download the script from that website.

Figure 4-37a: Original image

Figure 4-37b: Strong color effect, done with Camera Calibration controls (Red Primary: Hue -26, Saturation -57)

4.12 The Tools of the Toolbar

Some of the tools for image adjustments are not placed in Parameter panels but in the Toolbar of the Develop module.* You will find tools for cropping and image alignment 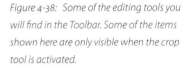, *Remove Red Eye* 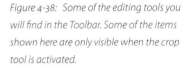 and the *Remove Spots* tool 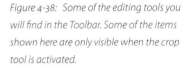. Additionally, two icons allow switching between *Loupe view* 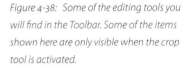 and *Before/After view* 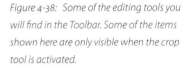.

* If the Toolbar is not visible, use [T] to show it.

Figure 4-38: Some of the editing tools you will find in the Toolbar. Some of the items shown here are only visible when the crop tool is activated.

Cropping and Straightening

There is actually not much to say about the *Crop* tool . It allows you to crop your image – naturally, nondestructively, allowing you to go back any time. When you export the image or call up an external editor, however, the crop will be rendered into the image. This tool also allows you to straighten your image. For both, you have to activate the tool explicitly.

You can either crop unrestrictedly or use a specific aspect ratio for cropping. For a fixed aspect ratio, click on the lock icon and it will change from 🔓 to 🔒. Then select the ratio from the *Aspect* drop-down menu. If nothing suits you, use *Edit Custom* to define a new aspect ratio. Click on 🔒 once more to go back to free cropping.

When the crop tool is activated, you can either drag the outer edges of your image in order to crop it or draw up a cropping rectangle. With the latter, the mouse cursor will change to ⬛ . After your crop is shown, you are free to move the cutout over the original image with your mouse (shaped as 🖐).

[Esc] terminates the cropping, and the updated preview shows the resulting crop only. Clicking the *Reset* button undoes all cropping.

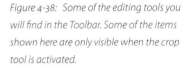

| Custom |
| Original |
| ✓ 1 x 1 |
| 2 x 3 |
| 4 x 5 |
| 4 x 6 |
| 5 x 7 |
| 8 x 10 |
| 8,5 x 11 |
| Enter Custom... |

There is a general design rule stating that important image elements should not be located in the center of the image but preferably on the thirds border – horizontally or vertically (or both).

This becomes obvious in an image with sky. When the horizon lies center-line, the image often looks a bit uninspiring. For many images, it is better if the sky takes up either the upper two-thirds of the image or just one-third.

To assist when looking for an optimum crop, Lightroom therefore includes a 3 × 3 grid when you adjust your crop (see Figure 4-39).

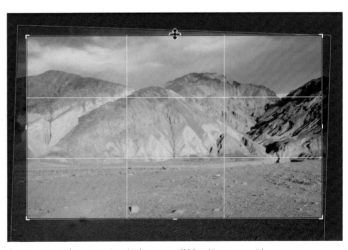

Figure 4-39: When cropping, Lightroom will blend in a 3 x 3 grid.

Lightroom offers two ways of straightening your image. For both, you have to activate the crop tool.

For the first way, zoom to a level where the whole image is visible with some spare room around it. Having activated the crop tool, move your cursor just outside your image and close to a corner. The mouse cursor will take on a ⤹ shape. Dragging the mouse with the left key pressed will rotate your image clock- or counterclockwise, depending on the direction you drag. At the same time, Lightroom will adapt your crop to fit the image frame. Instead of dragging the mouse, you may use the *Straighten* control that will appear in your Toolbar (see sidebar). You can either move the slider or, in the input field, enter an angle by which the image has to be rotated.

The second way is by using the *Straighten* tool ▬.* Click on it. In the preview, use the mouse to draw a line along an edge that should be horizontal or vertical, e.g., your horizon. Lightroom straightens the image so that the resulting line will be horizontal/vertical in the corrected image.

Straighten – 4,55

** This, too, will show up in the Toolbar when cropping is activated.*

The Remove Spots Tool

The Remove Spots tool ◼ is our small darling. We recently had, for instance, a dust particle on the sensor of our Canon 5D. It reflected nastily in our photos (see Figure 4-40).

With Lightroom's Remove Spots tool, repairing this was easy. Click on ◼ to activate the tool. Then click on the area that you want to patch, e.g., a dust spot. Drag the upcoming green circle to the area from which you want to copy your patch (the source).

Figure 4-40: Patching a dust spot. The alignment is not yet correct with the image in the middle. There we drag the source a bit to the right until the alignment is correct.

To customize the size of your spot, move your cursor to the border of the circle, it will now be an ⊠, and drag the circle smaller or larger. Another way is to use ⌐ to decrease or ⌐ to increase the spot size. Yet another way is to use the *Spot Size* control that will appear in the Toolbar. The spot has to be selected for resizing, any way you do it.

The correction can be customized any time – you can change the position of the source as well as that of the destination, including the size of the spot. In order to move the source or the destination, move your cursor inside the corresponding circle. When your cursor changes to ⟨⟩, drag the circle to the new position.

You can do several of these corrections. The operation is terminated by ⎋. If you intend to delete all spot removal corrections of the image, click the *Reset* button. To delete just one of your corrections, move your cursor either onto the corresponding source or the destination spot and press ⎆Delete⎆.

➜ *Clicking the "Reset" button (at the right side of the Toolbar), will undo all "Remove Spots" corrections done in your current image.*

Don't forget to deactivate the tool after spotting is done. You may either use ⎋ for this or click on 🖉 once more. The corrected spots will stay; however, the circle markers will be hidden.

Lightroom offers two kind of spot tools: a *Clone* tool and a *Heal* tool. While the Clone tool applies the sampled area of the photo to the selected area, the Heal tool matches the texture, lighting, and shading of the sampled area to the selected area.

If you have dust on your camera sensor, it is very likely that all images of a shoot may show dust spots and they are most likely to be all in the same place. Retouching all individual images is tedious work. With Lightroom, it can be less painful if you copy the correction from one image to the other images of the same session showing the same dust spots.[*] In this case, you only copy the *Remove Spots* settings.

* *As described in Chapter 4.14 on page 109.*

The correction may not be an optimal fit for all images. Because the source spot is not suited for the destination, for some photos some manual adaptations of your corrections may be necessary. Nevertheless, this process can simplify the corrections of dust spots in a series of shots considerably.

Even small dust spots can interfere in the printed image considerably. In a standard image view, small spots may be hard to recognize. Therefore, you should scrutinize your image (e.g., before doing a costly print) using a large zoom factor. Inspect the image from the left top corner down to the right bottom one. If you are in Loupe view, the Page up and Page down keys of your keyboard will help with your inspection. The ⎆Home⎆ or ⎆↑⎆ key will set the visible section of preview to the upper-left corner of your current image, the ⎆↓⎆ or ⎆End⎆ key to the lower-right one. The ⎆Page down⎆ key shifts down your visible section just below the previous location. When it reaches the bottom, it will shift the section back to the top of the next column. The ⎆Page up⎆ key will do it the other way round. Thus, these keys allow for a very careful yet fast inspection path using a zoom view.

Figure 4-41: Your arrow keys will guide your close-up view (in Loupe view) systematically across your image.

The Remove Red Eye Tool

Most of you know how red-eye originates. Using a flash that is integrated into the camera, you can hardly avoid this effect when shooting somebody from a frontal position. Nowadays, practically all image editors offer a tool to remove red eyes, so does Lightroom. As there is no other tool in Lightroom to desaturate red eyes without desaturating the rest of the image, this tool might be useful for some shots.

Zoom to 1:1 or greater and activate . Then set the mouse cursor on the center of the red eye and drag outward until the cursor covers the eye (or is even a bit larger).* If you release your left mouse button or click your mouse, Lightroom desaturates the eye. You have to repeat this process for each eye that needs it. Carefully adjust your cursor to the shape of the eye each time you do this. The amount you want to darken the eye (the amount of desaturation) can be controlled by the *Darken* slider that is visible when this tool is active. Additionally, another slider to control the hue of the replacement would be desirable.

The correction, by the way, only works with red eyes, not with yellow ones, which can appear with animals when using a flash.

Sometimes, if the eye you want to correct is only a light red, Lightroom will refuse to correct it. If another eye is a darker red (and LR is willing to correct it), first correct this eye.** Using the mouse, drag that correction over the other eye (where Lightroom refused to do its job) and do the correction this way.

The user interface changed a bit from LR version 1.0 to version 1.1 (but no additional change was made for version 1.2). The handling is somewhat better now.

** *If the eye is too dark (red) for LR to correct it, temporarily increase the brightness of the image, e.g., using Exposure, correct the red eye, and finally set the brightness to its previous state.*

Figure 4-42a: Typical image, with a frontal flash, resulting in red eyes

Figure 4-42b: Same image after applying the "Remove Read Eye" tool

To delete a correction, simply select the patch circle and press `Delete`. Clicking the *Reset* button will remove all red eye corrections in your current image. The size and position of the individual corrections can be adapted the same way you do it using the spot removal tool (described earlier). Don't forget to disable this tool when you are finished.

4.13 History and Snapshots

Mark Hamburg, the chief architect of Lightroom, introduced in Photoshop 5.0 the best undo mechanism we know. What he implemented was the Photoshop History panel, which easily allows undoing your recent editing steps. We are happy he carried this feature over to Lightroom as well. However, while in Photoshop you lose your history when you save and close an image, the history is saved if you close a Lightroom session.

The *History* pane is part of the Navigation panel. It lists all the editing steps you did on an image (see Figure 4-43), showing the operations you performed, the number of steps the value was changed, and the new value of the slider. If you roll your cursor over a list item, the *Navigator* preview will show the editing stage of the image at that point of editing (history state). If you click on the item, the state at that point of editing in history is applied, but you can still go up or down in your history list. Only when you do some more new editing, all steps newer than your last item selected will be removed and are lost.

Because your history list will be embedded in the XMP metadata of your image, it increases the size of the metadata slightly. Therefore, Lightroom allows you to clear the list (click on *Clear* Ⓐ).

The same way you can undo your recent editing steps with Photoshop, you can undo them with Lightroom using ⌈Ctrl⌉-⌈Z⌉ (Mac: ⌈⌘⌉-⌈Z⌉). This can be repeated until you reach the bottom of your history list. ⌈Ctrl⌉-⌈⇧⌉-⌈Z⌉ (Mac: ⌈⌘⌉-⌈⇧⌉-⌈Z⌉) will restore the steps just deleted, thus moving up the list again. If you carry out a number of undos and quit Lightroom, the history items beyond (upward from) this state will be lost. To preserve a specific history state, use snapshots.

Figure 4-43: The History pane shows all your editing steps. You can go back to a specific state by clicking the list item.

Snapshots

Snapshots allow the preservation of a specific editing state of an image and work well in conjunction with the History panel. To freeze the current state, click on the ▣ icon in the Snapshots panel. Give it a brief but descriptive name, and keep in mind that snapshots will not be listed sequentially (by time or state) but alphabetically. Instead of freezing the current editing state, you can select an item of the history list and then click the ▣ icon in the Snapshots panel to freeze that state into a snapshot.

As with the History list, your Navigator preview shows the image of the snapshot state if you roll your cursor over the items in the snapshots list. Clicking on a snapshot item reapplies the settings of that snapshot state to the image. This allows the production of image variations starting with that snapshot.

Your Snapshots list, by default, has one item at least: *Import.* This is the state of the image without any editing done (at the time it was imported, returned from an external editor).* To delete a snapshot, select it and click the ▬ icon (or use the right-click context menu).

Figure 4-44: Snapshots allow you to freeze a specific editing state of an image and recall it later on.

* *The "Import" snapshot applies to the state of the Master photo at the time of import.*

Figure 4-45: The switch allows you to temporarily deactivate the effect of the controls.

Deactivating Corrections

Often, you would like to see the exact effect that a certain correction has on an image. Therefore, Lightroom allows you to disable a correction temporarily. Most corrections groups (panes) have a small activation/deactivation switch ■ at the top. Clicking on it will toggle the correction on and off ■. Lightroom updates your preview accordingly. This switch, however, applies to all the corrections located in that pane and not to individual sliders!

Before/After View

Compare view is not only available in *Library* mode, but also in *Develop*. In *Develop*, however, Lightroom will show a Before/After view. Clicking on Y|Y in the Toolbar or Y will activate this view (and toggle back to Loupe view when pressed a second time).

The Y|Y menu offers four different presentation forms (see the image to the left) for this view. Clicking the icon will toggle between them.

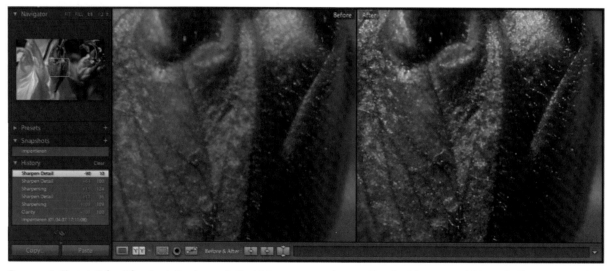

Figure 4-46: Photo in Before/After view in Develop mode. The left image was not sharpened but the right one was. Additionally, Clarity was turned up.

These views still allow zooming in and out. The zoom will apply for both parts of the view, and as in standard Loupe view, you can shift the visible part using your mouse or your ←, →, page-up and page-down keys. If any of these views is active, your Toolbar will show three new icons: ⬛⬛⬛. These allow the swapping of the settings of the two image states.

You may continue doing further corrections staying in this Before/After view.

Lightroom 1.2 now also allows the selection of a snapshot as your *Before* image.

4.14 **Presets Browser and Creating Presets**

Presets are a top feature of Lightroom. A preset is a named record of settings saved in a file. There are presets for Develop settings and for slideshow, print and Web gallery settings (and some more). When you install Lightroom, a number of presets are already predefined. You can delete presets, change presets and add your own. (However, you cannot delete or modify those original presets that come preinstalled with Lightroom.)

To make use of these presets, open your Navigation panel and expand the *Navigator* pane as well as the *Presets* pane. If you roll your cursor over a preset item (see Figure 4-47, Ⓐ), the *Navigator* preview will show the effect without actually applying the preset. Clicking on the preset will apply its settings to your active image. The preset applied will be highlighted in the *Presets* list (see Figure 4-47, Ⓑ). If several images are selected, the preset will be applied only to the active one. To apply the preset to all photos that are selected in your Filmstrip, you have to use *Sync* (as described in section 4.15 on page 110).

To save the current settings of your image as a preset, click on ➕ in the *Presets* panel (or use Ctrl/⌘-⇧-N). In the dialog that will appear, you define which settings of all of your settings will be part of this preset (see Figure 4-48). With Develop presets, in most cases you will only want to include a subset of all current settings. Give it a good descriptive name. Because you can create several versions of the same type of preset, improving it bit by bit, it's a good idea to append a version number to the name.

Figure 4-47: *The Presets browser will show the effect of a preset (here, A) in the Navigator's pane.*

New Develop Preset

Preset Name: B&W high-contrast.01

Folder: User Presets

Auto Settings

☐ Auto Tone ☐ Auto Grayscale Mix

Settings

☐ White Balance ☑ Treatment (Grayscale)

☐ Basic Tone ☑ Grayscale Mix
 ☐ Exposure
 ☐ Highlight Recovery ☐ Split Toning
 ☐ Fill Light
 ☐ Black Clipping ☐ Lens Corrections
 ☐ Brightness ☐ Chromatic Aberration
 ☐ Contrast ☐ Lens Vignetting

☑ Tone Curve ☐ Calibration

☑ Clarity

☐ Sharpening

☐ Noise Reduction

(Check All) (Check None) (Cancel) (Create)

Figure 4-48:
When saving your settings as a new preset, you have to define which settings will be included.

In version 1.0 of Lightroom, by default all presets were stored in the same folder (one for each type of preset), but since Lightroom version 1.1 Lightroom's standard presets and user-defined presets are stored in separate folders. This allows for better structuring of your presets. You can add more folders to enhance this basic structure.

To add a new folder, right-click in the Presets pane. The fly-out menu provides an item to create a new folder.

To delete a preset, right-click it in the Presets pane and choose *Delete* from the fly-out menu (or select it and click on the ■ icon in the head of the *Presets* pane). You can't delete any of Lightroom's basic presets this way.

Presets are not catalog-specific but are available independent of the catalog you use. To make a preset available to somebody else (or to transfer it to another system), Lightroom allows you to export it. For this, right-click the preset item and choose Export from the fly-out menu. The dialog that appears allows you to specify a new (external) name and a destination. There is no special Lightroom function to import an exported preset. You can do it, however, by simply placing the preset file in the Presets folder (as described in section 9.5)

4.15 Copying Correction Settings, Pasting, and Synchronizing

In *Library* and *Develop* mode, you can copy image settings from a selected image to Lightroom's clipboard. Use Settings ▸ Copy Settings for this. Lightroom will bring up a dialog that allows the definition of the settings to be copied (see Figure 4-49).

Figure 4-49:
The Copy Settings dialog.

From the clipboard, you can then paste these settings to another photo (or even several photos at the same time). To this end, select in your Filmstrip or in the matrix of your Grid view the target image for the settings and use Settings ▸ Paste Settings. Instead of using the menus, it is quicker to use keyboard shortcuts: ⇧-Ctrl-C (Mac: ⇧-⌘-C) to copy and ⇧-Ctrl-V (Windows: ⇧-⌘-V) to paste the settings.

If you use Settings ▸ Sync Settings, a dialog appears, similar to that of Figure 4-49, where you specify which settings (from your clipboard) should be applied to the target images.

You can not only copy and paste image settings, but also metadata.[*] For metadata, use ⇧-Ctrl-Alt-C (Mac: ⇧-⌥-⌘-C) to copy the data to Lightroom's clipboard and use ⇧-Ctrl-Alt-V (Mac: ⇧-⌥-⌘-V) to paste them from the Lightroom clipboard to your target images. When you copy, a dialog appears from which you choose the data items to be copied.

[] As described in section 3.5, page 70.*

Editing Presets

As mentioned, the easiest way to create presets is to do some corrections and save the settings as a new or modified preset. This way, however, some settings will not be possible. For instance, Lightroom does not allow you to freely manipulate *Curves* (the way you can do it in Photoshop and Adobe Camera Raw) – you can not invert it in Lightroom, for example. Therefore, you should do this in Adobe Camera Raw, then save an image with this inverted Curves setting in ACR, import it into Lightroom, and then save the setting as a new Lightroom preset. This way, for instance, you can get an inverted curve or some other unusual *Curves* setting into Lightroom. Another way of editing presets is shown in section 9.5, where we will explain how to edit a Develop preset directly using a text editor.

A frosty winter walk

The Slideshow Module

5

The slideshow is one of the presentation possibilities for images – either on a monitor or using a digital projector. Lightroom offers two kinds of slideshows:

1. *A kind of ad-hoc slideshow that you call up from any of Lightroom's modes by clicking the ▶ icon in the Toolbar or by* Ctrl*-*↵ *(Mac:* ⌘*-*↵*). Using this "Impromptu Slideshow" mode, the images of your current view – those visible in your Filmstrip or Grid view – will be shown in full-screen mode. Impromptu mode is a comfortable way of inspecting your images full-screen. However, it offers no further design features and does not allow saving the slideshow.*

2. *A slideshow that allows for a lot of display and other parameter settings (e.g., transition time and using a soundtrack). This form will be discussed in this chapter.*

You quit both slideshow modes by pressing Esc*.*

You can use Slideshow templates to define how the images are presented just with just a click on one of your templates. Alternatively, you can use your own settings or use a standard template set and modify it to your liking.

The slideshow can be started in a kind of preview mode. It is displayed in the central content window or in a full-screen mode. If you like your show, you can save it by exporting it as a PDF file that can be viewed on any system that has a PDF viewer installed (e.g., Acrobat Reader).

5.1 Preparing Your Images for a Slideshow

→ *With LR 1.2 you can also select the*
images that should go into the slideshow,
switch to Slideshow mode and use:
Web ▶ Which Photos ▶ Use Selected Photos.

When you change to the *Slideshow* Module and start a show, all photos of your current view will be included. So, in most cases it is better to first create a collection – either a Quick Collection or a named collection – containing the photos that are part of the show. This should be done in Library mode. Next, set your view to show that collection. Then – best still in Library Grid view – arrange your images in the way you want them to appear. Just grab the image with your cursor in your filmstrip or Grid matrix and drag it to the appropriate position. If you want to show a caption along with the images, edit your image captions* at this time.

** Editing image captions is described in*
section 3.4.

Now, that most of the work is done, switch over to Slideshow mode (e.g., using Ctrl-Alt-3 (Windows) or Ctrl-Alt-3 (Mac)). Figure 5-2 shows Lightroom in this mode.

5.2 Designing a Slideshow

Lightroom offers numerous settings for the design of your show:

▸ Placement of the slides on the display backdrop
▸ An Identity Plate as well as general and image specific information
▸ Color and structure of your backdrop
▸ Parameters that define how long each image shall be shown and how long the slide transitions should take

As with all Lightroom modules (with the exception of *Library*), Lightroom comes with a number of predefined templates for slideshows and you can add your own or modify existing ones. If your left Navigation panel is open and you roll your cursor over one of the templates, your preview window in that panel will show the style of that template. A click on the template will set the template's parameters to your current show.

Go to first slide Rotate text item
 Previous slide Add custom
 Next slide text

Start slideshow
(❚❚ = Pause slideshow)

Figure 5-1: Lightroom's direct media player
and its controls

Lightroom starts a preview show when you click the play button ▶ in the Toolbar. Activate the Toolbar with the T key if it's not yet visible. ■ will bring you back to the first slide (image), ➡ to the next image, and ⬅ to the previous slide of the show. While the show is active, a click on ❚❚ will pause the presentation. ABC allows you to add text to the slides. Enter your text in the opening text field. The text string entered here shows for all slides. If you want individual text for each slide, you have to use a text template that defines what kind of metadata should be included. Clicking on one of the ↳↵ symbols will not rotate the image but the additional text elements.

Stop the slideshow by Esc. The [Play] button (below the parameter pane in the left panel) starts the show in full-screen mode.

The controls for the design of your slideshow are grouped into five panes (see Figure 5-3).

Figure 5-2: Lightroom window when in Slideshow mode

They are *Options* which define how the images are placed inside the window, *Layout*, *Overlays* (additional information on the images), *Backdrop*, and *Playback*. Most of these settings are easy to understand, so we will only give a brief description and some recommendations.

Figure 5-3: The five panes of the slideshow creation

Options

In the *Options* pane (Figure 5-4), in most cases you want to deactivate the *Zoom to Fill Frame* option because it will probably introduce some cropping to fill the frame. If so, you can grab the image in your central preview panel and position the visible part to your liking. A small *stroke border*, usually a 1 to 4 pixel width is enough, will set off the image from the backdrop. You also can

Figure 5-4:

This pane holds the basic settings for the show.

define the color of this border by clicking on the color field. A color picker allows you to pick your border color.

Lightroom offers a rich set of different ways (palettes) to pick your color (see Figure 5-5). Whenever you are asked to choose a color for an element, you can use this set – not only for selecting the border color, but at many other places in Lightroom. Take your time to get acquainted with these options. Don't get confused – most of the time you can probably get along with just one of these pickers. First, select the kind of color picker you prefer by clicking the corresponding icon Ⓐ. Then, with some pickers, you can additionally select a color list or mode Ⓒ. Finally, choose your color using the sliders at Ⓓ or picking a color from the list or a color pane.

If you need several colors regularly, you can set up your own color palette (see Figure 5-5 Ⓔ). It will be visible at the bottom of the color picker dialogs. To add a color to your custom palette, just drag it with the mouse from the color field Ⓑ to the palette Ⓔ at the bottom of the dialog box.

Figure 5-5: There is a choice of different palettes to pick your colors – here we show just a few of them. First select a kind of color picker using the icons Ⓐ, then choose your color mode Ⓒ, and finally choose your color Ⓓ.

A slight *cast shadow* often adds some elegance to images and helps to frame them on the backdrop. Lightroom offers a lot of control: *Opacity, Offset, Radius,* and *Angle.*

Layout

The controls of the *Layout* pane (Figure 5-6) define how the image is placed on the backdrop frame. The optional guides help to adjust elements on the screen. They don't show up in the slideshow. Images often make a stronger impression if they have some free space (air) around them to "breathe".

Figure 5-6: Here, you define the position of the image inside the backdrop frame.

Overlays

This is a relatively complex set of controls (Figure 5-7) that can be ignored if you just want to show nothing but your images in the slideshow. With overlay elements, however, you can add additional information items to each slide. This includes an Identity Plate, a common text for all slides, or any information element that is taken from the metadata of the individual image, e.g., a caption, an image title, the filename, or a star rating. You can set the

color of these item groups and their opacity. With text elements, you can additionally set the font to be used. If you have set up several different identity plates, you can choose one for the slideshow from the ▼ drop-down menu (see Figure 5-7 Ⓐ).

Adding Text Info to the Slides

If you want to add a title to the slideshow that will appear on all slides, just click on the `ABC` icon and enter text in the opening field:

If, however, you want to add text to individual slides, you have to call up the *Text Template Editor*. You will find *Edit* in the *Custom Text* menu (*Custom Text* is visible only when you click `ABC` at least once). This will bring up a template editor (Figure 5-8), in which you define your template elements by entering text into the input field and by inserting metadata items that you select from one of the drop-down menus. You can use several items.

Figure 5-7: These controls allow you to add additional information items to the slides.

Figure 5-8:
Build up your metadata template by inserting those items you select from the drop-down menus. You may add text between the items.

When your template is complete and you intend to use this same set several times, save the template giving it a descriptive name. You'll find the *Save As* function in the *Preset* menu of the *Text Template Editor* (see Figure 5-8). From now on, this template will be listed in your *Custom Text* drop-down menu. You will find some simple templates already included with your Lightroom installation. To make your template effective, click *Done.*

Figure 5-9: You can select a text badge and drag it to a new position. Dragging at a corner allows you to size the text item.

As a result, one or more text badges will appear in your preview (see Figure 5-9). You can place and scale these info items by clicking on them and dragging them to a position you like. Lightroom will show you the anchor point of the item, and this anchor point may jump to a different edge when the item is dragged. The anchor point indicates relative to which edge the item will be placed on the slides. This may be relative to an image edge or a backdrop edge.

If you want to scale an item, just select it and drag at a corner of the selection. You can rotate an item using the ⤴ ⤵ icons on the Toolbar

All this allows you to control what additional information is included and where to place it. But keep in mind that it's overloading your slides.

Backdrop

The basic *Backdrop* settings (see Figure 5-10) are either a plain colored background or a color gradient (Ⓐ, called *Color Wash*). You can select the basic background color Ⓔ as well as the second color for the Color Wash (Ⓐ). Both colors are selected in a way previously described for the border color.

Additionally, you can add a background image Ⓓ. It has to be part of your current view (must currently be visible and thus be part of your Lightroom library). Just drag it from your Filmstrip onto this pane.

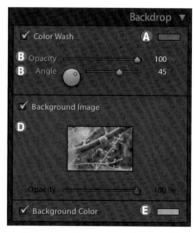

Figure 5-10: These controls let you add additional information items to the slides.

Often, when using a photo as a background image, you don't want the image itself to be part of the slideshow. In this case first drag it onto the Backdrop pane, then select all images but not the one for the background, and finally select Play ▸ Run Slideshow. This will prevent the background image from being a slide in your slideshow but it will still be used as the background image. Another method would be to flag all your images but the background image and set *your* filter to show only flagged images by activating the first flag icon (▣) in *Filters.*

Playback Controls

There are just a few, clear controls for playing back a slideshow. This indicates that up to now Lightroom only classifies as a simple slideshow program (which will still be plenty for most users). The basic parameters are the time frame in which each slide is displayed (see Figure 5-11 ©) and the time the slide transition will take to fade into the next slide.

When you're working on a multi-screen workstation, Lightroom will offer to choose the monitor the show will play on (Ⓑ). You can also choose to play the slides in a random order (Ⓔ). These duration settings will only be effective when the slideshow is called from Lightroom but not when it is exported as a PDF file. The same applies to the option *Random Order*, which will not be effective when showing a PDF slideshow.

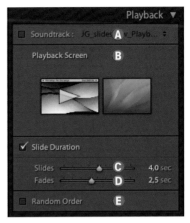

Figure 5-11: Playback controls

Adding a Soundtrack to Your Slideshow

You can also add a soundtrack to your slideshow. To do so, activate the *Soundtrack* option (see Figure 5-12 Ⓐ) and select the playback folder that holds your playback audio files. With Mac OS X, use iTunes to create that playback folder containing the playback list and arrange it in the order you prefer. With Windows, create a standard file folder where you place the MP3 music files in the order you want them to be played. If the slideshow runs longer than your playback list runs, Lightroom starts over at the beginning.

However, this will only give you very simple background music with no comfortable way to synchronize your music with slides and slide transitions. In addition, the soundtrack only works when the show is started directly from Lightroom; PDF files won't support the soundtrack.

If you need more sound control or more control on your slide transitions, you will have to export your images and resort to a more advanced digital slideshow program such as *Magix* [32] for Windows or Apple *Keynotes* for Mac OS X. *FotoMagico* (by Boinx [33]) runs with Windows as well as Mac OS X and is a high-end slideshow program. The features of FotoMagico are quite impressive.

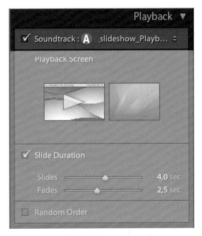

Figure 5-12: Playback controls with an active soundtrack attached

Magix: http://site.magix.net

FotoMagico: http://boinx.com/fotomagico/

However, most of these programs will need a separate player program that is usually free but may not be available for all computer platforms. There are a whole lot of other applications dedicated to generating slideshows not mentioned here. It would go beyond the scope of this book to cover them all. Though the capabilities of the Lightroom may seem a bit restricted, the slideshow feature is a free part of Lightroom and easy to handle – you don't even have to export your images. The slideshow feature is reasonably fast and capable of including selected metadata from your images. If some metadata is missing, just change over to Library mode and add them to your photos.

5.3 Exporting a Slideshow as a PDF File

With a click on the *Export* button below the Parameter panel (to the right), Lightroom will generate a PDF show file. In Lightroom version 1.2, PDF is the only supported export format. PDF, however, has the advantage that it can be played on almost all platforms easily because there are free Acrobat Reader versions for Windows, Linux, and Mac (OS X as well as OS 9) and some Acrobat viewers for most UNIX systems.

In the export dialog (see Figure 5-13), the name and destination folder as well as the quality should be set. All images of the slideshow will be exported as JPEG images using an Adobe RGB (1998) color space* (before they are imbedded into the PDF file).

** Adobe RGB will be used for RAW files. TIFF and JPEG files (and other formats) will retain their initial color space.*

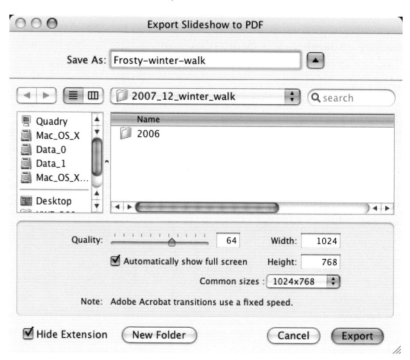

Figure 5-13:
Export dialog of Lightroom version 1.2

Most of the time, a *Quality* setting of 50 to 60 is good enough and yields considerable smaller PDF files than using a value of 100. A smaller quality factor may especially be useful if you intend to send your PDF files to friends or customers using e-mail.

Additionally, you can define the dimension of the images in pixels. Lightroom down-samples the images to this size. For an appealing presentation you should usually activate the *Automatically show full screen* option.

Clicking the *Export* button initiates the export. Depending on the number of images in your show and the size of the photos, it may take some time. Lightroom shows a progress bar on the top panel (if it is visible, see Figure 5-14).

Figure 5-14: While the export and PDF slideshow generation is running in the background, you see a progress bar.

Unfortunately, there is no way to save a slideshow as a Lightroom object. You must save it as a PDF document. We hope that Adobe will fix this in a future release. For the time being, if you intend to do some more work on your slideshow in the near future, you should save your set of images as a named collection and save your current settings as a slideshow template. Give this template the same name as your collection. This makes it easy to recall the collection at a later time and apply the corresponding template.

5.4 How to Modify Slideshow Templates

The easiest way to create a new slideshow template is to apply an existing template to a set of images. Then modify the settings and save them as a new template. But you can do even more, though it is somewhat more difficult, by editing a template directly using a text editor. We show the basics of a template in section 9.5, where we explain the anatomy of a Develop template.

To our knowledge, there is currently no official description of slideshow templates available from Adobe. Nevertheless, some tips on modifying and enhancing slideshow templates may be found at the website of *Oaktree Imaging* [21]. As these templates are XML-based text files, there is no harm in opening one – preferably a copy – using a Unicode-supporting text editor and snooping around in it to learn more on its anatomy and maybe even modify some parts. In section 9.5 we'll tell you where to find these templates.

Website of "Oaktree Imaging":
www.oaktree-imaging.com/knowledge/

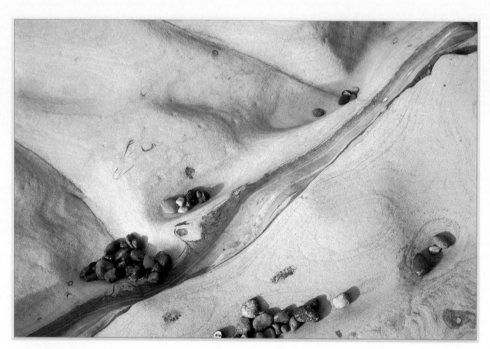

Print

6

*Presenting your photographs on-screen in a slideshow
is nice, and Web galleries are good for advertising, but
the ultimate goal for every demanding photographer is
a perfect print – either done on silver halide paper by a
photo service or, better still, by using a professional inkjet
printer, which offers full control of all parameters.*

*Producing professional prints requires some know-how.
You will find whole books on the subject – one of them
is ours: "Fine Art Printing for Photographers" [02]. That
book covers in detail how to choose a good inkjet fine art
printer, how to select the right papers and inks for fine art
prints, and how to get high-quality color profiles. It also
explains how to fine-tune your photos for printing and
how to set the numerous preferences in the printer driver
properly. The book also covers matting and framing prints.*

*That book targets Photoshop users. However, the
process described for Photoshop may also be applied
to Lightroom. In this book, we will provide a con-
densed version of the workflow for Lightroom.*

*Section 6.4 gives you some advice if you want to
send your photos to a printing or photo service.*

6.1 Preparing Your Prints

For optimal quality, you have to prepare your image for the special kind of output method you intend to use. The essential steps for the print output are as follows:

1. Choosing a suitable crop
2. Optimizing the tonality of the image for printing*
3. Scaling your image for the intended print size
4. Sharpening for printing
5. Placing your image in a pleasing way on the page

** You may need to take into account what kind of paper you use, e.g., matte or glossy.*

Lightroom will help with some of the tasks mentioned here (steps 3 to 5). If you want to do some simple printing, Lightroom can do almost everything automatically – as part of the print output. If however, you intend to do a portfolio print and want to achieve optimal results, you have to fine-tune the tonality of your image, probably do some test prints, retune your image, and undergo several iterations until the print is at its best.

For a portfolio print, it's best to start by producing a virtual copy and using that for cropping, fine-tuning the tonal values, and applying additional sharpening and maybe some local contrast enhancement. This may require using an external editor like Photoshop. Usually we group (stack) this new image together with the original photo and call it our "Master Image".

High-quality prints take time. You need to choose the right paper for your purpose, taste, and image subject, and set up all the printing parameters.

6.2 Lightroom Print Settings

Until quite recently, we considered Photoshop to be one of the best standard applications for printing. Nevertheless, we were often looking for more control when printing. To some extent, Lightroom fulfills these wishes. As you can see only partially in Figures 6-1 and 6-2, Lightroom provides numerous print parameter settings. These are split into four panes (see Figure 6-1).

The first three panes control the placement of the image (or images) on the page, while the *Print Job* pane contains the parameters for the actual print process. Additional preferences may be found using the *Page Setup*, and *Print Settings* buttons (see Figure 6.2).

In addition to all these settings, more parameters have to be set in the printer driver dialog, which is launched by the *Print* button. You have to carefully set these parameters to avoid time-consuming and costly misprints. We will guide you through this printing jungle.

As with most other Lightroom modules, you'll find a template browser on the left (if the Navigation panel is visible). It offers a number of predefined

Figure 6-1: Lightroom's print settings are grouped into four panes.

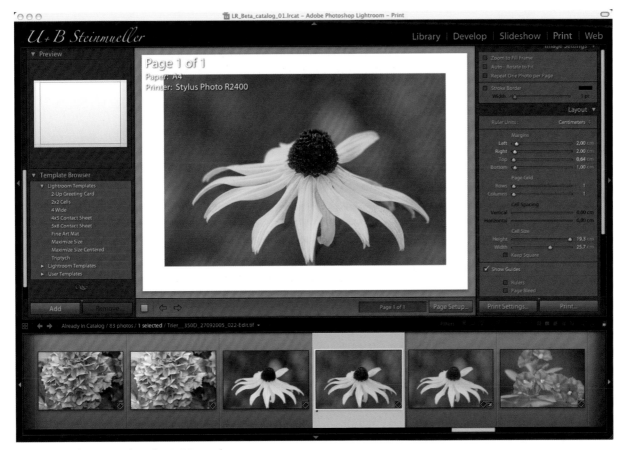

Figure 6-2: Lightroom window when in Print mode

print settings. Hovering the cursor over one of these will show the scheme of the template in the Navigation Preview window. Again, you can add your own templates.

The first decision when printing is whether you want to print a contact sheet or individual images. With the contact sheet, all images selected in the film strip will be printed on one or more pages, depending on the number of images to show and the kind of contact sheet you choose from the templates (or using your own settings). The predefined contact sheet templates include the file name in the print. If you define your own template, you can add additional information about the images, as described later on. When printing contact sheets, we recommend you use *Draft Mode Printing* (activated in the *Print Job* pane). This will speed up your printing quite a bit because the preview images are used (instead of the original images being down-sampled for print output).

However, let us progress one step at a time: For printing, Lightroom divides a page into one or more cells; the total number of cells is defined by the number of rows and columns you set in the *Layout* pane. In the simplest case, there is just one cell.

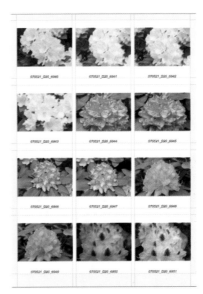

Figure 6-3: A typical contact sheet

Figure 6-4: Choosing you paper size is the first step in Print set

Figure 6-5: Here you define how the images are placed into the cells.

Figure 6-6: You define the size and the spacing of the cells.

Page Setup

Though not placed as prominently as some other settings, the first step in Print setup should be to click *Page Setup* (the button just below your preview window). Here you choose the printer you intend to use, your paper size and orientation, and optionally, a scaling factor. This will tell Lightroom the basic size of the printing area. Selecting your target printer first is important because it will determine the paper sizes offered by the printer driver.

The *Page Setup* dialog (Figure 6-4) you will probably know from other applications, and it will differ slightly from Mac OS X to Windows. The settings are straightforward and may be saved as part of a print template. With Mac OS X, you can define your own custom paper size. You can find a selection in the *Paper Size* drop-down menu.

Image Settings

In the *Image Settings* pane, you define what you intend to place into the cells and how you want to place it there – either the currently selected images placed sequentially or a single selected image repeated several times (into several cells). You also define how these images are fitted into the cell.

Additionally, you can add a small colored contour to the images using the *Stroke Border* option. A small 1-pt wide gray contour may help to set off a high-key image from the white paper. To change the border color, just double-click on the color field in the pane. A color picker appears and allows you to select the border color.

In most cases the *Zoom to Fill Frame* option should be disabled, as this will scale the image to completely fill the cell and usually results in some cropping. If, however, you use this option, you can position the visible part by clicking on the cell in the preview window and moving the image inside the cell with your mouse.

Layout

The printing area on the page is defined by the *Margins*. The cells are placed inside this printing area. The *Cell Size* defines the maximum size of the image inside each cell space. Additionally, you can add some intercell spacing using the *Cell Spacing* sliders. All this allows for very fine control for placing the image (or images).

Activating *Show Guides* gives you some visual orientation about the layout of the cells and borders on the page (see Figure 6-7). These guides are only visible on-screen and do not print.

Instead of adjusting the various margins and spacing using the sliders of the Layout pane, you can adapt these parameters using your mouse in the Lightroom preview window (content pane). Click on a guide and just drag it. This in some cases might be more convenient. The images will auto-adjust when you drag.

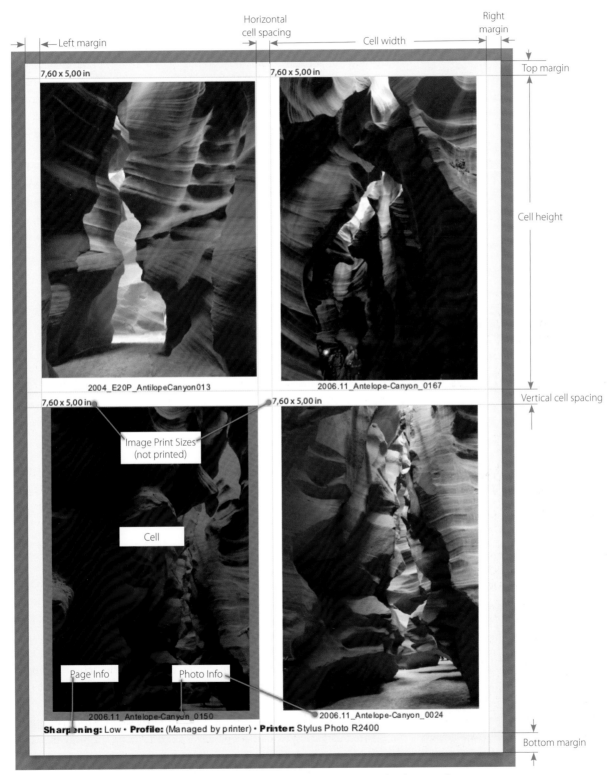

Figure 6-7: *Page layout with its cells and margins. You can select and drag these margins directly in your Content pane.*

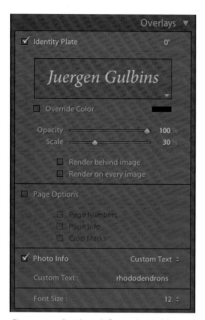

Figure 6-8: Overlays defines what additional information should appear in your print.

Overlays

In *Overlays,* you define if and what kind of additional information should appear in your print. The scheme is identical to that of *Slideshow.*

There are three kinds of information: *Identity Plate*, *Page Options*, and *Photo Info*. While Page Options – you check *Page Numbers*, *Page Info,* and *Crop Marks* – and Identity Plate will be printed just once per page, the *Photo Info* will be attached to each individual image on the page. The Identity Plate will by default appear just once per image. You may, however, activate the option *Render on every image* (see Figure 6-8) to print this plate on every image. If you have defined several Identity Plates, you can choose one from the drop-down list under ▼. If you are using a graphical Identity Plate, however, keep in mind that the graphic may only have a maximum height of 60 pixels and this will be too low of a resolution for larger high resolution prints.

Photo Info, mostly targeted for contact sheet prints, is the way to add individual information to each printed image. As described in section 5.2 on page 113, you can define your own template for those metadata that should be printed with each image. In order to call up the editor, choose *Edit* (see Figure 6-9) from the *Custom Text* menu. While with *Slideshow* these items may be placed freely, with *Print* this is only the case for the Identity Plate; just select the plate item with your mouse in your preview and place it where you want it to appear. Optionally, you can scale and rotate the plate with your mouse.

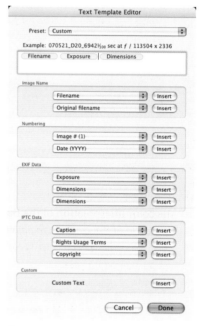

Figure 6-9: You can add some metadata information to your printed image.

Print Job

Here, you will find some of the essential settings for the actual print process. Some of the settings very much depend on your output device – be it a laser, a dye-sublimation, or an inkjet printer. As inkjet printers are probably the ones used most frequently, we will cover them here.

For most inkjet printers, the optimal *print resolution* will be from 300 to 360 dpi (also called *printer's native resolution*). Don't confuse this with the printer's printing resolution which is usually much higher – 1400 to 5600 dpi for modern inkjet printers. For Canon and HP printers, the best native resolution setting here should be 300 dpi, while for Epson Printers

Figure 6-10: Here you set some important parameters for your print.

you should use 360 dpi. If you use a dye-sublimation printer, refer to your printer manual for the native resolution. It probably will be 200 or 240 ppi.

With high-quality fine art inkjet printers, you might get an even better print if you use a *Resolution* setting of 600 ppi for HP and Canon printers and even 720 ppi for Epson fine art printers. This, however, is *not* supported by Lightroom, where the maximum setting for *Resolution* is 480 ppi – which, to our experience is good enough.

To get the best detail reproduction, use glossy paper, or semigloss at least. These will also provide for the richest color gamut. A matte paper, however, may better suit your subject. So, deciding on the right paper is no easy decision.

Use *Draft Mode Printing* only if you produce contact sheet prints or just want to do a fast draft. Lightroom will use the preview image (if available) instead of down-sampling the actual image. This may speed up the printing, but it does not produce optimal image quality. If you use draft mode, color management settings are not available.

If you plan to produce a fine art print, your settings for color management are relevant: selecting an ICC color profile and a rendering intent. They depend on whether you intend to print color or black and white.* We elaborate on this in section 6.3. There, we also cover more settings for specific printer drivers.

Print Sharpening

With RAW image, there actually are two types of sharpening:

a) The first has to compensate for the slight fuzziness that is produced by the color interpolation of the Bayer pattern.** With JPEG images as they come out of the camera, the camera will already have done some sharpening to compensate for this. For RAW images, use the sharpening sliders in Develop mode.

b) The second type of sharpening is output-specific and has to compensate for some fuzziness that may be produced by the output method.

When you produce output for on-screen presentation or print on a dye-sub printer, you can usually omit the second sharpening step. When producing output for offset printing or when using an inkjet printer, in order to simulate halftones, dithering is used by means of a pattern of tiny ink droplets. This will result in some degree of fuzziness that can be compensated for by some sharpening.

For prints, use the *Print Sharpening* menu in the *Print Job* pane (see Figure 6-11). Lightroom offers only three settings: *Low, Medium,* and *High*. The right degree of sharpening depends on the extent to which you have already sharpened in Develop mode. It also depends on your image. In most cases, using *Low* is just fine. With sharpening, photographers have a saying: *Sharp, sharper, busted*. So don't overdo it. But without extensive

→ *Print resolution (ppi = pixels per inch) here is the number of image pixels set per printed inch, while the dpi of the printer (set via the print quality setting in the printer driver) is the number of ink droplets laid down on paper to reproduce image pixels – several droplets per pixel.*

* *Provided the printer has a special mode for black-and-white printing.*

** *This interpolation is part of the RAW conversion .*

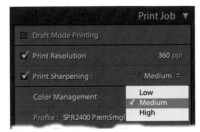

Figure 6-11: Here, you can set your print-specific sharpening.

experience, it is quite hard to properly judge the right sharpening for printing from your on-screen preview (and Lightroom does not simulate its additional print sharpening in its preview). So, some iterations may be necessary until you find your best settings. Having found them, save them in print template.

Print Settings Dialog

The dialog activated by the *Print Settings* button is almost identical to the *Print* dialog, which we will explain later. You will find descriptions of these settings in section 6.3. The *Print Settings* dialog has the advantage that you will be able to include the settings into a print template.

→ *Right-clicking on a print template brings up a menu that lets you update that template with your current settings:*

Save Your Settings in a Print Template

As mentioned, Lightroom allows saving your print settings in a print template. Just open your Navigator/Preview panel, if it's not opened already, and click the *Add* button. Lightroom prompts you for a template name. However, there is no dialog that lets you choose which settings to include into the template; Lightroom includes all current settings.

6.3 Color Management Settings

For printing, the colors of your image have to be mapped to those of the output device – the printer in this case. This is what color management is all about. This mapping may be done either by the application (Lightroom) or by the printer driver. With color printing, we recommend to let Lightroom do the color mapping using a printer ICC profile. A printer ICC profile provides information on how to translate (map) device-independent colors to device-specific color values (those of the printer).

If, however, you print black and white and the printer provides a special black-and-white mode, which many fine art printers do nowadays, we recommend letting the printer driver do the mapping.

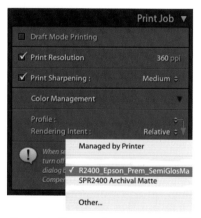

Figure 6-12: Here, you choose your printer ICC profile.

Settings for Color Prints

When you're printing color, we recommend letting Lightroom do the color management – the mapping of the colors of the image to color values that will reproduce the image colors as truthfully as possible. Lightroom is fully color managed and makes use of a printer ICC profile to perform the proper color mapping.

There are only two Color Management settings in Lightroom: *Profile* and *Rendering Intent*.

For modern quality fine art printers, your printer manufacturer provides generic profiles; however, this applies only for the inks and the papers they offer. If you are using third-party inks, you will have to create your

→ *A profile is specific to the printer, inks, and the paper used, and includes some special printer driver settings.*

own printer profiles.* If you are using third-party papers, you will either have to do your own profiling or find a matching ICC profile for your printer on the paper manufacturers' website.

Because a good printer profiling kit – consisting of a photo spectrometer for measuring colors and some profiling software – is not cheap (500–2500 US$) and requires some knowledge and experience, we recommend using a printer profiling service to profile your printer and paper for you. The price for such a service ranges from about $30–$100 per profile (printer + paper combination).

Selecting an ICC Profile

When you try to select an ICC profile, Lightroom will offer only a few, though you might have quite a few more installed on your system. So, you first have to select which profiles show up in the *Profile menu*.

To do so, select *Other* (see Figure 6-12). Lightroom will bring up a dialog containing a list of printer profiles (Figure 6-14). Check profiles that you want to be listed in the Lightroom profile menu and click OK.

Now select the profile from the menu that you intend to use for the print. The profile name should (hopefully) include the printer type is was designed for, the paper it is intended for, and the quality settings used in the printer driver.*

Rendering Intent

Rendering Intent defines how out-of-gamut colors are mapped to the colors of the target device. Out-of-gamut colors are the colors of your image that can't be reproduced 1:1 by your printer, so they have to be mapped to some other colors that can be reproduced. With digital photographs and printing on paper, these out-of-gamut colors in most cases are saturated reds and blues that have to be mapped to somewhat less saturated ones. In most cases, we use *Relative* which stands for *Relative Colorimetric*. With this setting, all image colors that can be reproduced 1:1 are reproduced 1:1, while all colors that lie outside of the printer's color space are mapped to the closest color in the printer's space. This will result in lesser color shifts than using *Perceptual* for Rendering Intent.

* Some ink manufactures will provide profiles for their inks for some well-known printers and papers.

Figure 6-13: When doing color prints, let Lightroom do the color mapping. You have to select a matching ICC profile and a rendering intent.

Figure 6-14: Place a checkmark next to all profiles that you want to be listed in the profile menu of Lightroom.

* Naming is up to the one who did the profiling. Though you can rename the profile file, we recommend against it because it may cause inconsistencies.

→ *Some profiles are designed for a specific Rendering Intent (RI). When you use them, you should use that specific RI. So, for instance, the profiles provided by Bill Atkinson and some of HP's printer profiles are designed to be used with a "Perceptual" intent. Some others (e.g., produced by basICColor) will offer the best mapping of saturated colors using a "Saturation" intent; this, however, is not offered by Lightroom. With those profiles, you may have to use Photoshop or some other print application or use "Perceptual" and achieve a somewhat less saturated print.*

If, however, your image has a lot of highly saturated reds and blues, using *Perceptual* may provide better results. With *Perceptual* (also called *Photographic*), if the source space (here, the color space of your photograph) is wider than the color space of the printer (which quite often is the case), all colors are compressed to fit into the destination space (printer's color space). This will result in less color clipping of out-of-gamut colors. Thus, images with highly saturated colors will retain more of the original image impression. With *Perceptual*, the result is more dependent on the quality of the ICC profile than it is with Rendering Intent set to *Relative*.

So far, unfortunately, Lightroom offers no soft-proofing. Soft-proofing, as provided by Photoshop, would simulate on-screen what the printed image would look like on paper (as truthfully as the monitor allows for and depending on how exact the printer ICC profile is).

If, as recommended, you let Lightroom do the color management, you must deactivate Color Management in the printer driver. How this is done depends on the printer driver.

As an example, we will show the settings for an Epson Stylus Photo R2400 printer. The R2400 is a semi-professional A3+ inkjet printer using pigmented inks. The R2400 also allows for excellent black-and-white prints. We will show the printer driver dialog for our example both for Mac OS X and Windows.

Figure 6-15: Our printer driver settings when doing a color print with an Epson R2400.

Printer Driver Dialog with Mac OS X

If all printing parameters have been set in Lightroom, and have been optionally saved in a print template, we adjust the printer driver settings using the *Print Settings* button. First, we demonstrate this for Mac OS X (here the Epson R2400). In the printer driver dialog of the operating system, there are several steps to follow:

1. Make sure the correct target printer is selected (see Figure 6-15 Ⓐ).

2. Now (perhaps again), make sure the correct layout is set (use *Layout* in the drop-down menu Ⓒ of Figure 6-15).

3. Make sure the correct paper size and paper handling is set (use *Paper Handling* in the drop-down menu Ⓒ); it should be OK, if you previously did your *Page Setup*.

4. Now we come to the actual printer driver settings. First select your media type – the type of paper you use (see Figure 6-15 Ⓓ).

If, in the *Media Type* menu, you do not find the exact type of paper you intend to use, try to find a close match. In the case of a third party paper, you'll have to estimate which Epson paper is closest to it's characteristics. You may even need to do some experimenting, using different media type settings. Often, you can find advice on paper type settings on the paper manufacturer's website.*

The right setting here is absolutely essential because it influences some internal printer settings, e.g., the amount of ink laid down. It will also influence settings offered by the driver, e.g., print quality (at least with Epson drivers).

Now, select your color mode in the *Color* menu. It should be *Color* for color prints (Figure 6-15 Ⓔ).

For *Mode*, activate *Advanced* to see some more important options (see Figure 6-15 Ⓕ). The *Print Quality* settings offered here depend on the media type you have chosen. For high-quality prints, in most cases we use *Best Photo* with this printer. *Photo RPM* would be the highest quality offered, but it uses more ink, takes longer to print, and will not yield much visible improvement in print quality.

We often deactivate *High Speed* (Ⓗ),* to achieve a somewhat better print quality at the cost of some printing speed.

* For example, Hahnemuehle, a well-known German manufacturer of fine art papers whose papers are sold worldwide, has published profiles for its papers for Epson, Canon, and HP printers. You will find these at [41]. You will also find information on the websites of manufacturers like Arches ,Crane, Ilford, Innova, Moab, or Crane.

* Thus disabling bidirectional printing

5. The next step is to disable printer driver color management. This option is part of the *Color Management* settings (see Figure 6-16). Never ever let two parties do color management. Because we let Lightroom do the color transformation (when printing in color), we disable it in the printer driver.

6. If you print on thick paper, you should let the printer driver know (see Figure 6-17). This is necessary only for a few heavy papers.

▲ *Figure 6-16: We disable color management in the printer driver when doing color prints and let Lightroom do the color mapping.*

Figure 6-17:
Use the "Thick paper" option if you are printing on heavy paper.

7. In the *Paper Configuration* subdialog, there is an option that lets you reduce or increase the amount of ink laid down and increase drying time

** E.g., for "Epson Enhanced Matte"*

per print pass. We use this option when using thinner papers,* to prevent them from warping and set *Color Density* to a slightly negative value.

Figure 6-18:
Paper Configuration tab with the Epson
R2400 driver

Some parts of the dialogs we show here are specific to the manufacturer and printer model. The basic scheme, however, is very much the same for most modern inkjet printers.

After you have finished all the proper settings in the printer driver, and checked them twice, we recommend saving the driver settings using a descriptive name.** The name should include the printer model, the type of paper, your print quality setting, and whether Color Management is on or off. You will have to use abbreviations for these parts. The saving may be done in the *Presets* drop-down menu (use Save As). When you call up the printer driver dialog the next time for the same kind of print, just select the new setting in the *Presets* menu. This avoids misprint due to incomplete or wrong settings. Misprints are costly – in terms of your time, your ink, and your paper.

*** This saving is done on the printer driver*
level (OS level), not in Lightroom.

Printer Driver Dialog with Windows

Here we show the dialog for color prints with Windows XP – again for the Epson R2400 printer. This time we are using Epson Premium Semigloss. The dialog for the whole current Epson K3-ink series (R2400, Pro 3800, Pro 4800, Pro 7800, and Pro 9800) are almost identical:

1. After opening the printer driver dialog using the *Print* button, make sure the correct target printer is selected; it's the R2400 in this example (Figure 6-19).

2. A click on *Properties* will bring up the tab with our important settings (Figure 6-19). In Windows, this dialog is a bit more compact than it is in Mac OS X offering most settings in just one tab.

Figure 6-19: Driver settings recommended for color fine art prints using the Epson R2400.

Select the correct paper (Figure 6-20 Ⓑ) or an Epson paper that closely matches your third-party paper, choose the print quality you want to use Ⓒ – in most cases with fine art papers we select *Best Photo* – and make sure the paper size and orientation is set properly (Ⓓ and Ⓔ).

If necessary, deactivate *High Speed*, *Edge Smoothing,* and *Print Preview* (Ⓕ).

3. In the Color Management section, check *ICM* (*Image Color Management*) and set *ICC/ICM Profile* to *Off* as shown in Figure 6-20 Ⓖ and Ⓗ) to prevent the printer driver from performing the color management – Lightroom does this job already.

4. Click the *Ink Config* button Ⓘ) for optional settings to reduce or increase the amount of ink laid down on paper, and you should once again check your layout settings using the *Page Layout* tab.

5. If everything has been properly set, save your driver settings using the *Save Setting* button (Ⓙ).

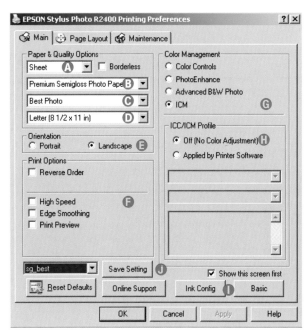

Figure 6-20: Driver settings recommended for color fine art prints using the Epson R2400.

Printing in Black-and-White

If the printer driver offers a special black-and-white mode and you want to print a black-and-white image from Lightroom (even if the image is still in RGB mode when you converted it to black and white using the Lightroom *Grayscale* function), you should leave the color management to the printer driver. In Lightroom's Print Job pane, select *Managed by Printer* in the *Profile* menu (see Figure 6-21) and set *Rendering Intent* to *Perceptual*.

We'll use the Epson R2400 as an example. With its K3 inks and providing a special black-and-white mode, it allows for very good neutral and detail-rich black-and-white prints. Additionally, you can add some toning if desired.

Figure 6-21: Use "Managed by Printer" when you do black-and-white prints.

Click the *Print* button and the print dialog for Windows appears.

1. First select your target printer and click *Properties* to enter the driver dialog.

2. Now, as with the color prints, select your paper handling, proper paper size, and the paper type you use. Also set your print quality to *Best Photo* (when using a fine art paper or a good photo paper). Deactivate all printing options (*High Speed*, *Edge Smoothing,* and *Print Preview*) as shown in Figure 6-23.

Figure 6-22: Make sure you selected your correct target printer.

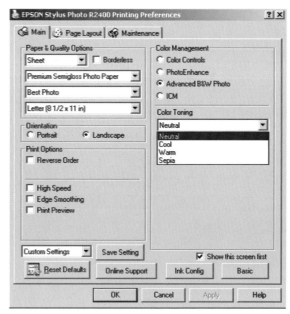

Figure 6-23: Printing in black-and-white with the Epson R2400 driver

3. Because we intend to use the printer's special black-and-white mode this time, under *Color Management* we set the driver to *Advanced B&W Photo* (Ⓐ). There are four standard options available for toning (Ⓑ): *Neutral, Cool, Warm,* and *Sepia.* It is best to start with *Neutral.*

 If you want to fine-tune toning and settings, select the *Advanced B&W Photo* dialog (see Figure 6-24).

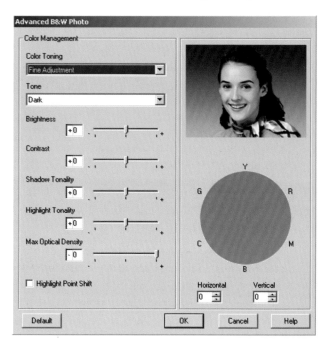

Figure 6-24:
R2400 "Advanced B&W Photo" dialog

Figure 6-25: Tone settings

Aside from the actual toning, you may first want to set a tone (e.g., "shadow brightness") you like.

For *Tone,* we found the default setting of *Darker* too dark and changed the setting to *Dark* (Figure 6-25).

Be very careful using toning that is too strong because you may get into a zone in which prints show some metamerism.

6.4 Print Preparation

Actually, we skipped some important aspects in our print setup. They are not that important if you do a small draft print, but they are crucial if you produce larger and high-quality prints. So let us go back and have a look at how to properly prepare a print and what to do after printing. Some of the points we already mentioned; others may be new to you:

▸ **Print regularly.**
Inkjet inks tend to dry up fast and may clog up the nozzles of your print heads. For this reason, use your inkjet printers regularly, e.g., once a week or at least once every two weeks. Nozzle clogging seems to be somewhat more of an issue with Epson printers, obviously due to the pigmented inks.*

▸ **Check your inks and run a nozzle check before you start a large print.**
It is annoying if you spoil an expensive sheet of paper due to clogged nozzles, or because there is not enough ink to complete your print. Therefore, it is well worth checking your inks.** If you have plenty of ink for your print and have not printed for some days, run a nozzle check, usually offered as part of the printer's maintenance utility to make sure that your nozzles are not clogged. Nozzle clogging may show as banding or as color shifts or stripes in the print.

▸ **Check your inks.**
Before starting a larger print, make sure you have enough ink. All current inkjet printers provide a function for this. With the Epson R2400, you will find this display as part of the print dialog using the Maintenance tab | ⚙ Maintenance |. Select the *Status Monitor* button there to see the dialog in Figure 6-26. This, for the Epson R2400, is also the place where you can check if Photo Black or Matte Black ink is in the printer.

With Mac OS X, to find the *Maintenance Utility* (including the Ink Status Monitor) look for your *Printer Setup Utility* (🖨).

Select your printer (here, the Epson Stylus Photo R2400), and click on *Utility* (🖨). With Epson inkjet printers, this brings up the Epson maintenance utilities dialog, as shown in Figure 6-27.

** HP and Canon printers that use pigmented inks should be powered on all the time. They will do a nozzle cleaning from time to time to prevent clogging (without using up too much ink).*

*** All of the printers we discuss here will show the status of all the inks.*

Figure 6-26: Ink status monitor with an ink-low warning

EPSON Printer Utility

EPSON SP R2400 (EPSON USB)

EPSON StatusMonitor
Use this utility to automatically check for errors and also check the level of ink remaining.

Auto Nozzle Check and Cleaning
Use this utility if your print quality declines.

Nozzle Check
Use this utility if gaps or faint areas appear in your printout.

Head Cleaning
Use this utility if your print quality declines or the Nozzle Check indicates clogged nozzles.

Print Head Alignment
Use this utility if misaligned vertical lines appear in your printout.

Figure 6-27:
From the "Printer Setup Utility", you can call up the "Epson Printer Utility", which offers major maintenance functions.

Here, you will find the maintenance functions already mentioned (*Nozzle Check* and *Status Monitor*).

▸ **Clean your paper before you print.**
Often, inkjet paper comes with some paper dust on it. Therefore, you should clean the paper before inserting it into the printer. You can use a large cosmetic brush[*] or a small, soft broom.

This prevents the dust from clogging your print heads or your printer's rollers. It is also annoying if tiny paper fragments stick to the paper when the print is done and fall off afterward, exposing plain paper spots with no ink.

Some paper is more susceptible to this problem than others. We experienced this with Hahnemühle paper (e.g., PhotoRag).

▸ **Give your prints enough time to dry before you touch and frame them.**
Actually, you should never touch the printed area of your prints, at least not with your bare hands. Wear cotton gloves when handling your prints or printing paper. Allow about 24 hours for your print to dry before framing.

▸ **Cover your printer when it's not in use.**
Cover your printer with a dust cover to avoid dust settling on and in your printer.

▸ **Keep your spare inks cool.**

▸ **Keep your spare paper dark, dry, and cool and store it horizontally.**

▸ **Make sure your printer is set up correctly for your paper.** You have to set up some printers to use thick paper. This is done either within your printer driver or with a lever on the printer, or you may have to use a special paper feed.

▸ **Make sure you use the proper profile for your paper and your printer settings.**
As stated, the profile is specific not only to the printer, the ink and the paper, but also to the printer settings. Printer settings, e.g., print quality settings, should be reflected in the profile name. Make sure you select a printer profile that closely corresponds to your settings in the printer driver.

This may all seem a bit superfluous. Be assured, however, that not only is this piece of advice the result of our printing experiences, it's considered best practice for printing professionals.

6.5 Print to PDF or TIFF

Lightroom does not print a contact sheet (or single print) directly to PDF or TIFF. With Mac OS X, however, this can be done in the printer driver dialog (see Figure 6-28) by using the *PDF* button at the bottom of the dialog box.

If, instead of using the *PDF* button, you click the *Preview* button, it will take some time to generate a Mac PDF document (this is done by Mac OS X, not Lightroom) and it's displayed by the Mac application *Preview*. When *Preview* shows the image, you can use Save As to save it in one of the formats offered (see Figure 6-29).

Figure 6-28: With Mac OS X, you can use the PDF button to produce a PDF instead of a regular print.

Figure 6-29: You can use the Mac Preview application to save your print (image) in various formats .

6.6 Prints on Silver Halide Paper

If you are going for digital photo print on traditional silver halide paper instead of using an inkjet printer, your output preparation is slightly different, because you will have to send your files to a photo service.

You have to export your images. To do so, use *Library* mode. Select the images you want to send to the service in your filmstrip or in Grid view and call up the *Export* dialog by clicking the *Export* button (which is part of the Navigator/Preview panel at the left side).

The right file format is often JPEG (see Figure 6-30 Ⓓ on the next page) with a low compression rate (high Quality factor, Figure 6-30 Ⓔ). Use *sRGB* for your destination color space (Ⓕ) because photo services that serve the consumer market assume that your images will be in sRGB.* The Resolution value Ⓖ for this type of output should be 300 dpi. We always use a maximum Quality setting for this and minimize our embedded metadata, as shown in Figure 6-30 Ⓗ. This reduces the file size slightly and prevents potentially confidential information from being disclosed to an external party.

* *Most of these photo services ignore your embedded ICC profile.*

We recommend setting up a new export folder for this job (name it in the *Put in Subfolder* field of the dialog Ⓑ). Use settings similar to those in Figure 6-30. You can constrain the maximum size of your images if you want to have smaller prints.

Save your export settings as a special export template. The Save As function is at the bottom of the *Preset* menu Ⓐ.

Figure 6-30:
Recommended export settings if you intend
to send your images to a photo service

The print quality from a consumer photo service is quite reasonable and often quite inexpensive. If however, you aim for high-quality prints, e.g., if you want to sell them, or need some large-format prints, you should use a quality printing service. This will cost you considerably more than a consumer photo service but the studio will allow for special paper, higher quality and will most likely listen to your specific wishes and answer your questions (if not, look for another service).

** For example, www.calypsoinc.com*

Most services will supply you with an output profile – downloadable from their website.* These ICC profiles can be used for soft-proofing (e.g., done in Photoshop) and should also be used to convert your images to a

color space. Lightroom 1.2 neither allows for soft-proofing nor converts to a color space other than *sRGB*, Pro*Photo RGB,* or *Adobe RGB (1998)*. Your conversion has to be done in another application (again, it could be done using Photoshop). If you don't feel you can do this yourself, ask your printing service for help (they may charge a bit for this work, but it shouldn't be much). In this case, use *Adobe RGB* as your output color space.

Using *ProPhoto RGB* makes sense only if your output format is 16-bit TIFF. This will considerably increase your output image size, and most services don't accepts 16-bit TIFFs. This may change in the future, when more high-end printers are able to work with 16-bit data (48-bit if all three RGB channels are considered).

Web Galleries

7

Photographers often like to present their images on the Web. It's an inexpensive way of advertising your work. In the past, quite a bit of HTML know-how was necessary – or the task was outsourced to a specialist. Even updating a website with new pictures was not trivial.

Today, the tools to create a Web gallery are included in the standard repertoire of every good image browser and image management system. There are four basic steps to consider when you're creating a Web gallery:

1. *Collecting the images for the gallery and sorting them into the order in which you would like them to be presented.*

2. *Converting the images into the right image format – for the Web, it is JPEG – and scaling them to a final size.*

3. *Building the Web gallery. In general, it consists of an index page with a thumbnail matrix and links to the single pictures in a larger size.*

4. *Uploading the gallery to the web server. Before you do this, you'll need to test the gallery on your local system.*

Lightroom provides tools for all these tasks. The scaling and format conversion is done in a very transparent way – you will hardly see it. The same is true for the generation of the actual gallery – be it an HTML or a Flash gallery. Be aware, however, that generating a Web gallery may take some time if you're using many (and larger) images that have to be converted and downsized.

7.1 Collecting and Sorting Images for the Gallery

As with the *Slideshow* module, Lightroom uses all images of your current view when generating a Web gallery – all photos visible in your Filmstrip. Therefore, the first step is similar to the one we use with slideshows and the Print module. First, collect all the photos you intend to place into your Web gallery. The best way is to create a new collection. We use either a named collection or a Quick Collection (see section 3.2). Make this collection your current view.

→ *When you work on a Web gallery, Lightroom will create a temporary gallery. This will take time – even on a fast system. Therefore, it makes sense to work with just a few images when designing a new gallery, save the resulting settings into a Web template, and only then select your complete set of images and apply the new template to that gallery set.*

The next step is to sort the images into the sequence in which the photos should be presented in the gallery. It's best to do this in Grid view in *Library* mode. If you intend to add some more metadata, which are displayed together with your images, add them while still in *Library* mode.

After collecting and sorting the images in Library mode, switch over to the Web module using Ctrl-Alt-5 (Windows) or ⌘-⌥-5 (Mac).

7.2 Creation of the Web Gallery

Lightroom creates Web galleries either as HTML or Flash galleries. The basic layout scheme for galleries depends on which kind you are building (HTML or Flash).

With HTML galleries, there is an index page containing the gallery title and a thumbnail matrix (see Figures 7-1 and 7-2). If your gallery has many images, Lightroom spreads them over multiple pages. If you click on one of the thumbnails, you are led to a page showing the image in a larger size.

Figure 7-1: The main two types of pages of a Lightroom Web gallery: an index page (left) and an image page (right)

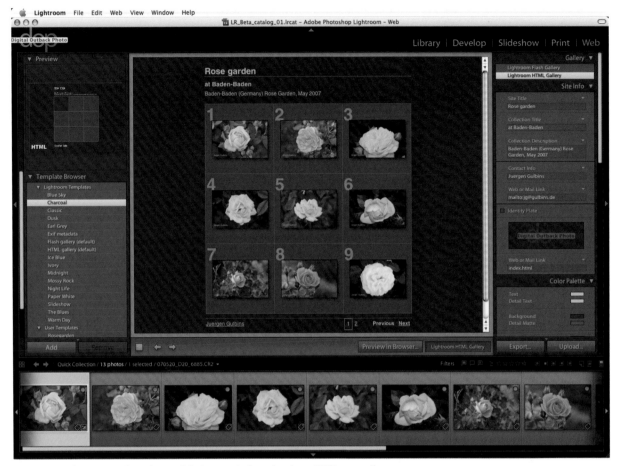

Figure 7-2: *Lightroom window when in slideshow mode, here showing a HTML type gallery*

With Flash galleries, there are two modes (see Figure 7-3): a *Slideshow* mode and a *Gallery* mode. You can switch between modes by using either the *View* fly-out menu (see top left in your preview window) or by clicking the icon that is part of the player control panel of the Slideshow window. In Gallery mode, there is an index list, similar to HTML galleries (see Figure 7-3). But instead of a thumbnail matrix, you find a scroll bar (if there are many images) and an enlarged display of the selected image. Clicking on a thumbnail in this list will show this image enlarged in the center of the page.

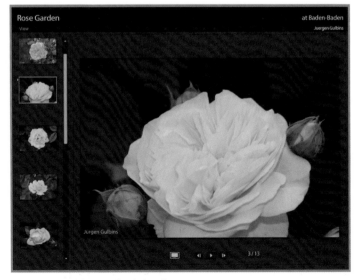

Figure 7-3: *Basic layout of a Flash gallery*

Figure 7-4: *Controls for the Web Flash gallery*
slideshow

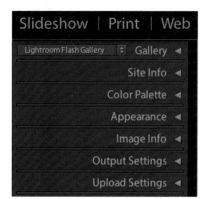

Figure 7-5: *The design controls of Web*
galleries are grouped into 7 panes.

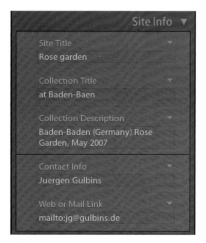

Figure 7-6: *Set your main text item in your*
Site Info pane.

Beneath the central image there are the player controls. These allow to start an automatic slideshow. In order to switch to *Slideshow* mode (in Lightroom's *Web* mode) use the *View* menu in the upper-left portion of the page, or switch using the ▢ icon. You start the slideshow by clicking the ▶ icon. To pause (or stop the show), click ▮▮.

Browsing Your Templates

Lightroom comes with a number of different Web templates. With version 1.2, there are initially 17 of them (7 HTML galleries and 10 Flash galleries). The layout of your gallery is strictly defined by the template you choose. Therefore, when designing your first Web gallery, you should start by inspecting the various templates using the *Template Browser* (part of the left panel) to see the schemes of the gallery templates in the preview windows. (If the Navigation panel is not visible, open it using ⌨Tab).

The controls for the gallery design are placed in the right parameter panel, grouped into seven panes (see Figure 7-5). The uppermost setting, *HTML* or *Flash Gallery*, is determined by the template selected. Alternatively, if you select the gallery type from the *Gallery* menu, either the *Flash Gallery (default)* template or the *HTML Gallery (default)* template is selected. The design items offered in the various panes depend on the template selected, but the basic scheme is very similar for all templates.

Site Info

You define most of the text items of your Web gallery in the *Site Info* pane (Figure 7-6) – for instance your page title, a subtitle for the collection, an optional description, and so on. There is an easy association between these fields and those of your gallery because initially all dummy text is identical to the corresponding text items in your gallery preview.

You can edit the text items either in the panel fields or directly in your Content window (just click on the item in the Content window). The text you enter in a panel field will immediately show up in your preview window. If you want to remove a text item of the basic gallery design, just clear the corresponding entry field in either the panel or your Content window.

The Web template defines the position of the different items as well as the font and the font size. There is no easy way to change this. This may be the reason so many different templates come with the Lightroom installation. They provide a number of different layouts and color schemes. Your choice of design, apart from the different templates, is mainly restricted to color schemes and optional image info (as described later).

To change the basic layout of a gallery, you have to directly edit the XML template file. This requires some understanding of the as now undocumented template structure. Editing is done using a text editor outside of Lightroom. For an introduction to templates see section 9.5. Additionally, you may find quite a few hints on editing Web templates in [42].

Additional information on individual photos can be added with the help of the *Image Info* and *Appearance* panes as described later.

Color Palette

The controls on this pane are self-explanatory. The colors of almost all gallery elements can be defined. A click on a color field calls up a small color palette (color picker) where you select your new color (Figure 7-8).

Figure 7-7: These controls define the color scheme of your gallery.

You can choose from different kinds of palettes and with some even from different color models (Grayscale, RGB, CMYK, and HSV) as described in Chapter 5. Clicking on the loupe (Ⓐ) allows you to pick a color from any point on your screen, e.g., from the current image in your Content window. The gallery in your preview window will be updated immediately with the new color, so that you can pick a different color without having to reopen this dialog if the result of the first selection is not what you wanted.

Figure 7-8: Using the loupe Ⓐ, you can pick a color from any point on your screen.

Appearance

The settings that you will find in the *Appearance* pane are very much dependant on the template you are using. Figure 7-9 shows those of the *Flash gallery (default)* template, while Figure 7-10 shows the ones of the *HTML gallery (default)*.

With most Flash galleries, you can choose where to place your index list by using the *Layout* menu. You can also opt for a *Slideshow-only* page.

With some templates, there is a choice between different sizes for the thumbnails and one for the large images. It is also available with some HTML galleries.

Additionally, with most Flash templates, you can add an Identity Plate to the gallery (see Figure 7-9). If you define more than one plate, you can select one

▲ *Figure 7-9: The settings offered by the Appearance pane will vary with the template you use. Here, we use a Flash gallery template.*

Figure 7-10: Appearance with the default Flash gallery

* As described in Chapter 5 on page 117.

Figure 7-12: Set the JPEG compression using the Quality control.

via the drop-down menu in the plate pane or even create a new plate by calling up the Identity Plate Editor using the menu item *Edit*.

For HTML galleries, you define the size of your preview matrix. Draw a rectangle with the mouse in the *Grid Pages* field to set the matrix size and with it the number of image icons in the entrance page. The minimum size is defined by the template (most often it is 3 × 3).

Image Info

While Site Info items provide information about the entire gallery, the info items of the *Image Info* pane are specific to individual images. There are only two items here (*Title* and *Caption*), but each may contain more than just one data or text entry. It can be a simple text string appearing with all images (for this, use the menu item *Custom Text* and enter the string in the input field that will appear) or some metadata that are specific for each image. For metadata, you can use one of the predefined templates (see Figure 7-11) or call up the Template Editor (use *Edit*) to set the items this template should contain.*

Figure 7-11: This pane allows to add image specific information.

As mentioned earlier, the placement of these items (as well as the font and font size used) is fixed and defined by the Web template you are using. It cannot be modified without editing the template itself.

Output Settings

All photos of your gallery are generated as JPEG files and use the sRGB color space (for more on this see section 8.3). You cannot specify the image size, only the JPEG compression factor by using the *Quality* control (see Figure 7-12). The size of the images is set by the controls of the *Appearance* pane. Additionally, you can check the *Add Copyright Watermark* option. When it's checked, the copyright note of the individual images – those in the Copyright IPTC field – will be included (if there are any). This watermark appears at the lower-left corner of the image in the gallery (there is no easy way to place the watermark somewhere else).

Upload Settings

In the *Upload Settings* pane, you set the parameters for your gallery upload. Use the *Edit* menu item on the *FTP Server* menu to set your FTP site data (see Figure 7-13). Optionally, you enter your password for the FTP site. This, however, may be insecure (and Lightroom will warn you about it, as illustrated in Figure 7-14) because the password will not be encrypted when it is stored in your template (when you save your settings into a template). If you prefer not to include the password here, Lightroom will ask for the password each time you upload a gallery to this site.

You can set up several site definitions that all show up in the *FTP Server* menu.

Figure 7-13: Here, you define your target FTP server and target folder.

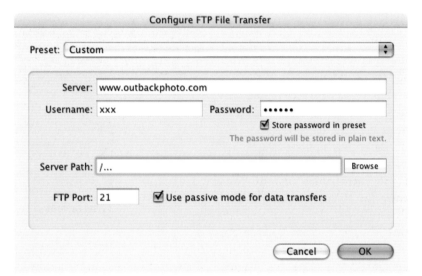

Usually, you won't want to upload your gallery to the root of your website but to a subfolder instead. Therefore, Lightroom allows you to specify a subfolder (see *Server Path* in Figure 7-14).

The actual uploading is done by clicking the *Upload* button at the bottom of your Parameter panel.

Figure 7-14:

In this dialog, you tell Lightroom where to upload your Web galleries and which password to use. You may set up several different FTP site sets and then choose one from the FTP Server menu in the "Upload Settings" menu.

➜ *Most of the time, we export the gallery to a local folder and use a separate FTP utility for uploading our galleries instead of using Lightroom.*

7.3 Testing Web Galleries

Before uploading a gallery to your Web server you should test the gallery locally. There are two methods for testing:

a) The first test can be done in your Preview (Content) windows, as the preview is no dummy gallery but a real interactive one; this is why updating it may take some time.

b) Clicking the *Preview in Browser* button below the Content window will initiate the creation of a full-blown gallery in a separate folder. A

progress bar will show the progress. This may take some time, depending on the number and size of the images. When it is finished, Lightroom will call up your default web browser with the new gallery. According to our experience, these Web galleries are well structured. Flash galleries, however, need an up-to-date Flash player for viewing (version 9 or later).

The second kind of test is a bit more thorough: Picking up the URL from your first web browser allows you to copy the local gallery address into another browser. Thus, you may test your gallery with different web browsers (e.g., *Firefox*, *Safari* (Mac), and Microsoft's *Internet Explorer*).

Spell Checking

Before publishing a gallery or slideshow, you should not only make sure it has an appealing appearance, but also check spelling. Choose Edit ▶ Spelling. See section 9.7 for more.

7.4 Uploading Your Web Gallery

Figure 7-15: If your template does not include a site password, Lightroom will ask you for the password of your website before uploading your gallery to the site.

After you have tested your gallery on your local system and done all the necessary corrections and fine-tuning, it's time to upload the gallery to your website. This is a very simple step: just click the *Upload* button. Lightroom asks you for your password (depending on your *Upload Settings* configuration). If this is not your first upload to that web page, Lightroom asks you for a new folder to prevent you from unintentionally overwriting an existing folder.

Before uploading a gallery to your website, it is good practice to check your *upload settings* as well as your *output settings*!

As mentioned, we personally prefer to use an FTP program for uploading because it gives us more control and lets us navigate the FTP site.

7.5 Exporting a Web gallery

Lightroom (even in version 1.2) does not allow saving a Web gallery as a Lightroom object that contains the set of image as well as all current control settings. For this reason, it makes sense to export your gallery even if you have already uploaded it to a website. This provides you with a local backup of your gallery and allows for a more refined upload using a FTP program. Also, you might copy the folder containing the exported gallery onto a CD or your laptop in order to do an on-screen presentation or to send it to a customer. A Web gallery can be an excellent way to present your work to a customer. If your gallery images include a name or a number, this can help in discussions about the images.

To export your current gallery, just click the *Export* button. Lightroom asks for a destination folder. The gallery is then generated and exported to your destination folder – as either an HTML or Flash gallery, depending on the type of template you are working with. The different elements are stored (well structured) in your destination folder and several subfolders.

As a rule, Flash galleries are bigger than HTML galleries. Therefore, check the total size of your main gallery folder to see how much space the gallery will occupy in your website and to get a feeling for the amount of megabytes a user will have to download when viewing your gallery on the Web. If the folder is too big, you should reduce the quality setting for your JPEG images (see Figure 7-12) in the *Output Settings pane* and regenerate your gallery. In our experience, for most galleries a quality setting of 50 will give a reasonable image quality at about one-fourth of the size of a setting of 100.

Flash galleries have the advantage that the viewer can activate Slideshow mode and watch an automatic slideshow, while with HTML galleries the viewer has to switch from image to image. HMTL galleries can show the images faster, because less data has to be downloaded from the website.

While images are exported, Lightroom will display a progress bar (This process runs in the background, so you may continue doing other work in Lightroom).

Web Template Browser and More Templates

As with the other presentation modules, when your Navigation palette is visible and in it the Preview pane is opened, the *Template Browser* shows you the look of a template when you roll your cursor over it.

Concerning the basic gallery layout, you are very much restricted to the layout of the gallery templates that come with your Lightroom installation. To achieve a real change in the layout, you have to edit the template directly, which is not that easy. Up to now, there is no official Adobe documentation on the structure of these templates. On the web, you may find some new templates (e.g., see [14] or [15]). You have to make sure these templates work on your specific system (Mac or Windows). If not tested thoroughly, such a template could crash Lightroom! Back up your catalog before exploring "the unknown"!

You'll find a number of additional tips for modifying Flash galleries in the Lightroom blog at Bluefire [46] – a site well worth visiting. There are more Web templates at [42], where you will also find information on Flash galleries. Some nice Flash galleries can be found at Matthew Campagna's site at http://theturninggate.com/blog/.

In the near future, you can expect even more Lightroom Web templates to be offered on the web; some may be free, others you'll have to pay for.

Figure 7-16: Inspect your range of templates using Lightroom's Template Browser.

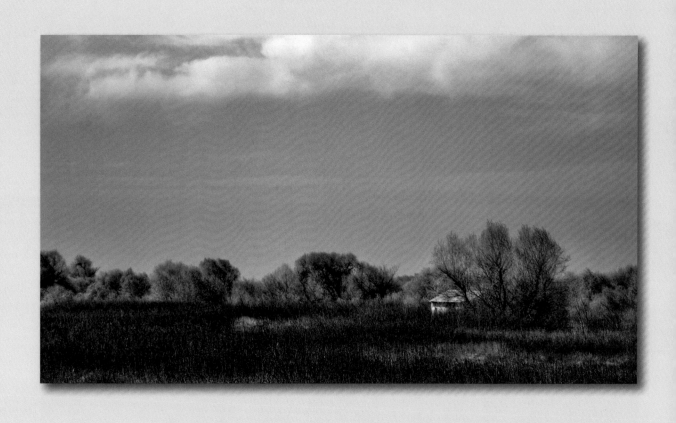

External Editors and Exporting Images

8

Remember, in Lightroom all editing is done nondestructively. All corrections (modifications) are merely stored as a set of correction settings along with the original image – namely, in the Lightroom library. Optionally, Lightroom writes this special kind of meta-data into a section of the XMP structure. With TIFF, JPEG, PSD, and DNG files it is embedded into the image itself and with RAW files it is written to a separate XMP file that Adobe calls a "sidecar file". Lightroom uses these instructions to include all corrections when showing the image on-screen and it will render these corrections into the image file when exporting the image.

Almost all external applications (with the exception of Adobe Camera Raw starting with version 4.2) will ignore these entries. There are three ways to make these corrections accessible to other applications:

a) *You select an image and then launch one of the two external applications Lightroom allows you to specify for editing the image. We will come back to this later.*

b) *You simply drag-and-drop the image onto an external application (unfortunately, so far this is only possible with Mac OS X). With RAW files, for instance, the external application may be another RAW converter.*

c) *You can export images explicitly (done in Library mode) using the Export button (on the left side under the Navigation panel).*

There as several reasons to export images – for example to work on these images outside of Lightroom, or if you want to make images, that are originally RAW files available for further use (e.g., e-mail). Exporting is also a way to make images accessible to external applications that need direct access to the image folder, e.g., to combine several shots into one new image, as is done when stitching several images into a panorama image or into a HDR image. Even if you like to create a slideshow using special slideshow programs, you have to export the pictures for this. Such programs, for instance, may allow for more finely controlled slide transitions than Lightroom does.*

HDR = "High Dynamic Range"

** They may also offer more sophisticated audio features.*

Figure 8-1: *You can configure two external editors in Lightroom Preferences.*

8.1 Using External Editors

As mentioned, you can pass a Lightroom-controlled image on to an external image editor (actually any external application). The Preferences settings allow you to configure two applications. Lightroom will automatically select the first of the two from the programs installed on you system (see Figure 8-1), e.g., Photoshop or another Adobe editor. You may choose the second entry, and define the file format (JPEG, PSD or TIFF) in which the images will be handed over.

Only the second editor can be configured freely, because the first one is selected by Lightroom – obviously looking for Photoshop. Alternatively, you might use the second entry to call up the same editor, this time, however, passing along files in a different format. Here, we chose Photoshop CS3 (actually selected by Lightroom), and LightZone and passed along 16-bit TIFF images.

To launch the external editor is either done in the drop-down menu under the right mouse button or by pressing [Ctrl]-[E] (Mac: [⌘]-[E]) the first editor and by pressing [Ctrl]-[Alt]-[E] (Mac: [⌥]-[⌘]-[E]) for the second.

Lightroom will show the dialog of Figure 8-2. There, you choose what Lightroom will pass on to the application.

Depending on the kind of the image selected in Lightroom, some of the options may be grayed out (not selectable). You will find the explanation for the different options in the dialog. If a copy of the image should be edited, Lightroom will create a rendered copy of the Lightroom file and place it in the same folder as the original. Lightroom will also append a suffix to the filename to mark it as an externally edited image. While in version 1.0 of Lightroom, this suffix was "-Edit" followed by a number. You can change this suffix since Lightroom 1.1 (see Figure 8-1). Lightroom will pass this filename on to the external editor.

When you modify the image and save it (using Save in the external editor), Lightroom will update its image preview (with a short delay). If you save the image, choose Save as and give the file a different name, Lightroom will not recognize the new

Figure 8-2: *Here, you define what will be passed on to the external editor.*

image until you either explicitly import it into Lightroom or you update your import folder.* This folder synchronization function is available since Lightroom 1.1.

** Select your LR folder in the Folders pane and choose* Library ▸ Synchronize Folder *for this.*

8.2 Drag-and-Drop an Image onto an External Application

Like Adobe Bridge (Photoshop's image browser), with Mac OS X Lightroom allows you to drag and drop images from the Filmstrip or Grid view on to another Mac application to open the image in that application. Unfortunately, with Windows this does not work with Lightroom version 1.0 or 1.2. The effect is very much the same as when starting an external editor as previously described. However, no dialog will come up and the selected file will be passed along as an original (no copy is produced).

If you edit the image in the application and save the changed image (by Save) under the same name and at the same place, Lightroom incorporates the updated image and updates its preview after a short time. If you save the image, under a different name, even in the same folder, Lightroom will not know this new image until you explicitly import it.

We frequently use this drag-and-drop feature under Mac OS to, for instance, edit images in LightZone.

If you drag an image from the Lightroom Filmstrip or Grid view onto a DTP document, it is placed there. However, this assumes that the DTP application can handle the image format. While with 8-bit TIFFs and 8-bit JPEGs this is the case in most DTP applications,* you might encounter more problems when doing this with 16-bit TIFFs or PSDs – just give it a try. Adobe InDesign will take any image format Lightroom supports (no RAW files), while FrameMaker and MS Word will not accept 16-bit images.

** As long as the format does not use any compression*

With TIFF files, the kind of compression can also be relevant. While almost all DTP applications will process uncompressed TIFFs, you should first run a test if you intend to use ZIP or LZW compression. No DTP application can import RAW files, however.

Most DTP applications will not embed these images; they will place them by reference. If you change the image in Lightroom or another application, the DTP document will refer to the updated image next time you open this document.

This drag-and-drop method does not work with MS Word, however.

Fig. 8-3: Photos can be placed in a DTP document using drag-and-drop.

8.3 Exporting Images

Lightroom's Export function may be considered to be the Lightroom Batch processor. While single images (all those currently selected) can be exported from all Lightroom modules, exporting a complete folder of images is only possible in *Library* mode.

If you intend to export only a single image, select it and click the Export button in Library mode. The same can be done with just a few selected images. In another module, use File ▸ Export.

If, however, you intend to export a whole folder (or collection) or all images of your current view, go to that folder or view, select all images, and click on Export.

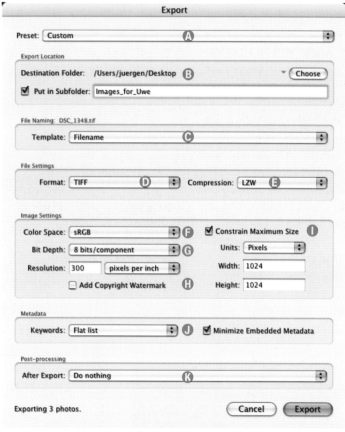

Fig. 8-4: *Lightroom's Export dialog. You can specify the format and destination folder for the exported images.*

When exporting images, Lightroom will render all corrections into the exported images, produce an image format according to the Export settings (see Figure 8-4), and place them into the selected destination folder.

When exporting, you can choose a naming scheme from a drop-down menu (see Figure 8-4 Ⓒ). You can also use an editor to define your own new naming scheme.

You can export your images as JPEG, TIFF, PSD, or DNG (see Figure 8-4 Ⓓ). Additionally, Lightroom can just copy the original files to your export folder (this has been introduced with Lightroom 1.1). With JPEG, a quality (compression) factor may be selected, and with TIFF, you can define a compression method (Ⓔ) and the color bit depth (Ⓖ). The best compatibility with other applications is achieved when selecting *None* for *Compression*. You can additionally add a copyright watermark (Ⓗ). The text of the IPTC copyright notice is used for the watermark. Moreover, you do an automatic image scaling by applying *Constrain Maximum Size* (Ⓘ).

In many cases, it makes sense to minimize your embedded metadata (Ⓙ) and to reduce them to a flat list, which is useful, if you are using keyword hierarchies.

Lightroom allows you to perform some additional post-processing on the exported images (Ⓚ). For example, you can do some more sharpening

using an external application (like *Photoshop Droplets*) or you can do an additional color space conversion. We will come back to this later.

As there are quite a few settings for an export, we recommend saving your settings using a descriptive name (you will find the function to save these setting in the drop-down menu under Ⓐ). From now on, you find this item as an additional preset in the *Preset* menu. A systematic usage of such presets avoids errors due to sloppy export setups.

Export Color Space

Internally, Lightroom uses a color space derived from ProPhoto RGB (but having a linear Gamma of 1.0). When exporting images, you have to specify a destination color space. With LR 1.2, three color spaces are available: *sRGB*, *Adobe RGB (1998)*, and *ProPhoto RGB*. For most users, especially for inexperienced ones, sRGB will be best. For Windows, sRGB is the default color space and it is the best color space for Web images and for presentations on-screen. It is also the best color space if you intend to send the image to a photo service for printing. But sRGB is the smallest of the three available color spaces, and if you have lots of saturated colors in your image, quite a bit of color clipping may occur. Clipping in this case means that those saturated colors will be mapped (clipped) to less saturated ones, because Lightroom will use a *Relative Colorimetric* rendering intent when mapping colors to another color space.

> ➔ *When on import Lightroom encounters an RGB file without an embedded profile, it assumes that it is an sRGB color space file. While with imported grayscale and Lab files the original file is preserved, all Lightroom internal calculation is done with RGB using the LR internal color space.*

If you send images to an advertising agency or want to keep as much color as possible when exporting to JPEG or 8-bit TIFFs, you should use Adobe RGB (1998), because it is a larger color space than sRGB (see Figure 8-5).

The widest color space is ProPhoto RGB. This space is able to cover the full range of color a digital camera can capture, which is why Lightroom uses this space internally. When exporting images, however, you should only use it if exporting TIFF or PSD images with a color bit depth of 16-bit. No color space has to be specified when exporting to DNG. In this case, ProPhoto RGB is used or none at all, as RAW files actually do not have a color space.

With Lightroom 1.2 , you are not free to use additional color spaces when exporting images. If you need another color space, which may be required when sending images to a photo studio for Lightjet-printing, you have to do that conversion outside of Lightroom. In this case, we recommend using either ProPhoto RGB when exporting 16-bit images or Adobe RGB when exporting with a color depth of 8-bit (per color channel). The color space conversion could be done using post-processing, as described in the next section.

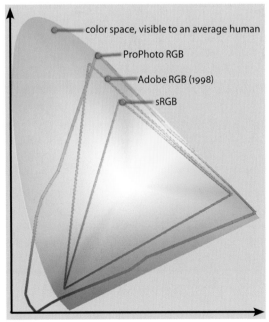

Fig. 8-5: The three export color spaces of Lightroom compared to the visible human color space

Figure 8-6: Some predefined export post-
processing actions of Lightroom 1.2

➔ *In section 9.2 we will show how to export*
images to a new Lightroom catalog.

Export Post-Processing

Lightroom allows for some post-processing when exporting images (see Figure 8-4 Ⓚ). There are some predefined actions that you will find in the *After Export* menu. However, you may add your own post-processing actions. For this, you have to place them into the *Export-Actions* folder. Where to find that folder will be explained in section 9.5. Instead, you may use the last menu item of the list to be directed to that folder.

The post-processing action has to be an executable file (program). If you want to use a Photoshop script for this, you have to create a Photoshop droplet (refer to your Photoshop online help for this).

With Mac OS X you may export the images to a folder that has an associated folder-action. How to set up such a folder can be found in your online help of Mac OS X.

One of the few predefined After-Export-actions is *Burn the exported images to a disc*. This will launch a CD/DVD burning function and may be considered one of Lightroom's backup features.

8.4 Workflow Example with LightZone

As mentioned before, there are a few corrections and optimizations that Lightroom does not provide up to now. For example if you want to fine-tune your image by applying selective corrections, which do not effect the whole image but only selected regions, you will have to break out of Lightroom and use another editor, e.g., Photoshop making use of Photoshop layers and layer masks. More often we use LightZone [30] for this.

The following example shows how Lightroom cooperates with other editors – here for example with LightZone. You may ask why we can't just do everything in Lightroom. The answer is very simple: Lightroom lacks the power of selective, layer based editing. In these cases, you need either Photoshop or LightZone (or any other editing application that supports selective corrections). We personally like to use LightZone for all of our black-and-white (and a lot of colorized black-and-white) work. The image we will work on in this example is the one on our chapter introduction page.

* *You will find a short introduction to*
 LightZone (LZ for short) at [31].

Preparations in Lightroom

The original image, which we have imported in Lightroom, is a soft image that does not have any clipping in the highlights and also hardly any in the shadows. The source image is to be seen in Figure 8-9.

Because the sky was so hazy (but had some clouds, that are quite rare in California), we wanted to enhance the blue for the future black-and-white work.

If we would increase the saturation of the blue colors we would get too much noise. Except for cropping the image, this is basically all we did in Lightroom.

To use LightZone as a second editor, we have to set up the preferences in Lightroom as shown in Figure 8-7. (We would like Lightroom to allow more than one extra external editor (Photoshop CS3 is default editor #1).

Figure 8-7: Preferences setting for LightZone as a second external editor

Now we select the image in our filmstrip and start the external editor either via Photo ▸ Edit in Light-Zone.app or using the keyboard shortcut ⇧-Ctrl-E (Mac: ⇧-⌘-E).

We chose to let Lightroom pass a copy (16-bit TIFF) of the image on to the external editor with all Lightroom's adjustments rendered into the copy (see Figure 8-8).

Figure 8-8: In this case, we chose to use a copy of the image with all Lightroom adjustments included.

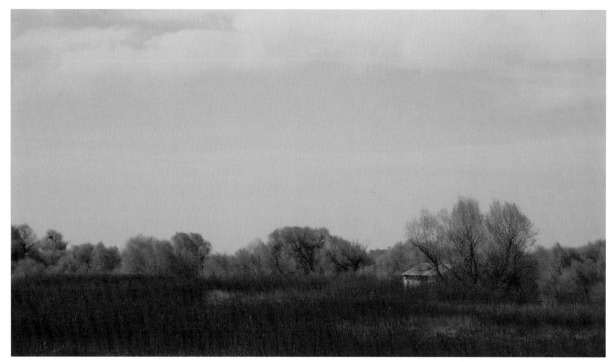

Figure 8-9: Our starting image in LightZone as it comes from Lightroom

Figure 8-10: *Our final stack in LightZone*

Figure 8-12: *We create a black-and-white layer but lower the opacity so that the color bleeds through.*

The Work in LightZone

Figure 8-10 shows the LightZone stack with all corrections done there. Each item of the stack is a correction applied in LightZone (bottom up). It looks like a lot of work, however, it needs relatively little time. We won't cover all the steps but only show some essential ones. Our goal is to create a colorized image (blend of black-and-white and color) in LightZone.

Our intention was to get a tinted image – a black-and-white image with the color version slightly shining through. For this, we have to use layers.

Unfortunately, the original image contained numerous small dust spots; it was time to clean the sensor once again. Figure 8-11 illustrates the numerous spots. (You can see the Lightzone marks of our spot patching.) It is your choice where you correct them: Lightroom or LightZone. We chose to do it in LightZone. That is why our first layer is a LightZone spotting layer.

Figure 8-11: *Spotting dust in LightZone*

1. Therefore, the first step Ⓐ is removing these spots with the LightZone spot tool.

2. Now the next step is the black-and-white conversion Ⓑ to create a colorized photo.

 As with Photoshop layers LightZone offers an opacity slider. We create a black-and-white layer but lower the opacity so that the color bleeds through (Figure 8-12 Ⓐ).

3. We then tune the global contrast using a LightZone ToneMapper Ⓒ and ZoneMapper Ⓔ.

4. The next step is to work selectively on the sky (here normal RAW converters do not help) – again using LighZone's ZoneMapper Ⓕ. For this our correction has to be selective – only working on the sky without changing the rest of the image. In the sky, we would like to work on the cloud contrasts. Therefore, we use a LightZone region. It works like

Photoshop layer masks and protects all image areas outside of our selection against changes. However, unlike Photoshop's pixel-based layer masks, LightZone regions are vector-based (actually spline-based). These regions may have an outer border providing a soft transition. You see the region borders in Figure 8-13.

Figure 8-13:
We are working on the
sky selectively (using a
LightZone Region and a
ZoneMapper.

5. Now it gets interesting. As the sky should not be tinted, but pure black-and-white (this is, of course, a matter of taste), we use a second black-and-white layer but this time with a region for the sky (Figure 8-10 Ⓖ). Figure 8-14 shows the result (the region borders can still be seen).

Figure 8-14:
Using a second black-and-
white layer we desaturate
the sky some more, again
using LZ regions to protect
other areas of the image.

6. Finally, we do some sharpening (Figure 8-10 Ⓗ). Here, we prefer the sharpening of LightZone to that of Lightroom, as LightZone uses a

threshold slider (that was not available in Lightroom version 1.0 when we did this optimization), which in our opinion gives a somewhat better sharpening result.

7. We enhance the cloud bands selectively with two selective ZoneMapper layers (Figure 8-10 ⓘ + ⓙ) using a soft transition. The LightZone region for this is shown in Figure 8-15.

Figure 8-15:
In order to fine-tune
the lower clouds we
use a LZ ZoneMapper
inside a region.

8. The next two layers (ⓚ and ⓛ of Figure 8-10) brighten the grass area and add some more contrast. You can see our region mask and the effect in Figure 8-16.

Figure 8-16:
Working on the grass
using a region.

Figure 8-17: Our final image coming out of LightZone and being returned to Lightroom.

9. The final and top layer (Figure 8-10 Ⓜ) adds some saturation. Figure 8-17 shows our final image, as it will come out of LightZone.

10. We are finished working in LightZone and can save the image. Lightroom will update its preview (with a short delay). LightZone does some tricks here.

LightZone actually saves a TIFF that includes these three parts:

a) TIFF file at the time LightZone was opened
b) The final LightZone rendering
c) All instructions in the layer stack that allow to get from a to b

This allows LightZone to keep all the information for a future fine-tuning (nothing is lost). The next time you want to update this file you open the original file into LightZone: With it the image contains all info, so that LightZone can perform further corrections when editing this same image again. You should not, however, do any modification to that image in Lightroom after returning from LightZone, as this will invalidate Light-Zone's information.

The next time you want to open this image in LightZone, you use somewhat different settings as shown in Figure 8-20. This way you continue in LightZone where you finished your last editing session (do not use a copy!).

Figure 8-18: The Metadata will show, that this image was edited by LightZone.

Figure 8-19: If you intend to access the previous LZ editing, you have to use the Original for editing with no further Lightroom renderings.

Figure 8-20: Save your LightZone stack in a LightZone template.

Figure 8-21: Make a copy of the LR-corrected image to be passed on to LightZone.

Back in Lightroom you can also find out which of your TIFF files were edited in LightZone by checking the Metadata panel. There, looking at the Software field, you should find that the image was edited by LightZone (see Figure 8-18).

Some advanced tricks

Lets assume you have edited your file in LightZone and find out that you should use some other settings in Lightroom as your basis. It is not possible just to exchange the base TIFF file with the LightZone edited TIFF file. Fortunately there is an easy and powerful technique to do the same thing:

1. Open the first version in LightZone (see above). This time, however, you don't open a new copy of the edited file but the original file (the copy created previously by Lightroom and edited in Lightzone). When calling LightZone, use the settings shown in Figure 8-19.

2. Save all layers (including regions!) as a new LightZone template (called *Styles* in LightZone 3.x). These styles are very powerful and are big time savers as you can apply the settings of these templates to other images very much like Lightroom presets.

3. Now go back to Lightroom. In the developing mode, change your RAW settings for the RAW original image (not the one edited in LightZone).

4. Open your modified RAW file once more in LightZone, this time using the setting as shown in Figure 8-21. A new duplicate TIFF file is passed on to LightZone.

5. After the file is open in LightZone you can now apply the old saved template – our style – to the new TIFF file (see Figure 8-22).

Figure 8-21:
Apply the saved template.

Tune the layers in LightZone (depending of course on the changes you made in the RAW file).

We hope you agree that LightZone and Lightroom work very well hand-in-hand and that there is clearly a need to perform selective editing on images like this one.

What we have shown with LightZone works very similarly with Photoshop. There, nondestructive corrections may be done using adjustment layers and smart filters. If you call up Photoshop another time and the layers and smart objects are still present, you may modify these and add some more corrections, very much the same way we do it in LightZone.

Be warned however: As soon as you edit these files in Lightroom, your modifications done in LightZone can get lost (to the extend that they are no longer present for further modifications). So, you should not touch these files in Lightroom in any way if you intend to go back and do some more modification in the external editor. In theses cases, just use Lightroom as a digital asset management system.

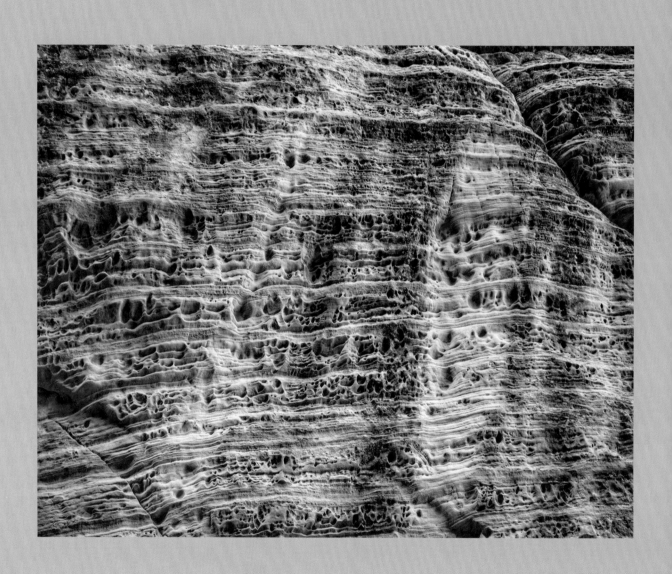

More Useful Lightroom Features

9

Now we will have a look at some Lightroom features that did not fit into any of the previous chapters. This includes the "catalog" – the administrative heart of Lightroom, in addition to which items the photographer should back up regularly and which tools he should use for this. This chapter will also come back to RAW files and will explain what they really are and why, aiming for the best quality of your image, they provide better material for editing than JPEG files.

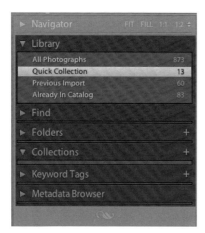

Figure 9-1: The items selected in your
Navigator panel define your current view.

Figure 9-2: When several folders are selected,
all images of these folders and their subfolders
are part of the "current view".

9.1 Views, Searching, Selections

Using the *Library* module you define your *current view*. A *view* consists of those images that are currently shown in your Filmstrip or your Grid view matrix and that may be worked on for editing, to create Web galleries, to print, or to create slideshows. The current view is defined by those elements that you select in the Navigator panel (see Figure 9-1):

1. An element of the list in your *Library* pane
2. The folders selected in your *Folders* pane
3. The collections selected in your *Collections* pane
4. The keywords selected in your *Keyword Tags* pane
5. The objects selected in your the *Metadata Browser* pane
6. Entries in *Find* form

The first five items are mutually exclusive. This implies, for instance, that when you click on a folder in your *Folders* pane, the element that was previously selected in your *Library* pane or any element previously selected in your *Collections*, *Keyword Tags,* or *Metadata Browser* pane are automatically deselected and vice versa. While in the *Library* pane, you can select only one item; you can select more than just one in your other panes (*Folders*, *Collections*, *Keyword Tags* and *Metadata Browser*).

If, for example, you select three folders in your *Folders* pane, as illustrated in Figure 9-2, all the images that reside in any of these folders and any of their subfolders will form your current view – provided no further restricting criteria are set up, as explained later.

To select several items on these panes, use your standard keyboard modifier keys: the Shift key for adjoining elements and Ctrl+click (Mac: ⌘+click) to add non-adjoining elements. If you select a folder in your *Folders* pane, all images of its subfolders are included as well. The same applies to items selected in the *Collections*, *Keyword Tags,* and *Metadata Browser* pane (though there are no subfolders there).

While earlier we said that selections in the *Library*, *Folders*, *Collections*, *Keyword Tags,* and *Metadata* pane are mutually exclusive, this is not completely true. Using the Ctrl key (Mac: ⌘), you can combine criteria (items) of theses panes. Thus you may select images that are part of the named collection *Roses*, are part of the folder *California,* and bear the keyword tag *Red*.

On top of those selections, Lightroom allows you to add more restrictions:

a) Further search criteria may be defined in the *Find* form pane (see Figure 9-3).

b) Additional restrictions may be set in the *Filters* pane (see Figure 9-14).

If an item in the *Find* pane and the *Filters* pane is active, all criteria have to be fulfilled in order to include an image in your current view. So, if you don't

see images in your view that you expect to be there, check your *Find* and *Filters* panes (the latter is part of the Toolbar) to see if there are any restrictions set there. Both *Filters* and *Find* may be disabled temporarily.* The restrictions of *Filters* and *Find* apply even when the corresponding pane is not visible!

* Use Ctrl-L (Mac: ⌘-L) to disable the filter function temporarily. Hitting this shortcut a second time will reenable it.

Lightroom's Find Function

A mentioned earlier, *Find* works as an additional filter on the images selected with any of the items on the list on the previous page.

If, for instance, you select the folder *Grand Canyon* in the *Folders* pane and set the *Find* mask to look for keywords containing "*Navajo Point*", only images that lie in the folder *Grand Canyon* (or any of its subfolders) and bear the keyword *Navajo Point* in their keyword IPTC field will be shown in the Filmstrip.

The *Find* pane (see Figure 9-3a) contains a maximum of two basic elements (both are optional):

1. A condition, which consists of a text string combined with a field in which the string has to show up, plus a rule that has to be fulfilled

2. A time frame

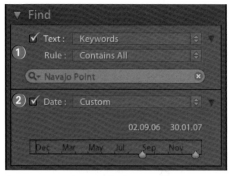

Figure 9-3a: Lightroom's Find pane

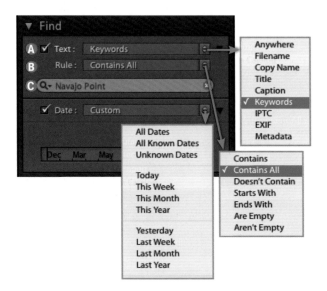

Figure 9-3b:
Find pane with all its various
drop-down menus

Let's have a look at the *Text* part first. The first drop-down menu Ⓐ allows you to select where Lightroom will look for the text given in field Ⓒ. It may be *Anywhere*, in the *Filename* or in one of the other metadata fields listed in the menu. There is some overlapping in this definition – for instance, *IPTC* is part of *Metadata* and *Caption* again is part of *IPTC* – so the menu items are just convenient metadata field groupings.

* And additionally fulfilling all other conditions

The *Rule* part Ⓑ allows to specify how the text has to appear. You can also specify that a certain field has to be empty or must not be empty (in both cases, the text string in the field below is ignored). Instead of these criteria, you may also use a modifier character with your text:

! The exclamation mark as a prefix to any word will exclude images containing this word from the current view.

+ The plus sign at the beginning of any string triggers the "Start with" rule for just that word, meaning that the string has to be at the start of text or a name or whatever.

+ The plus sign at the end of a text string triggers an "End with" rule, meaning that this text string has to be at the end of a text string or a name.

If you enter more than one word in the text field, the combination defined by these words depends on the rule selected. When *Rule* is set to *Contains,* this means that images containing any of these words will match the rule. When rule is set to *Contains All,* only images containing all of the words in the corresponding field will match. The rule *Doesn't Contain* means that the images must not contain any of the words entered. When you select the rule *Starts With,* Lightroom will look for images with words that start with the text string specified. Finally, with *Ends With* Lightroom looks for images that contain items that have words ending with the string typed in.

Time Frame Restrictions

On top of a text condition that has to be fulfilled by the images, or simply as an alternative, you may specify a time condition that the images have to meet. The *Date* drop-down menu allows you to specify a date for the image you are looking for. Here, we are talking about the date the image was shot. This date is the date that is found in the EXIF metadata.

If you want to specify a time frame, select *Custom* in this drop-down menu and then click on either the start or the end date. The dialog that comes up allows you to set the time frame, down to seconds (see Figure 9-4). For a more coarse setting, you can use the ◖ sliders of the dialog (see Figure 9-5).

Figure 9-4: Here you may select the time frame within which the date the image was shot has to lie.

Figure 9-5: Dragging the sliders allows you to set the time frame .

** *Using combinations of items in the Library, folders, collections, keyword tags, and the Metadata Browser pane*

All the mechanisms:

▶ of a primary selection to choose one or more items in the same or in different panes ,**

▶ plus the criteria set in the Find pane (text plus time frame)

▶ plus the criteria that may be set in Filters (described later)

add up to many possibilities to compile your view. With all this, keep in mind that making full use of the *Metadata Browser* adds still more possibilities. For instance, you can additionally restrict the current view to images that were shot with a certain lens (and you can use some more metadata criteria like camera, aperture, and so on; see Figure 9-6 for an example). It might become difficult to understand what your selection implies if you combine many of these conditions, but you can start with just a few of them and then add more.

Filters

You can further narrow down the list of images in your current view by *Filters* (above the Filmstrip). It also restricts your images to those also fulfilling the criteria that are set in *Filters*. This may include a minimal star rating, certain color labels, certain flag settings, and images that are a *Virtual Copy* or a *Master Image* (see Figure 9-7).

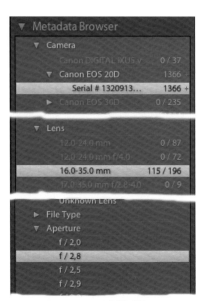

Figure 9-6: By using the Ctrl/⌘ *key, you can combine several criteria in the same or even in different panes for a view.*

The switch ▮ to the right of *Filters* activates and deactivates the filter function. Instead of the switch, you can use the shortcut Ctrl-Ⓛ (Mac: ⌘-Ⓛ) to deactivate and reactivate the filter.

The current view can be preserved in a collection. Select all images of the view – e.g., by Ctrl-Ⓐ (Mac: ⌘-Ⓐ) – and put them in a new collection (see section 3.2, page 56). These collections are quite cheap memory-wise, so you can afford to have a multitude of them.

Apart from building a collection that contains all images of a view, there is up to now (LR 1.2) no way to preserve a view – meaning all current settings of your view-defining panes and your current *Filters* settings. A collection, however, will not be updated if new images match the settings of the current view.**

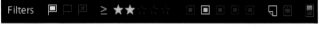

Figure 9-7: You may restrict your current view to those images, that fulfill the criteria set here in Filters.

** *Apple Aperture offers such collection. It it is called a "Smart Album".*

However, there is help. Have a look at your Info-bar – the one just above your Filmstrip. The small 🔽 drop-down menu will list your recently accessed views, as illustrated by Figure 9-8.

Folders / 2004 or 2005 / 3619 of 3627 photos / **1 selected** / 20030831_D200_Ducks._0460.JPG

This should remind you of the usefulness of this easy-to-miss pane and the information that you find here.

All Photographs
Quick Collection
Previous Import

✓ Folders / 2004 or 2005
Metadata / Location / Germany / Bayern / München / Garden
Keyword Tags / Anna
Collections / Sheep or Winter-Collection
Folders / 1999 or 2001
Folders / 2001

Clear Recent Sources

Figure 9–8:
The drop-down menu of the Info-bar contains a list of your recent views. Selecting one of them will bring that view back.

Selecting Images

In a view – be it in your Filmstrip or in Grid View – you may select individual images. The easiest way to do this is by a simple mouse click on the preview icon (thumbnail). This image is called *active image*. The image is marked by brightening its frame. In most modules and in most situations, this image will be shown in the Content pane. Using your arrow keys you can move your selection to the previous or next image of your view. Using ⇧-← or ⇧-→ will add those images to your current selection.

Shift-clicking on another thumbnail will select all images from those previously selected up to your new image. This will be familiar to you from your *Finder* or *Explorer*.

In the same way as you selected noncontinuous items for your view, you can add more images with the help of the your current selection by pressing Ctrl (Mac: ⌘) and clicking on further thumbnail. To select all images of your current view either use Edit ▸ Select All or Ctrl-A (Mac: ⌘-A). To deselect all images use Edit ▸ Select None or Ctrl-D (Mac: ⌘-D). It is also possible to invert your selection by using Edit ▸ Invert Selection.* (The latter, however, only is available in Library mode).

** There is no keyboard shortcut for this.*

not selected
selected images
active image

Figure 9-9: Lightroom brightens the frame of all selected images. The "active images" is a bit brighter than the others.

When several images have been selected, only one can be the *active image*. By default it is the first one selected. The active image is the one that is shown in the Content pane when Loupe mode is active or when in Develop mode. Its frame is a bit brighter than those of the other selected images (see Figure 9-9). If, in a selection, a different image should be the active one, just click on the new target a second time (if it was already selected) – this time, however, without using ⇧ or Ctrl/⌘. All other images will stay selected.

Selections are useful for a number of operations. For instance when printing, only selected images will be printed in Print mode. When exporting images (using File ▸ Export), Lightroom will export only those currently selected. When you are working in the Web module and use Web ▸ Which Photos ▸ Use Selected Photos, the gallery is built by only those images that are currently selected. Selections are also useful when assigning or appending keywords and other kinds of metadata to all images of a selection.

The *active image* of a selection is important with some operations. When, for instance, you select photos, stack them (use G), and then collapse your stack, the active image will be on top of the stack. When using Settings ▸ Sync Settings in Develop mode, the settings of the active image are copied to the rest of the images selected. The same is the case when using the function Settings ▸ Match Total Exposures (which is also a function of the Develop module). So, keep in mind how to select and deselect images for your purpose.

9.2 Lightroom's Catalogs

Lightroom is based on a *repository* – a database. While this repository was called a *Library* in Lightroom version 1.0, in Lightroom 1.1 (and later) it is called a *Catalog*. Lightroom allows for several catalogs and stores all its metadata and administrative information on images in catalogs. The preview icons that Lightroom generates when importing images are stored in a separate structure alongside the catalog and not in the primary catalog itself (see Figure 9-10). Other administrative elements (e.g., all templates) are stored separately in folders– section 9.5 will show where.

With version 1.0, 1.1, and 1.2, Lightroom uses an SQLite database.

Figure 9-10:
The folder containing the LR catalog also contains a library item for the preview images and a folder for catalog backups.

You basically have three files/folders in your catalog folder:

▸ Your actual catalog file (extension ".lrcat")
▸ Your previews (extension ".lrdata").
▸ *Backups* – a folder containing all backup copies archived by Lightroom

While Lightroom is running, you will find two additional files in that folder: a lock file (using extension ".lock"), which prevents two applications from accessing the same database, and a journaling file (using the extension ".lrcat-jounal") which holds information on changes that have not yet been written into the catalog.

→ *The journaling file may not be present all the time. It is important however, as, in case of a crash, it will help to recover your last operations done in Lightroom. So, don't delete it after a crash!*

With the standard settings you find your default catalog in the following folder:

Mac OS X:* ~/Pictures/Lightroom/

Windows XP and Windows Vista: C:\Documents and Settings*username*\My Documents\My Pictures\Lightroom\

** ~ is the symbol for your private user directory.*

If you want to move your catalog to another disk, e.g., one with more disk space– simply copy it to the new destination. Lightroom should not be running while you're doing this. You should not only copy the catalog file (the one with the ".lrcat" extension), but also the Previews file (the one with the ".lrdata" extension). Then start Lightroom while holding Alt/⌥. Lightroom starts with a dialog where you can choose the catalog to be opened.**

After verifying that Lightroom works well with your new catalog, you can delete the old one. Use File ▸ New Catalog to create a new catalog. Lightroom will create not only a new catalog, but also a new folder that will (by

*** Alternatively, you can also start Lightroom and then choose File ▸ New Catalog*

default) contain the new catalog, a catalog backup folder, and a repository for the preview icons of the images of the catalog. If you're running version 1.2 (or later), Lightroom then restarts to open the new catalog.

Synchronizing Your Lightroom Folders

When you import images in a folder, Lightroom knows only those images that were present at the time of import. If you add more images to that folder later on, Lightroom will not know about them.

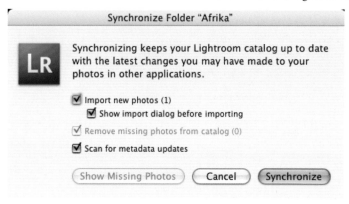

Since LR 1.1, you can, however, synchronize your physical folder and your Lightroom image folder (with your LR catalog). Call up this function by first selecting the corresponding folder in Lightroom in the *Folders* pane of the Navigation panel and then use Library ▸ Synchronize Folder. Lightroom asks you what to do (see Figure 9-11). This operation allows importing new images, removing images that were deleted, and scanning for metadata updates. The latter, for example, is convenient if you have been editing images using an external editor and saved them using new names to get duplicates or new versions.

Figure 9-11: LR allows you to synchronize your physical folder with your Lightroom image folder.

Reconnecting Images

If you move, rename, or delete images by means of an external tool, Lightroom's repository will be out-of-sync. If you try to access the corresponding folder or images, Lightroom will look for them, recognize some discrepancy, and mark the images with a ⑦. If your preview icons of the images are still available, you may still see the preview, and may even be able to print a contact sheet, but you can't modify the image, or use them in any other way. If you try to work with them, Lightroom will bring up an error message.

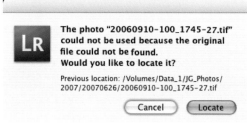

If you merely moved an image or renamed it, you can easily refer Lightroom to the new image location. Click on the ⑦ icon in the Filmstrip, and Lightroom offers to locate the file (see Figure 9-12). If you confirm this request (by clicking *Locate*), Lightroom brings up a browser dialog. In the dialog, you can direct Lightroom to the new folder or new name of the image and Lightroom will update its reference. Of course, you can also delete the image or folder from your catalog as described in section 3.2.

Figure 9-12: LR offers to locate a moved file and reconnect its link to the new location.

Occasionally, you may wish to move your whole filing system containing your image hierarchy to a new disk, e.g., to migrate your images to a faster disk or a disk providing more space. With Lightroom, there are two ways of doing this:

1. Use Lightroom to transfer your files to the new location.

2. Move your files by other means, e.g., your Windows *Explorer* or Mac OS *Finder*. When you're doing this, Lightroom should not be running.

 If you have merely copied your files and not moved them, temporarily rename your old top folder.

Moving Files Using Lightroom Tools

Moving complete folders or even a whole folder hierarchy to a new location can be done using Lightroom. This will ensure that all links (those in the catalog to your image files) are kept consistent and Lightroom's database will be up-to-date when the transfer is finished. It may, however, take a bit longer than using external tools.

1. First create your new destination folder. When you're moving a complete file hierarchy, this will be the top folder. In Lightroom, choose Library ▸ New Folder. The new folder will be listed in your *Folders* pane.

2. In your Folders pane, drag the current folder onto the new folder. Lightroom brings up a warning (see Figure 9-13). If you confirm the operation (click *Move*), Lightroom performs the transfer. With a large folder, this indeed will take some time, and you can't really work with Lightroom while this process is running. On the other hand, no further action is required when the job is finished. Files and folders will be removed from the old location.

Figure 9-13: *Lightroom will ask for a confirmation before moving folders.*

Moving Files Using External Tools

Sometimes it may be more convenient to move your files using your *Finder* (Mac) or *Explorer* (Windows) or some backup application. When Lightroom detects that a folder is no longer available at its previous location, it marks the folder red in the Folders pane.

Right-clicking the folder (in the Folders pane) will offer two options (see Figure 9-14): to *Delete* the folder (removing it and all its images from the Lightroom catalog) or to *Locate Missing Folder*. Selecting the latter brings up a dialog allowing you to refer Lightroom to the new location. The update of your catalog will be reasonably quick.

Figure 9-14: *Lightroom will mark the missing folder red. The fly-out menu allows you to delete the folder or to direct LR to its new location.*

Exporting Folders to a New Lightroom Catalog

Since Lightroom version 1.1, you can export images or folders (or any selection) to a new Lightroom catalog.

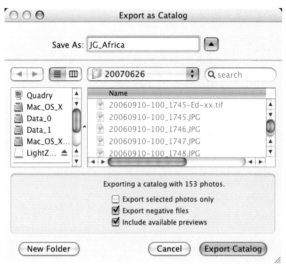

Figure 9-15: When exporting folders to a new catalog you can include the previews icon as well as the images files.

First select the folder you intend to export. Right-click on the folder and select *Export This Folder as a Catalog.* Lightroom will bring up an export dialog (see Figure 9-15). It allows you to include all images contained in the folder and all its subfolders. You can exclude individual subfolders. Lightroom optionally allows you to export the current previews as well.

This is also a good way to migrate images including all catalog information from one system to another, for instance, from your laptop to your workstation at home. Both have to be connected using a LAN or wireless LAN. Having transferred your images and catalog info this way, in a second step you then import your catalog information into your main catalog (as described later) and then delete the temporary catalog.

This intermediate step, however, is only necessary if you have grouped images into stacks, built collections, or made some virtual copies. Standard metadata and editing settings you will be able to transfer by simply copying your folders to your target system and importing their content. On your source system, you should, however, activate the options: "*Write develop settings to XMP for JPG, TIFF, and PSD*" and "*Automatically write changes into XMP*" in the catalog settings.* Alternatively, before copying your folders from source to destination, select all images (in your original catalog) and save the metadata to files (Metadata ▸ Save Metadata to Files). This will ensure that at least all metadata and editing done on your laptop will be transferred to your target system.

* See section 2.8, Figure 2-17 Ⓑ and Ⓒ on page 38.

Importing from Another Lightroom Catalog

With Lightroom 1.2, there is no function yet to directly copy or move images from one catalog to another. However, Lightroom allows you to import images from another catalog (or a library of version 1.0).

Use File ▸ Import from Catalog. Lightroom analyzes the catalog that has to be imported. Depending on the size of the catalog, it may take a while for the import dialog to show up (Figure 9-16).

In this dialog, you can choose folders to import – all or just specific ones (Figure 9-16 Ⓐ). With *File Handling* (Ⓑ), you decide if you want to copy the files to a new location or leave them at their current location. This is all very much the same as importing new images. Finally, you can specify how to handle duplicate photos (see Figure 9-16 Ⓒ).

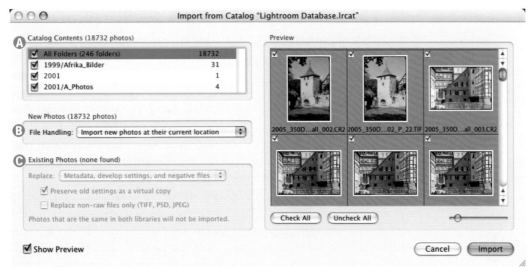

Figure 9-16: Import dialog when importing from another LR catalog

Migrating Catalogs/Libraries to New Lightroom Versions

You can also use the method previously described to migrate your data from a LR version 1.0 "library" to a Lightroom version 1.1 or 1.2 catalog. As is often the case with databases, a database conversion has to be done when updating to a new version of a database application. This may be a nuisance, but can't be helped. In most cases, the transition will take a while but will run smoothly.

Alternatively, you can simply open your old catalog* using LR 1.1 (or any newer version). Lightroom will convert your old catalog on-the-fly. In this case, however, we recommend making a backup of your old catalog/library. After such an import or conversion, we recommend optimizing your new catalog as described later.

** Previously called "library"*

Take care of your catalogs

Your catalog, being the Lightroom repository, is the administrative heart. Its health and the consistency of its data is essential for the welfare of Lightroom and your images. Therefore, it is advisable to check regularly and to create additional backup copies. Both functions are offered by Lightroom and can be configured in the Catalog Settings (see Figure 9-19),* and both processes will take time but are well worth it.

Since Lightroom 1.1, some of the Preference settings are specific to the individual catalogs. You can find these settings and can change them via File ▸ Catalog Settings, where you find three tabs: *General*, *File Handling* , and *Metadata*. In *General*, you define your backup strategy for the catalog. For most users, *Once a day upon starting Lightroom,* is sufficient.

➜ With the current version of Lightroom the active catalog must not reside on a network drive and has to be write-enabled!

** Additionally, see section 2.8, page 37.*

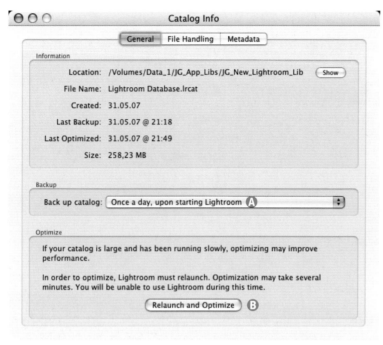

Figure 9-17: From time to time, it may be well worth optimizing your catalogs.

Catalog Optimization

Though Lightroom uses a database for its catalogs, a catalog can get cluttered and slow to work with. If this happens, you should optimize your catalog: choose File ▸ Catalog Settings and click the *Relaunch and Optimize* button of the *General* tab (see Figure 9-17 Ⓑ). If your catalog was cluttered, this should improve the performance. Depending on the size of the catalog, the optimization may take a few minutes (or even a bit more).

If you work frequently with Lightroom, we recommend that you do this once a month and after having imported from another large catalog.

You can find more about the settings in *Catalog Info* in section 2.8 page 37–40.

Additional Catalog Backups

Although Lightroom allows you to verify the catalog's integrity every time Lightroom starts, and, additionally, to create a copy of the current catalog, this copy might not really be sufficient as a backup because the backup copy by default is placed on the same disk and in the same folder as the working catalog (see Figure 9-18). Therefore, you should create backup copies on another disk or media – either on removable media like a DVD or on an external disk. Lightroom can do this if you configure the catalog in a way that places the backup copy on a separate disk. You set a new destination folder for your catalog backup in the startup dialog of Lightroom (see Figure 9-18) by clicking the *Choose* button.

If a dialog does not appear when Lightroom starts, open the catalog settings (File ▸ Catalog Settings) and select *Every time Lightroom starts* from the *Back up catalog* menu Ⓐ (see Figure 9-17).

Figure 9-18: Depending on your catalog's configuration, Lightroom may ask you whether you want to backup your catalog when starting Lightroom.

As these catalogs tend to become quite large when the number of images in the library grows, you should delete your older backup copies from time to time. However, you can also save space by compressing these backups using some sort of compression software.

Working with Mac OS X and using a backup folder with an associated folder action that automatically compresses new backups, this compression can be done automatically. Daniel Neeley created such a folder Automator, unfortunately, only for the Mac OS. You will find it at [21], including detailed instructions for the setup. This compression will save you about 85% of the space required for the backup. A solution that would keep only the last few versions of the backup would be a further improvement.

If you compress the backup copy, you naturally have to decompress it before using it with Lightroom.

9.3 Back Up Your Data

If your images and the time spent in grouping, optimizing, and attributing them are of any value – personally or professionally – you should take the time to back up your essential data. First let's have a look at which items to back up:

1. Image files – the originals as well as your derived files.[*]

2. Lightroom repositories (catalogs). This may optionally include your preview images, though in case of a loss, they can be re-created easily. Lightroom will re-create missing previews images on-the-fly when accessing the folder containing the files or when displaying the icon in the Filmstrip or in Grid view.

3. All self-created or downloaded preset and template files. Because these files reside in your user directory, you can use your common backup tools.

4. Your operating system disk, including Lightroom and other programs.

Originals coming from the camera In section 3.1, you saw how to create an (optional) additional first backup copy for your imported images.

Lightroom, if properly configured, can automatically create backup copies of its catalogs. As mentioned, for safety reasons this backup should be stored on a different physical disk than the one where your primary catalog resides. However, it may make sense to have an additional offline copy of these files.[*]

Backup of your OS and programs disk With Mac OS X, to do the backup of the system disk (including all applications installed) we use *SuperDuper!* [34]. It is able to produce bootable copies of the OS disk, works quite reliably and fast, can operate in a scheduled manner, and is reasonably priced.[**] Having done a complete backup once, it can do an intelligent scheduled incremental backup the next time, saving some time.

For Windows, you can use *Acronis True Image* for the backup of the operation system disk. It can be used even while Windows is running.

** "Derived files" are those that were developed (derived) from original files.*

→ We recommend putting your operating system files (including installed applications and associated libraries) on a disk or partition that is separated from your user data (including your images files).

** For professionals, we even recommend storing them out of your house, e.g., in a bank safe or the house of a friend or at home if your originals are at your company's site.*

*** With Mac OS X, a suitable alternative – though a bit less comfortable – would be "Carbon Copy Cloner" [36].*

Backup of user data With Mac OS X, for the backup of the user data and image data (your filing system for your images and for the backup of Lightroom's catalogs), we use *CronoSync* [35]. We save this data on an external hard disk drive twice: one copy will remain on a network drive and a second copy on an external disk that can be detached and stored in a different location.

To back up user data (and other standard files) on Windows we use *PCBack* [37]. Like *CronoSync,* it allows you to synchronize folders, and we use a LAN disk for our backup there.

Of course, there are many other alternative solutions. However, it is important that the backup is done regularly, preferably automatically, and that you check whether the backups are readable and complete. After you've done the backup the first time and then from time to time, you should definitely make sure you can really restore your data from your backup media.

➡ *This whole discussion may sound excessive, but both authors worked in IT departments and have learned from grievous experience.*

We burn another backup copy, only of the RAW images, on DVDs. We create them using the DVD folders as described in section 3.1.

9.4 Performance Issues

➡ *The performance of Lightroom will improve by upgrading from LR 1.0 to LR 1.1 and again some more with version 1.2. This may be partially due to the fact that with LR 1.1, preview icons are no longer contained in a folder but in the library. This prevents virus scanners from doing a virus check each time a preview is accessed.*

All applications that use a database and access a lot of files are performance sensitive. The same is true for Lightroom. When you work with a large catalog, doing a catalog optimization (as described) from time to time is one way to improve the performance of Lightroom.

Another critical issue (when you work with lots of files) are the Preferences/Catalog settings "*Write develop settings to XMP …*" and "*Automatically write changes into XMP*". Though these settings will increase the interoperability with other applications (see section 9-19), it can cause performance issues.

If you have these issues, deactivate this feature (call up the setting using File ▸ Catalog Settings and click on the *Metadata* tab), as illustrated in Figure 9-19.

Figure 9-19: Deactivating the option might improve your LR performance.

Further performance improvements can be achieved by setting up your virus scanner in a way that avoids doing virus checking on the image folders (each time an image file is accessed). Though this might increase the risk, it should be sufficient only to check these files (folders) once a week or only with the nightly virus checks.

9.5 Lightroom's Templates and Presets

The basic concept of the templates was described in section 2.6. Depending on the module the template is intended for, these items are either called *templates* or *presets*. There are templates (or presets) for each of the different modules (*Develop*, *Slideshow*, *Print,* and *Web*). You can easily create or add additional templates and presets and modify existing ones.

Additionally, there are templates for *Export* preferences, templates for file naming, and templates that can be used with Import and Export. You can create templates for metadata too and assign them to your images when importing, and, metadata templates that you can use to define which kind of information (metadata) should be shown as overlays for slideshows, when printing, or for Web galleries. The different kinds of templates are stored in separate files and directories.

Where to Find Your Templates

Mac OS:[*] ~ /Library/Application Support/Adobe/Lightroom/

Windows XP:[**] C:\Documents and Settings*username*\\Application Data\\Adobe\\Lightroom\\

Windows Vista:[**] C:\Users*username*\\Application Data\\Adobe\\Lightroom\\

** ~ is the abbreviation for your user'directory.*

*** Replace the "username" part of this path with your Windows username.*

With Windows, these are hidden folders that are visible only if you activate and deactivate suitable options in Explorer under Folder Options. Select Tools ▸ Folder Options and select *View* tab there. Then set options as illustrated in Figure 9-20.

Often, it's simpler just to select your template in your Template Browser (part of the Navigator panel to the left), right-click it, and select *Show in Finder* from the fly-out menu (see Figure 9-21). Lightroom will open the file browser of the operating system and show you the template file there.

Figure 9-20: To see your template folders and files, deactivate the viewing options marked above.

Figure 9-21:
To see the template in its folder, select the template, right-click, and select "Show in Finder".

Figure 9-22: There is a separate folder for each group of presets.

There is a subfolder for each type of template, e.g., "Develop Presets" for the templates of *Develop* mode. Figure 9-22 shows these folders. You can structure your templates by using more subfolders that will be mirrored in your Presets list. Since Lightroom 1.1, there is a separate subfolder for all user-defined presets/templates. If you have a lot of presets/templates, we recommend using subfolders.

Using the fly-out menu shown in Figure 9-21, you can also delete existing templates and folders and you can export and import templates that you may have downloaded from the Web – some of them even free of charge. See [16], [17], and [19] for some examples of free Lightroom templates and presets.

These presets (or templates) are text files, readable and editable using an XML structure. You can edit them using any text editor that supports UTF-8 encoding. With Mac OS X you can, for instance, use *TextEdit* or *Bedit*; with Windows, *WordPad* (but not *Notepad*) can be used for editing.

The templates all have an ".*lrtemplate*" extension. Because by default this extension has no associated application, you can't open them simply with a double-click; you have to open them in the editor explicitly.

When you save a modified template, make sure it is saved as a UTF-8 text file and not as a RTF or in another format. Additionally, the name must have an ".lrtemplate" extension; otherwise Lightroom will not recognize it!

When you're editing these templates, it is mandatory to know their anatomy and stick to the XML syntax. A description of their anatomy can be found at a website called "*Inside Lightroom*". Before editing a template using an editor, first make a copy of the template and only work with this copy.

Inside Lightroom:
http://inside-lightroom.com/docs/

With some intuition, you will find your way in these templates relatively easily. Figure 9-23 shows an example of a Develop Preset and its associated Lightroom preferences.

Modifying a slideshow or web template is more complicated. For those, we recommend visiting the web blog by Bluefire.

Bluefire blog: www.bluefire.tv

Preset Anatomy

We assume that Adobe will soon provide a detailed description of the template/preset structure. Therefore, here we will provide only a brief and somewhat simplified description without going into much detail. Figure 9-23 illustrates a Develop preset. It is a copy of the *Cyanotype Develop* preset, provided with version 1.0 of Lightroom. To get a better mapping of items in this example to the Lightroom's settings as illustrated in Figure 9-23, we have changed the order of some items. This reordering does not damage the Develop preset.

The preset starts with a *Title* line, containing the filename, followed by the name that will show up in Lightroom for this preset (the part behind the = character):

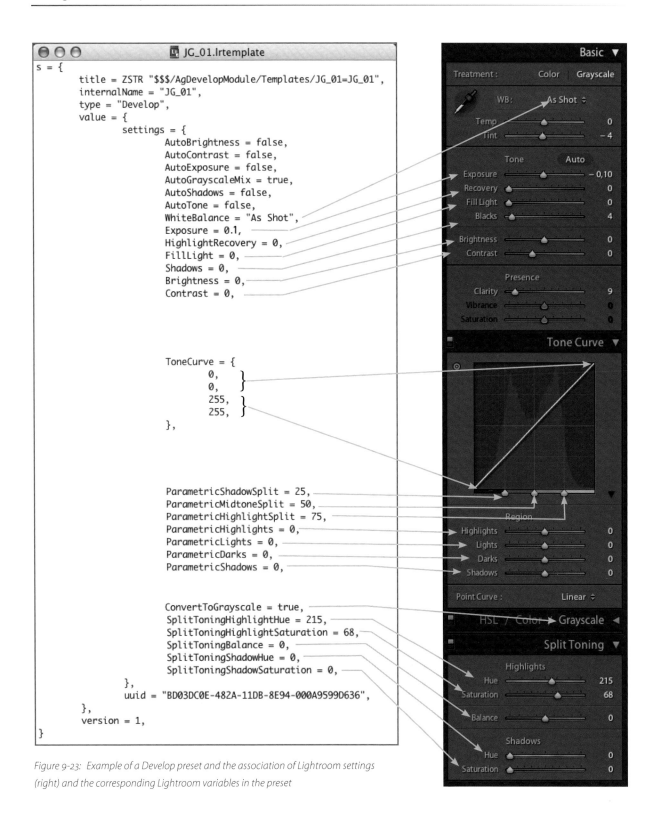

Figure 9-23: Example of a Develop preset and the association of Lightroom settings (right) and the corresponding Lightroom variables in the preset

> **title=ZSRT** "... *filename=name_as_shown_in_LR*"

This is followed by

> **internalName** = "*LR_internal_name*"

and the kind of the template

> **type** = "*kind_of_template*"

Here, for instance, *Develop* stands for a template for the *Develop* module.

This is followed by the actual parameter settings given as pairs of names and values in the following way:

> *name = value*

where *name* is Lightroom's internal name for the respective setting. The different settings may have different types of values, and we could not find an official Adobe description of the various variables; in most cases, however, you can easily see the type of value when looking at the corresponding setting in the Lightroom panels.

Here are some examples of value types:

▸ Numeric (e.g., 75). Non-integer values (e.g., ›Exposure = 0.1‹)
▸ Logical values (›true‹ for *on* or *active* or ›false‹ for *off* or *inactive*)
▸ Character strings, placed in "..."

If an item value is built up by several individual parts, a comma separates the parts. Indents and line breaks serve for clarity, but they have no syntactic meaning.

This list is followed by an UUID (explained in the next section). Additionally, in its templates and presets, Adobe makes use of version numbers. You should do the same with your own templates and presets.

With all these items, a proper, symmetrical {...} bracketing is mandatory.

UUIDs

Develop presets all have an UUID – a *Universally Unique Identifier*. This is an identification that must be unique for each preset. With the help of this UUID, Lightroom identifies the preset used for an image.

If you create your own Develop presets using Lightroom, the application will automatically generate a new unique UUID for you. If you create your own preset using an editor (or modify an existing preset), you should give it a new, unique UUID (not used up to now). You will find the UUID line at the end of the preset. This UUID line looks like this:

```
uuid = "BD03DC0E-482A-11DB-8E94-000A9599D634"
```

With Mac OS X, there is a small utility that will generate unique UUIDs. You can call it up in the *Terminal* utility:

```
uuidgen
```

Just copy and paste the result from the terminal window to your editor window.

The simplest way to make a custom Develop preset is by editing an image, setting up all the controls you want to use in your preset. Now save these settings to a new preset. You can then open it by using a text editor and inspect and optionally modify it. Especially with metadata templates, editing may be useful in some cases. As the presets and templates will appear in the list of your Template/Preset Browser alphabetically sorted, you can influence the order of appearance with the names you apply.

9.6 Interoperability

Lightroom turns out to be a rather open system. It operates well with Adobe applications like Photoshop CS2 and CS3, with Adobe Camera Raw, as well as with Bridge of CS2 and CS3. If you still use Photoshop CS2, we recommend ACR 3.7 (or any follow-up version of it) because this ACR version will understand the correction set of Lightroom 1.0 – even if it does not offer all interface elements of Lightroom. Using ACR 4.2 provides all the Develop controls Lightroom 1.2 offers. Exceptions are as follows:

▸ Snapshots
▸ History
▸ Stacks
▸ Virtual copies

➡ *ACR 4.2, which provides all the basic controls of Lightroom 1.2, runs with Photoshop CS3 and Photoshop Elements 4 and 6. Probably more ACR versions and Lightroom updates will come out before Lightroom 2. They will support new cameras and fix problems, but provide no new functionality.*

Lightroom also imports images from Adobe Photoshop Album and Adobe Photoshop Elements libraries.

To achieve a high degree of interoperability with ACR and Bridge, you should set your Lightroom catalog preferences so that all metadata and corrections are written back into the image files or into a sidecar file.* With this setting, metadata will also be visible to other applications that can deal with XMP-based information (e.g., iView MediaPro and Extensis Portfolio and in parts also Apple Aperture).**

If you failed to activate this option or omitted it for specific reasons,*** this metadata can still be exported or embedded later on. For this, in Library mode, select the images whose metadata you want to export. Then export them by using Metadata ▸ Save Metadata to File (or use Ctrl-S or ⌘-S with the Mac).

You can also convert RAW files (from Lightroom) using other RAW converters. These RAW converters (all but ACR starting with version 4.2)

* *See section 2.8, page 38 for this setup.*

** *With this option set, ACR 4.x and Photoshop will even be aware of Lightroom's develop settings for this image.*

*** *One reason for not activating this option is performance issues, as mentioned earlier.*

will, however, ignore all the corrections done in Lightroom. We frequently use Photoshop as well as LightZone to enhance Lightroom-controlled images using functions Lightroom does not provide. This, for instance, applies to selective editing* or corrections of lens distortion or perspective corrections (in Photoshop). We also use this method to apply filters (mostly in Photoshop, e.g., to do some local contrast enhancements). In all these cases, we use 16-bit TIFF files that are passed along by Lightroom to the external editor.

** We do it this either in Photoshop using adjustment layers or in LightZone using regions.*

All-in-all, the interoperability of Lightroom with Photoshop, Bridge, and Adobe Camera Raw is quite good. This will please all those professionals who have to use Photoshop from time to time for some special tasks – e.g., converting images to CMYK for offset printing, layer-based editing, and more.

9.7 Spell Checking

Typos are common mistakes when editing on a computer. A spell checker helps to find some of these typos. Therefore, before you publish a slideshow, a print with additional text information, or a Web gallery, you can use Lightroom's spell checker to check your document. It will work on keywords as well as other types of metadata or added text. You will find the spell checker under Edit ▸ Spelling.

Figure 9-24: When "Check Spelling as You Type" is active, LR will mark words not spelled correctly with a red squiggly line.

However, this feature can be activated only if the mouse cursor is inside an input field. Unfortunately, it is not possible to check through all the text of a slideshow, Web gallery, a print, or all your metadata for an image but only through individual fields. This turns out to be quite annoying.

Figure 9-25: LR dialog when it finds a misspelled word, suggesting a correction.

Therefore, we recommend activating *Check Spelling as You Type* when you begin to edit the very first entry. With this option active, Lightroom will immediately check any text that you enter. It will mark any word unknown to Lightroom or misspelled with a red squiggly line.

As with most spell checkers nowadays, when detecting an unknown word, Lightroom offers to add this word to your dictionary (click on *Learn*), and also to select the dictionary language to be used. Finding a word spelled incorrectly, Lightroom will in many cases suggest a correction, which you may accept or correct. Alternatively, for the time being, you can tell Lightroom to ignore the word.

In practice, due to its restriction to single entries, Lightroom's spell checking turns out to be of little use.

9.8 Calibrate and Profile Your Monitor

For the assessment and editing of images, a correct color reproduction on screen is essential. How can you correctly assess colors and tonality if you are not sure that the colors on your monitor are the ones that are in the image?

Manufacturers' monitor settings will result in crisp and pleasing image reproduction – often, however, the colors are not necessarily reproducing truthfully. Therefore, you should calibrate and profile your monitor if you intend to do serious color work. There are two basic approaches for this:

a) Calibrating and profiling your monitor visually using your eyes as a measuring instrument

b) Making use of a colorimeter to calibrate and profile your monitor

The first way is inexpensive but rather inexact, unfortunately. The second way requires investing in a calibration suite (including software and hardware) but results in a more precise profiling.

In all cases, the first step is to set up your graphics card to a color depth of 24 bits or more. Additionally, the monitor should have warmed up for approximately 30 minutes.

Actually, what is called *calibration* (or *profiling*) ideally consists of two steps:

1. **Calibration**
The aim of calibration is to define a highly accurate, *standardized state* for the device; for example, when calibrating a monitor, you manually set the controls to achieve a certain *luminance** that is known to suit color work. Also, you set a *white point* that conforms to an industry standard, such as D50 or D65 (color temperatures of 5,000 or 6,500 Kelvin, respectively). The *white point* of your monitor is a mix of R, G, and B that will represent *white*.

 * *Brightness of your monitor's white*

2. **Characterization (profiling)**
When a monitor is characterized, colored target patches with known color values are sent to the monitor. Their color values, as reproduced by the monitor, are recorded by a colorimeter. The profiling software will then compare these color values to the ones sent out and calculate a device's *color profile* from that. The profile is essentially a translation table. It translates the color values of the image to those that have to be sent to the monitor in order to produce a color as close as possible to that of the original image.

 A colorimeter is an instrument that measures the red, green, and blue light spectrum (returning an RGB value) of a light source – here that of the colored light sent out by the monitor.

To perform either step, especially when calibrating a monitor, it is advisable to use a hardware device like a colorimeter or a spectrophotometer to measure color.

Only somewhat more expensive profiling suites will offer both functions, while the less expensive packages (like Pantone's *huey*) will offer only profiling (characterization).

Lightroom, of course, is "color management" aware, implying that it does color-manage your images wherever possible, also making use of monitor ICC profiles.

Software-Based Profiling for Monitors

Windows

The current versions for Windows as well as Mac OS X offer a simple calibration/profiling of the monitor without a profiling appliance, instead using test images and a wizard.

With Windows, you will find this application under Start ▸ Control Panel ▸ Adobe Gamma – only, however, if you have installed any of the numerous Adobe application supporting color management.*

** For instance, Adobe Photoshop, Elements, FrameMaker or Acrobat*

Adobe Gamma offers two modes: "Step by Step (wizard)" or more directly using the Control Panel.

Figure 9-26: Calibration Assistant (Adobe Gamma) under Windows

When you're using the Control Panel version of Adobe Gamma, the panel will include all essential preferences (Figure 9-26) in a dialog box. You can also call up the Gamma Wizard from this dialog. In the dialog, you set three parameters:

▸ **Phosphors** (LCD displays use another luminous type)

▸ **Gamma** (see the description on the next page; we recommend a value of 2.2): If you deactivate *View Single Gamma Only* (Figure 9-26), you can set up the individual gamma values for red, green and blue. Using the sliders below the colored patches, make the inner and outer rectangles blend as well as possible. For this, it helps to slightly close your eye until the fields get blurred.

▸ **White Point**: Here you should set the white point to that of the color space with which you work predominantly. With sRGB and Adobe RGB (1998), this is 6500 K.

The monitor profile thus created can be saved – actually, Adobe Gamma will do this automatically – and can be recalled later on – either automatically using the Adobe gamma loader or by using Start ▸ Control Panel ▸ Display ▸ Settings ▸ Advanced ▸ ↓ Color Management.

Display Calibrator Assistant of Mac OS X

With Mac OS X, a *Display Calibrator Assistant* is available for calibrating (actually for calibrating and profiling) your monitor. You will find it by following these steps: Open *System Preferences* from your Dock. Select *Displays* and choose the *Color* tab. Now select your monitor (if you have more than one) and click *Calibrate*. This will bring up the *Display Calibrator Assistant* (see Figure 9-27). Here, activate *Expert Mode*. Now follow the instructions of the Assistant. It will guide you through the whole process using simple steps, finally creating a monitor ICC profile and activating it.

Figure 9-27:
The "Display Calibrator Assistant" of Mac OS X will guide you with simple, well-explained steps through the whole calibration process.

For Windows, and to a lesser extent also for Mac OS X, there are some more ways to set up your monitor for the best results. To the right we've listed the URLs with more information.

Sites with help for monitor calibration:
http://epaperpress.com/monitorcal/
http://www.softpedia.com/get/Tweak/
Video-Tweak/

Monitor gamma

With monitors, there is a nonlinear relation concerning input voltage and brightness. Applied to CRT monitors, for example, to achieve 100 percent luminance will require more than double the voltage of 50 percent luminance. The gamma value of displays gives, moreover, a correction factor. This curve also depends on the white point you intend to use. This gamma curve actually describes how luminance values are distributed from black to white and what luminance level 50 % will have. Traditionally, a gamma of 2.2 is used for Windows, while with Mac OS, a gamma of 1.8 was the standard for a long time. This means that the same image looks brighter and shows a bit less contrast when displayed with Mac OS (using gamma 1.8) than it does with Windows (using gamma 2.2). To achieve a similar look on both

* Lightroom, however, does not support CMYK.

systems, you have to use the same gamma value. The standard gamma value of 2.2 fits better to sRGB and Adobe RGB color space, while the Mac value of 1.8 better matches ECI-RGB as well as the processing of CMYK images when preparing them for press printing.* In general, a gamma of 2.2 is preferable; we recommend it explicitly. Of course, other gamma values can be used; however, you should not go beyond a gamma of 2.2.

For a fine color differentiation with your monitor, in particular in grayscale, lower gamma values (about 1.4–1.8) are better suited than higher ones. Unfortunately, this does not get on optimally with the Windows default settings and the gamma values accepted there of digital photos– such as those without embedded color profiles.

* For instance see
www.hutchcolor.com/images_and_targets.
html

The gray wedges, which one finds on the web,** allow you to check whether the current gamma setting (brightness and contrast) of your display is suitable for photo editing. If you can distinguish all grayscales to be found there cleanly on the display, you have a useful setting.

Hardware-Based Profiling for Monitors

Although calibrating your monitor by eye is better than doing no calibration at all, if accuracy and precision are important, you should use a hardware-based, color-measuring device, e.g., a spectrophotometer or colorimeter to achieve optimal results. There are several reasonably priced packages currently available starting from $90 and going up to about $250 for a complete kit.* If you can afford it, we recommend the GretagMacbeth/X-Rite Eye-One Display 2 kit. While the cheaper packages (e.g., Pantone's huey) allow only for profiling and provide no calibration, the more expensive packages also allow you to calibrate your monitor and to freely select the target values (gamma, luminance, and white point).

* Your choices include: GretagMacbeth Eye-One Display 2 [44], ColorVision Spyder and Spyder Pro products, and the entry-level device huey, which is sold by Pantone as well as by GretagMacbeth/X-Rite [44].

→ Here are the target values we recommend you to use when calibrating and profiling your monitor (both for Windows and Mac OS X):

Gamma: 2,2
White Point: 6 500 K (D65)
Luminance: 100 cd/m² for CRTs and
 120–140 cd/m² for LCDs

The entire calibration and profiling process will take you about ten minutes. After a good initial calibration is achieved, the next calibration will be even faster. Depending on your personal quality requirements, you should re-calibrate (and re-profile) your monitor every month. Some professionals do this even once a day.

With hardware-based calibration packages such as huey™ or Spyder2 Express for about $90, there is hardly an excuse for not using one of these hardware-based monitor profiling packages if you care about color confidence in your work!

Monitor Profiling with huey

Of all the monitor profile packages we know of, **huey** is the simplest to use. This set, sold by Pantone for less than $100, will run with Windows XP (and Windows 2000), as well as with Mac OS X (10.3 or higher). It requires a spare USB port. It will profile CRTs as well as LCDs and LCD laptops.

The package includes profiling software and the huey colorimeter. This is a device used to measure the three primary colors (R, G, and B) of a monitor.

The colorimeter is quite small and handy and comes with a small support stand seen in Figure 9-28. The stand helps to measure the room light.

The colorimeter is connected to your computer via USB – though the USB cable is a bit short for our taste.

The installation of the huey package is straightforward and doesn't pose a problem – but you should connect the huey to the USB port only *after* installing the software. After installing the package, you will see a huey icon on your desktop (Windows) and in your Taskbar. A click on it will start the profiling of your monitor. With Mac OS X, having two or more monitors, you will have to relocate the menu bar to the display you want to profile.

Figure 9-28: huey colorimeter, about 4 inches tall

What is missing, unfortunately, is a reasonable online manual containing at least a brief introduction on monitor profiling. However, the program provides some online help.

The entire process of monitor profiling takes about five minutes and will run like this:

1. After starting huey, you must select the kind of display in use. The program, in almost all cases, will do an educated guess, so you need only to confirm the selection and continue.

2. The program next measures the room ambient light. So it can do so, you place the device in its stand and align it with your display – facing you (see Figure 9-28) and away from the screen.

3. Now, remove the device from its stand and place it on your monitor using its suction cups. The position for the huey is clearly marked (see Figure 9-30). While reasonable with CRTs, this is questionable with an LCD, whose surface is quite sensitive to damage.

Figure 9-29: The second step is measuring the room ambient light.

Other packages use a counterweight on the USB cable hanging at the rear of the monitor. They should have done something similar for the huey (using a longer and stronger USB cable). I prefer to hold the huey with light pressure to the LCD surface by hand for the few minutes taken for the entire process.

Place sensor on the display as shown.

Be sure that the sensor is properly attached to the screen surface so it does not fall off during measurement.

Click **NEXT** when ready.

Hints:

Clean the suction cups or moisten them with a bit of water if the sensor does not stick well.

For best results make sure that your screen is clean, too. Use a cleaning product approved by your display's manufacturer.

Figure 9-30: Place your huey on the screen on top of the place indicated.

4. In the next step, the program outputs a sequence of colored patches onto the monitor. The colors of these patches are measured by the colorimeter (Figure 9-31).

Figure 9-31:
The huey program will display a sequence of different colored patches that are measured by the colorimeter. To the left, you see a kind of progress bar.

This process takes about 3–4 minutes. Do not switch to another program while the huey profiling is running.

Calibration Successful!

Show Corrected Show Uncorrected

Calibration Successful

Select **Show corrected** to see how the screen looks with huey calibration.

Select **Show uncorrected** to see how the screen looks without huey calibration.

Hints:

You can also select between corrected and uncorrected in the huey Preferences window.

Access the huey Preferences window by selecting it from the menu that appears when you click on the huey icon in the system tray (Windows) or the huey system preferences

Figure 9-32: A first version of the profile is finished. You can switch between a before and after view.

5. Having finished the displaying/measuring sequence, the program has all the values to calculate the monitor profile. The display in Figure 9-32 will appear, allowing you to see the test image before and after profiling.

6. The huey program offers profiles for a number of different purposes (see Figure 9-33). The names are a bit fuzzy. This may be for novice users to color management, but it is – in our opinion – not a good choice for photographers. On the right of Figure 9-33 is a translation for these settings (color temperature and gamma).

Figure 9-33: The switch allows you to temporarily deactivate the effect of the controls.

Target values for the different huey settings (white point and gamma):

Gaming:	*D65, G 1,8*
Web-Browsing & Photo Editing:	
	D65, G 2,2
Graphic Design & Video Editing:	
	D65, G 2,5
Warm, low contrast:	*D50, G 1,8*
Warm, medium contrast:	*D50, G 2,2*
Warm, high contrast:	*D50, G 2,5*
Cool, low contrast:	*D75, G 1,8*
Cool, medium contrast:	*D75, G 2,2*
Cool, high contrast:	*D75, G 2,5*

D50 corresponds to 5 000 Kelvin.
D65 corresponds to 6 500 Kelvin.
D75 corresponds to 7 500 Kelvin.

With this, you are finished. Huey will install the new profile – in a directory appropriate for your operating system, and activate it.

7. In a final dialog, you can select whether huey should monitor your ambient room light and adapt the profile accordingly (see Figure 9-34). We disabled this function, but you may change this setting later on.

Figure 9-34:
You can activate a permanent measurement of the room light and a corresponding adaptation of the monitor profile.

Profiling your monitor with huey is extremely easy – really made for the beginner. Our results with a laptop were good – better than with some more expensive packages. Those others, however, lead to somewhat better results with standard monitors, but not with laptops.

We repeated this on Macintosh monitors and also with our Windows systems. In both cases, the results using huey were good.

Since 2007 there is a Pro version of the huey tool available* which will permit to calibrate several monitors to the same setting, and offers D-numbers and gamma values instead of the ones shown in the sidebar above.

** The standard huey can be upgraded to the Pro version by a firmware update.*

9.9 Geotagging

Recently, we had a photo shoot walking in San Francisco's Chinatown. We tested the new DeLorme Earthmate GPS PN-20 tracking the route (see Figure 9-35). At home, we saved the track from the GPS onto a Mac as a ".gpx" file. A nice Mac freeware ([50], donations welcome), *GPSPhotoLinker,* opened all our RAW files and the GPX file. Using these data, GPSPhotoLinker is capable of embedding the GPS data into the RAW file's metadata – the EXIF part. Lightroom understands and displays these GPS data. An example is shown below.

Figure 9-35: Earthmate GPS PN-20 by DeLorme. This we used to track the GPS position of shots we took.

Figure 9-36: Lightroom's preview of one of the images we shot on our walk.

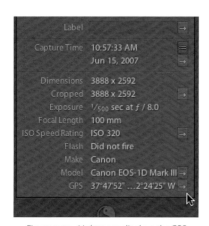

Figure 9-37: Lightroom displays the GPS data that was embedded into the image by GPSPhotoLinker.

We shot this image during this walk. Figure 9-37 illustrates the GPS data as shown by Lightroom. If you click on the little arrow to the right of the GPS data, Lightroom will launch Google Maps in your browser and show the location (see Figure 9-38).

After you copy the coordinates in Google Maps, it is easy to use Google Earth for even a closer inspection, as illustrated by Figure 9-39.

The automatically estimated GPS location (see coordinates) differ by about 20 meters (we took the shot at the location with the red dot). At this point, we had been walking at least 2 to 3 miles using our Earthmate GPS tracker. (Satellite connections were on and off due to the shade of buildings.) This is amazing and also great fun. We are sold on the concept of Geotagging and will frequently carry the Earthmate appliance with us from now on.

One thing you have to watch for doing geotagging is that your camera's clock is set to the correct date and time.

Figure 9-38:
A first view using Goggle Maps on the location we did the shot.

Figure 9-39:
A close-up view of Google Earth of the location we took the shot in Figure 9-36.

Keyboard Shortcuts

 Lightroom offers keyboard shortcuts for all important operations frequently used. Working with them accelerates the workflow considerably. Therefore, here, we summarize the most important ones. On top of this, the ⌥Alt key (with Windows) and the ⌥ key (with Mac OS X have special functions with some controls as described below.

A.1 Use of Special Keys with Some Controls

In the following descriptions, replace the Windows Alt key by the ⌥ key when working with Mac OS X.

→ Some of these shortcuts we learned from a list published by Ian Lyons at his website: ww.computer-darkroom.com

Pane/Control or Tool	Effect with Alt/⌥ held down when using slider (working in the Develop module)
Basic pane	Preview pane will show clipping control of the image when using *Exposure, Recovery,* or *Blacks* slider.
Split Toning pane	Preview will show full saturation when using Highlights or Shadow *Hue* or with *Balance*.
Detail pane	Preview will be grayscale when using any of the Sharpening sliders. With Masking it show the mask.
Lens Corrections pane	Preview will be somewhat desaturated in order to show better the fringes when using the Chromatic Aberration sliders *Red/Cyan* or *Blue/Yellow*.
Keyboard + click actions	
Alt/⌥ + click on side panel	Toggles Solo mode of Parameter panel on/off
Ctrl/⌘ + click on side panel	Open or closes all panels
Caps Lock	Activates auto-next-image when rating, flagging, or color labeling
⇧ + click on pane of side panel	Opens or closes additional panes

A.2 Keyboard Shortcuts for Mac OS X

We use the following symbols for special keys: ⏎ = Return, ⇧ = Shift, and Fn function key *n*.

Shortcut (Mac)	Module	Function
Switch to module		
⌥-⌘-1	All	Mode Library
⌥-⌘-2	All	Mode Develop
⌥-⌘-3	All	Mode Slideshow
⌥-⌘-4	All	Mode Print
⌥-⌘-5	All	Mode Web
⌘-↑	All	Go back to previous Module
G	All	Module Library, Grid View
Zooming and Loupe		
⌘-=	L, D	Zoom in
⌘--	L, D	Zoom out
space	L, D	Temporarily activate ✋
⇧-⌘-Tab	L, D	Full screen mode, no palettes
⏎ (Return)	L	Loupe or 1:1
Stars ratings, Flags, and Color Labels		
1 ... 5	L, D	Set 1–5 star ratings
]	L, D	Increase star ratings
[L, D	Decrease star ratings
0	L, D	Set star ratings to none
6 ... 9	L, D	Color Label Red, Yellow, Green, Blue
P	L, D	Accept flag (**P**ick)
U	L, D	No flag (**U**nmarked)
X	L, D	Reject flag
⌘-↑	L, D	Increase flag status
⌘-↓	L, D	Decrease flag status
Image organization		
B	L, D	Add to Quick Collection
⌘-B	L, D	Show Quick Collection
⌥-⌘-B	L	Save Quick Collection
⌘-⇧-B	L	Clear Quick Collection
⌘-N	L	Create new named collection
⌘-⇧-N	L	Create new LR folder
F2	L	Rename image
⌘-L	L	Enable/Disable Filters

Shortcut (Mac)	Module	Function
Show/hide panels		
Tab	All	Hide/Show panel
⇧-Tab	All	Hide/Show all panels
F5	All	Show/Hide module picker
F6	All	Show/Hide Filmstrip
F7	All	Show/Hide left module panel
F8	All	Show/Hide right module panel
T	All	Show/Hide Toolbar
Screen modes and "Lights out" modes		
⇧-⌘-F	All	Full screen mode, no panels
F	All	Cycle screen modes
L	All	Cycle "Lights out" modes
⇧-⌘-F	All	Go to normal screen mode
⇧-⌘-L	All	Go to "Lights out" mode
Image inspection		
G	L	**G**rid view
C	L	**C**ompare view
E , D	L, D	Loupe view (**E**valuate)
#	L	Switch between Loupe and Grid
⏎	L	Switch: Fit, 1:1, Grid
Delte	L	Delete image
⌘-Delte	L	Delete rejected images
⌘-[L, D	Rotate left 90°
⌘-]	L, D	Rotate right 90°
⌘-G	L	Group images into a stack
S	L	Collapse/Expand stack
⇧-⌘-G	L	Ungroup images of stack
⌘-F	L	Find pane + switch to Grid View
Page up , Page down	L	Leave through preview images
⌘-R	L	Show in Finder
⇧-⌘-C	L	Copy Develop settings
⇧-⌥-⌘-P		Paste Develop settings
⇧-⌥-⌘-C	L	Copy metadata to LR clipboard
⇧-⌥-⌘-V	L	Paste metadata from LR clipboard

Shortcut (Mac)	Module	Function
Library Module specific		
⇧-⌘-I	L	Import photos from disk
⇧-⌘-E	All	Export
⇧-⌥-⌘-E	All	Export with previous settings
⌘-'	All	Create Virtual Copy
⇧-⌘-K	L	Set keyword shortcut
⌥-⌘-K	L	Enable/Disable Paint tool
F2	L	Rename image
Develop Module specific		
R	D	Activate Crop tool
N	D	Activate Spot Healing tool
Esc	D	Terminate tool
[D	Decrease size (Clone/Heal/Red-Eye)
]	D	Increase size (Clone/Heal/Red-Eye)
D	D	Loupe view
Y	D	View Before/After (left/right)
⇧-Y	D	View Before/After (up/down)
J	D	Show/Hide clipping
⇧-⌘-U	L, D	Auto White Balance
⌘-U		Auto Tone
⌘-E	L, D	Edit using first external editor
⌥-⌘-E	L, D	Edit using second external editor
⌘-[/ ⌘-]	L, D	Rotate left / rotate right
⇧-⌘-C	L, D	Copy settings to clipboard
⇧-⌘-V	L, D	Paste settings from clipboard
⌥-⌘-V	D	Paste settings from previous
⌘-N	L	Create new snapshot
v	L, D	Convert to Grayscale
Miscellaneous		
⌘-↵	All	Activate Impromptu slideshow
⌘-O	All	Open Catalog
⌥-⌘-, (comma)	All	Open Catalog Settings
⌘-?	All	Lightroom Help
⌘-/	All	Show shortcuts of current mode
⌥-⌘-?	All	Hide Help
⌘-C	All	Copy (field content)
⌘-P	All	Paste (into field)
⌘-X	All	Cut (field content)

Shortcut (Mac)	Module	Function
Slideshow specific		
⌘-↵	All	Activate Impromptu slideshow
↵	S	Start slideshow
Esc	All	Terminate slideshow
Space	S	Pause slideshow
⌘-T	S	Add text overlay
⌘-[/ ⌘-]	S	Rotate left / rotate right
⌘-J	S	Export slideshow
Print Module specific		
⌘-P	All	Print
⇧-⌘-P	All	Page Setup
⌥-⌘-P	P	Print one copy
⇧-⌘-T	P	Show/Hide image cell
⌘-R	P	Show/Hide rulers
⇧-⌘-H	P	Show/Hide guides
⇧-⌘-M	P	Show/Hide margins and gutters
⇧-⌘-Y	P	Page blend
⌘-[P	Rotate left
⌘-]	P	Rotate right
⇧-⌘-←	P	Go to first page
⌘-→	P	Go to next page
⌘-←	P	Go to previous page
⌘-→	P	Go to last page
Web Module specific		
⇧-⌘-P	W	Preview in Web browser
⌘-J	W	Export Web gallery
⌘-R	W	Reload Web gallery
⌘-S	W	Save Web settings
Miscellaneous		
⌘-S	All	Save current settings
⌘-N	D, S, P, W	Create new template
⇧-⌘-N	D, S, P, W	Create new template folder
⌘-A	All	Select all images
⌘-D	All	Deselect all
⌘-Z	All	Undo last action
⇧-⌘-Z	All	Redo last Undo
⌘-:	All	Spelling dialog (for current field)
⌘-; (semicolon)	All	Check spelling (current field)

A.3 Keyboard Shortcuts for Windows

We use the following symbols for special keys: `⏎` = Return, `⇧` = Shift and `Fn` for Function key *n*.

Shortcut (Win)	Module	Function
Switch to module		
`Alt`-`Ctrl`-`1`	All	Module Library
`Alt`-`Ctrl`-`2`	All	Mode Develop
`Alt`-`Ctrl`-`3`	All	Mode Slideshow
`Alt`-`Ctrl`-`4`	All	Mode Print
`Alt`-`Ctrl`-`5`	All	Mode Web
`Ctrl`-`↑`	All	Go back to previous Module
`G`	All	Module Library, Grid View
Zooming and Loupe		
`Ctrl`-`=`	L, D	Zoom in
`Ctrl`-`-`	L, D	Zoom out
`space`	L, D	Temporarily activate 🖐
`⇧`-`Ctrl`-`Tab`	L, D	Full screen mode, no palettes
`⏎` (Return)	L	Loupe or 1:1
Stars ratings, Flags and Color Labels		
`1` … `5`	L, D	Set 1–5 star ratings
`]`	L, D	Increase star ratings
`[`	L, D	Decrease star ratings
`0`	L, D	Set star ratings to none
`6` … `9`	L, D	Color Label Red, Yellow, Green, Blue
`P`	L, D	Accept flag (**P**ick)
`U`	L, D	No flag (**U**nmarked)
`X`	L, D	Reject flag
`Ctrl`-`↑`	L, D	Increase flag status
`Ctrl`-`↓`	L, D	Decrease flag status
Image organization		
`B`	L, D	Add to Quick Collection
`Ctrl`-`B`	L, D	Show Quick Collection
`Alt`-`Ctrl`-`B`	L	Save Quick Collection
`Ctrl`-`⇧`-`B`	L	Clear Quick Collection
`Ctrl`-`N`	L	Create new named collection
`Ctrl`-`⇧`-`N`	L	Create new LR folder
`F2`	L	Rename image
`Ctrl`-`L`	L	Enable/Disable Filters

Shortcut (Win)	Module	Function
Show/hide panels		
`Tab`	All	Hide/Show panel
`⇧`-`Tab`	All	Hide/Show all panels
`F5`	All	Show/Hide module picker
`F6`	All	Show/Hide filmstrip
`F7`	All	Show/Hide left module panel
`F8`	All	Show/Hide right module panel
`T`	All	Show/Hide Toolbar
Screen modes and "Lights Out" modes		
`⇧`-`Ctrl`-`F`	All	Full screen mode, no panels
`F`	All	Cycle screen modes
`L`	All	Cycle "Lights Out" modes
`⇧`-`Ctrl`-`F`	All	Go to normal screen mode
`⇧`-`Ctrl`-`L`	All	Go to "Lights Out" mode
Image inspection		
`G`	L	**G**rid view
`C`	L	**C**ompare view
`E`, `D`	L, D	Loupe view (**E**valuate)
`#`	L	Switch between Loupe and Grid
`⏎`	L	Switch: Fit, 1:1, Grid
`Delte`	L	Delete image
`Ctrl`-`Delte`	L	Delete rejected images
`Ctrl`-`[`	L, D	Rotate left 90°
`Ctrl`-`]`	L, D	Rotate right 90°
`Ctrl`-`G`	L	Group images into a stack
`S`	L	Collapse/expand stack
`⇧`-`Ctrl`-`G`	L	Ungroup images of stack
`Ctrl`-`F`	L	Find pane + switch to Grid View
`Page up`, `Page down`	L	Browse through preview images
`Ctrl`-`R`	L	Show in Finder
`⇧`-`Ctrl`-`C`	L	Copy Develop settings
`⇧`-`Alt`-`Ctrl`-`P`		Paste Develop settings
`⇧`-`Alt`-`Ctrl`-`C`	L	Copy metadata to LR clipboard
`⇧`-`Alt`-`Ctrl`-`V`	L	Paste metadata from LR clipboard

Shortcut (Win)	Module	Function
Library module specific		
⇧-Ctrl-I	L	Import photos from disk
⇧-Ctrl-E	All	Export
⇧-Alt-Ctrl-E	All	Export with previous settings
Ctrl-'	All	Create Virtual Copy
⇧-Ctrl-K	L	Set keyword shortcut
Alt-Ctrl-K	L	Enable/Disable Paint tool
F2	L	Rename image
Develop Module specific		
R	D	Activate Crop tool
N	D	Activate Spot Healing tool
[D	Decrease size (Clone/Heal/Red-Eye)
]	D	Increase size (Clone/Heal/Red-Eye)
Esc	D	Terminate tool
D	D	Loupe view
Y	D	View Before/After (left/right)
⇧-Y	D	View Before/After (up/down)
J	D	Show/Hide clipping
⇧-Ctrl-U	L, D	Auto White balance
Ctrl-U	L, D	Auto Tone
Ctrl-E	L, D	Edit using first external editor
Alt-Ctrl-E	L, D	Edit using second external editor
Ctrl-[/ Ctrl-]	L, D	Rotate left / Rotate right
⇧-Ctrl-C	L, D	Copy settings to clipboard
⇧-Ctrl-V	L, D	Paste settings from clipboard
Alt--Ctrl-V	D	Paste settings from previous
Ctrl-N	L	Create new snapshot
V	L, D	Convert to Grayscale
Miscellaneous		
Ctrl-↵	All	Activate Impromptu slideshow
Ctrl-O	All	Open Catalog
Alt-Ctrl-, (comma)	All	Open Catalog Settings
Ctrl-?	All	Lightroom Help
Ctrl-/	All	Show shortcuts of current mode
Alt-Ctrl-?	All	Hide Help
Ctrl-C	All	Copy (field content)
Ctrl-P	All	Paste (into field)
Ctrl-X	All	Cut (field content)

Shortcut (Win)	Module	Function
Slideshow specific		
Ctrl-↵	All	Activate Impromptu slideshow
↵	S	Start slideshow
Esc	All	Terminate slideshow
Space	S	Pause slideshow
Ctrl-T	S	Add text overlay
Ctrl-[/ Ctrl-]	S	Rotate left/rotate right
Ctrl-J	S	Export slideshow
Print Module specific		
Ctrl-P	All	Print
⇧-Ctrl-P	All	Page Setup
Alt-Ctrl-P	P	Print one copy
⇧-Ctrl-T	P	Show/Hide image cell
Ctrl-R	P	Show/Hide rulers
⇧-Ctrl-H	P	Show/Hide guides
⇧-Ctrl-M	P	Show/Hide margins and gutters
⇧-Ctrl-Y	P	Page blend
Ctrl-[P	Rotate left
Ctrl-]	P	Rotate right
⇧-Ctrl-←	P	Go to first page
Ctrl-→	P	Go to next page
Ctrl-←	P	Go to previous page
⇧-Ctrl-→		Go to last page
Web Module specific		
⇧-Ctrl-P	W	Preview in Web browser
Ctrl-J	W	Export Web gallery
Ctrl-R	W	Reload Web gallery
Ctrl-S	W	Save Web settings
Miscellaneous		
Ctrl-S	All	Save current settings
Ctrl-N	D, S, P, W	Create new template
⇧-Ctrl-N	D, S, P, W	Create new template folder
Ctrl-A	All	Select all images
Ctrl-D	All	Deselect all
Ctrl-Z	All	Undo last action
⇧-Ctrl-Z	All	Redo last Undo
Ctrl-:	All	Spelling dialog (for current field)
Ctrl-; (semicolon)	All	Check spelling (current field)

Resources

B *Please keep in mind that Web links may change, specific information may be removed or a web address may vanish completely. We welcome information about such discrepancies so that we can correct them in the next edition of this book.*

B.1 Recommended Books and E-books

[01] Uwe Steinmueller, Juergen Gulbins:
DOP3002: *The Art of RAW Conversion. Optimal image quality from Photoshop CS2 and leading RAW converters.*
E-book on RAW conversion using Adobe Camera Raw, RawShooter Essentials, and other RAW converters:
www.outbackphoto.com/booklets/booklets.html

[02] Uwe Steinmuller, Juergen Gulbins:
Fine Art Printing for Photographers. Exhibition Quality Prints with Inkjet Printers
Rocky Nook, Inc, Santa Barabara, CA, 2006

[03] Bettina & Uwe Steinmueller: DOP3001:
Photoshop Layers for Photographers
www.outbackphoto.com/booklets/booklets.html

[04] Brad Hinkel: *Color Management in Digital Photography. Ten Easy Steps to True Colors in Photoshop.*
Rocky Nook, Inc, Santa Barbara, CA, 2007.

[05] Sascha Steinhoff: *Scanning Negatives and Slides. Digitizing Your Photographic Archive*
Rocky Nook Inc, Santa Barbara, CA, 2007

[06] Peter Krogh: *The DAM Book. Digital Asset Management for Photographers*
O'Reilly, Sebastopol, CA, 2005

[07] Brad Hinkel, Stephen Laskevitch: *Photoshop CS3 Photographer's Handbook. An Easy Workflow.*
Rocky Nook, Inc, Santa Barbara, CA, 2007.

B.2 Useful Resources on the Web

Keep in mind that web addresses may change or vanish over time.

[08] *Outbackphoto.com*
This is Uwe's website, full of up-to-date information on digital photography, including lots of informative papers on photography:
www.outbackphoto.com

[09] *Outbackprint.com.* This is Uwe's website on fine art printing:
www.outbackprint.com

[10] Uwe's FAQ on Lightroom. It is a user forum on Lightroom:
www.outbackphoto.com/artofraw/raw_31/lightroom_faq.html

[11] *FotoEspresso* is our free photo-letter with in-depth papers on various topics related to digital photography. As a subscriber, you will receive an email when a new issue is available. You can then download the document from:
www.fotoespresso.com

[12] Adobe: *Lightroom Product site.* You can download a free 30-days trial version of Lightroom:
www.adobe.com/products/photoshoplightroom/

[13] *Adobe Lightroom User Forum*:
www.adobeforums.com/cgi-bin/webx/.3bc2cfoa/

[14] *Lightroom News* An Adobe site with news on Lightroom. A number of useful tips can also be found here:
www.lightroom-News.com

[15] *Lightroom Killertips* A website with a number of tips on Lightroom (including a lot of advertisement):
www.lightroomkillertips.com

[16] *Lightroom-Presets* A website containing a number of Develop presets for Lightroom:
http://lightroompresets.com/

[17] *Lightroom Extra* Quite an informative site on Lightoom with a good FAQ list:
www.lightroomextra.com

[18] *The Image-Space* This is Joe Barret's website on various photo topics, Lightroom is among them:
www.image-space.com

[19] *inside lightroom* A number of presets and templates:
http://inside-lightroom.com
We also recommend reading the paper: *The Anatomy of a Lightroom Develop Preset*:
http://inside-lightroom.com/docs/develop_presets.pdf

[20] *Luminous Landscape* Michael Reichmann's popular website covering a number of topics on digital photography including Lightroom:
www.luminous-landscape.com/tutorials/lightroom-illuminated.shtml

[21] *Oaktree Imaging* Provides processing of Raw files and other Photoshop services. Also a number of tips and other kind of information on Photoshop, Color Management and Lightroom:
www.oaktree-imaging.com/knowledge/lightroom-tips/
This site also provides a Mac OS X folder action to automatically compress the backup copy of your catalog:
http://www.oaktree-imaging.com/blog/archives/2007/03/25/107/

[22] *International Press and Telecommunication Council:* A lot of information on IPTC metadata:
www.iptc.org

[23] IPTC: *IPTC4XMPCore User Guide* explains the ›IPTC core data‹ as used by Adobe XMP files:
www.iptc.org/IPTC4XMP/

[24] *IPTC New Codes* lists the codes used for some of the IPTC fields:
www.iptc.org/NewsCodes/

[25] *ISO 3166* List of country codes according to ISO 3166:
www.iso.org/iso/en/prods-services/iso3166ma/02iso-3166-code-lists/list-en1.html

[26] *Controlled Vocabulary* This site, provided by David Riecks, is an excellent introduction to IPTC data and keywording and advocates the use of a controlled vocabulary for keywording. It also provides a lot of links to more information:
www.controlledvocabulary.com

[27] *Caption and Keywording Guidlines* provides a good introduction on keywording:
www.controlledvocabulary.com/metalogging/ck_guidelines.html

[28] *ExifTool* is a small utility that is able to read, edit, and show EXIF, GP-, IPTC, and XMP metadata. There are versions of this tool for Windows, Mac OS, and Linux (🪟, 🍎):
www.sno.phy.queensu.ca/~phil/exiftool/

[29] HDRSoft: *Photomatix* is a tool we use to blend several shots taken with different exposures into a High Dynamic Range image. This tool is more powerful than the HDR function of Photoshop CS3 (🪟, 🍎):
www.hdrsoft.com

[30] Lightcrafts: *LightZone* – is an image editor you can use to work on Raw files, TIFFs, JPEGs, and PSDfiles. It provides nondestructive as well as selective editing and a very fine tone-mapping functionality: (🪟, 🍎):
www.lightcrafts.com

[31] Uwe Steinmueller: *The Art of RAW Conversion #30 – LightZone 2.0.* Paper on Lightroom: www.outbackphoto.com/artofraw/raw_30/essay.html#20070319

[32] *Magix* is a nice application to produce a digital slideshow (🪟): http://site.magix.net

[33] Boinx: *FotoMagico* is a very powerful application for producing digital slideshows (🍎): http://boinx.com/fotomagico/

[34] Shirt Pocket Software: *SuperDuper!* is a backup utility allowing the production of bootable disks (🍎): www.shirt-pocket.com

[35] econ: *CronoSync* is a fast and very reliable utility for backup and folder synchronization (🍎): www.econtechnologies.com

[36] *Carbon Copy Cloner* is a donation shareware utility for cloning Mac OS X operating system disks (🍎): www.bombich.com/software/ccc.html

[37] *FileBack PC* This backup utility allows a scheduled, automatic backup and folder synchronization (🪟): www.maxoutput.com/FileBack/

[38] *PTLens* Photoshop plug-in that performs profile-based corrections of lens distortions (🪟): http://epaperpress.com/ptlens/

[39] *LensFix* Photoshop plug-in that performs profile-based corrections of lens distortions (🍎): www.kekus.com

[40] PowerRetouche: *LensCorrector* (🪟, 🍎). PowerRetouche offers a number of Photoshop plug-ins like "Black&White Studio", "Lens Distortion Correction", and "Dynamic Range Compression": www.powerretouche.com

[41] *Hahnemuehle*: A maker of fine art papers of various kinds. You also find some ICC profiles for its papers for various fine art printers (e. g., Epson): www.hahnemuehle.de/site/us/798/home.html

[42] Michael Slater, Trent Bown: *Flash Article: Creating web photo galleries in ActionScript for use with Adobe digital imaging software.* www.adobe.com/devnet/flash/articles/adobe_media_gallery.html

[43] Ian Lyons: *Computer-Darkroom*. A interesting site on digital photography, including some good information on Lightroom. You will also find an (almost) complete list of Lightroom's keyboard shortcuts: www.computer-darkroom.com

[44] *X-Rite*: Color-Management Tools (Profiling packages, e.g., Eye-One Display). They also sell the ColorChecker color target: www.xritephoto.com www.xrite.com, www.gretagmacbeth.com

[45] Akvis: *Enhancer* is a Photoshop plug-in that helps to enhance the micro-contrast of an image: www.akvis.com

[46] *Bluefire* is a prepress service provider. It also provides a good blog on Lightroom with a number of good papers on Flash galleries: www.bluefire.tv

[47] *Jeffrey Fiedl's Blog* is a good blog on Lightroom and offers an online utility to produce a *Lightroom Configuration Manager* for metadata: http://regex.info/blog/2007-02-20/386

[48] *Adobe Photoshop Lightroom Support Center:* wwws.adobe.com/support/photoshoplightroom/

[49] *chromoholics* This is Thomas Fors's website providing a Photoshop script (and a description on its usage) to calibrate your camera using a Gretag MacBeth ColorChecker as a color target: www.fors.net/chromoholics/

[50] *GSPPhotoLinker* allows you to link GPS data to your shots: http://oregonstate.edu/~earlyj/gpsphotolinker/

Index

C